BEDFORDSHIRE

D1138740

9 39277157

Chris Wadsworth is the gallerist of Castlegate House
Gallery in Cockermouth. Her exhibitions have included
work by artists such as L.S. Lowry, Shelia Fell, Bill Peascod,
Percy Kelly, Winifred Nicholson and Mary Fedden.

Hercules and the Farmer's Wife

and Other Stories from a
Cumbrian Art Gallery

CHRIS WADSWORTH

First published in Great Britain
2009 by Aurum Press Ltd
7 Greenland Street
London NW1 0ND
www.aurumpress.co.uk

Copyright © Chris Wadsworth 2009

This paperback edition first published in 2010 by Aurum Press

Chris Wadsworth has asserted her moral right to be identified as
the Author of this Work in accordance with the
Copyright Designs and Patents Act 1988.

All rights reserved. No part of this book may be reproduced or utilised
in any form or by any means, electronic or mechanical, including
photocopying, recording or by any information storage and
retrieval system, without permission in writing
from Aurum Press Ltd.

Every effort has been made to trace the copyright holders of material
quoted in this book. If application is made in writing to the publisher,
any omissions will be included in future editions.

A catalogue record for this book is available from the British Library.

ISBN 978 1 84513 554 6

1 3 5 7 9 10 8 6 4 2
2010 2012 2014 2013 2011

Typeset in Fournier by M Rules
Printed by CPI Bookmarque, Croydon, CR0 4TD

To the two Michaels

Bedfordshire County Council	
9 39277157	
Askews	920 WAD

Contents

Prologue

There is a tide in the affairs of men,
Which, taken at the flood, leads on to fortune.

Shakespeare, *Julius Caesar*, IV: iii

'You haven't,' he groaned. 'Tell me you're winding me up.'

'No, it's true,' I said in a small voice – my humble, apologetic voice. 'I bought it by mistake just now – at Christie's – the Nicholson.'

'But you're supposed to be in Newcastle seeing your daughter . . . Oh' – I could hear the penny dropping – 'a telephone bid, was it?'

There was a long silence. I was glad there was a fifty-mile distance between us.

'But – *thirty-eight thousand*!' he spluttered. 'How could you do that?'

Easily, I thought to myself. *It was easy.*

When the music had been faced and the dust had settled;

when the painting had been restored and sold and I had been forgiven, I wrote the story down. Then I thought of other paintings that had passed through my hands over the years, and in rare spare moments – and in a busy gallery like mine, where we mount about eight or nine solo shows and hang at least a thousand paintings a year, they are rare – I wrote the stories of those paintings down as well. I discovered I enjoyed writing. It was an escape.

I suppose opening a gallery in the far north-west of England was rather an unexpected decision as well. Cumbria isn't the first place that would spring to mind for a contemporary art gallery, as many well-meaning people pointed out when they saw my planning application, and then again more forcefully when they noticed that I didn't show local artists and local views.

'You've got to have views,' they told me. 'That's what people here want.'

But art is a very personal thing, and my only benchmark was to exhibit what excited me in the hope that if it gave me a buzz then there must be others who would feel the same. I had no desire to second-guess other people's tastes, let alone base my decisions solely on the grounds of what might sell. So I started modestly, without views but with a vision that maybe one day, if the gallery survived long enough, I might mount exhibitions by great Cumbrian painters like Winifred Nicholson and Sheila Fell. Perhaps I would discover new young talent fresh out of college and build up their reputation from first base. Maybe I would graduate in time to showing some of

my own favourites like Mary Fedden, Sandra Blow and other Royal Academicians. I fancied a Frink in the garden, fantasised about a crowd-pulling Lowry show and dreamed of handling the estate of an important but undiscovered artist. My ambitions were high but every one has now been realised.

From the moment I opened the big front door for the first time to the art-loving public, on 7 July 1987, a varied and continuous procession of people has passed through Castlegate House. Some have gone out carrying a painting under their arm, or hauled a sculpture or pot away to their car boot. Others have arrived bringing in works of art in the hope of being offered an exhibition. Hundreds of thousands of paintings must have passed, conveyor-belt style, before my eyes. I have met an extraordinary number of interesting, distinguished, famous and infamous people – people who I would never have met in ordinary life. They have enriched my life and I hope that to some extent the gallery has enriched theirs.

A knitting vicar caught me by surprise in the first month. He was proudly wearing a Fair Isle sweater over his dog collar with an in-your-face John Lennon on the front. He came bearing binbags full of similar garments and rugs which he proceeded to tip out in the main gallery, as if setting up a market stall, aided and abetted by his chubby apple-cheeked wife who, with a flourish, unrolled a rug with a Mick Jagger design on it. I fought my way through the crowd that had gathered around them and politely showed them the door.

The sugarcraft ladies with their intricate icing-sugar sculptures and the lacemakers with their doileys and collars joined

3

the cast of thousands, puzzled and disbelieving that I wasn't going to offer them an exhibition. One man arrived with a pair of windscreen wipers. He strode around the gallery for a bit, the wipers wiggling in his hands, and then declared that a leyline went right through my desk in the hall. It was very entertaining until he finally reached the crux of his speech – his brother was a painter and he thought this an auspicious place for him to show.

One day a lovely secondhand book dealer turned up, looked round and, theatrically throwing his arms wide, declared in a broad local accent: 'This is the cultural hub of Cumbria!' When he disappeared and returned hauling a flotilla of metal utensils – odd-shaped buckets, bowls and jugs – which were gaudily painted with flowers in primary colours on black, bargeman style, I realised that the flattery was just part of the softening-up process. Every day brought something new – rich material for my inquisitive mind.

A definition of an artist is someone who alters our perception of things. And after twenty years in the art world I find I now look at things differently. I see a landscape, a vase of flowers or a group of household objects through the eyes of a particular artist. There is a Peascod landscape outside my window, a Nicholson pot of wild flowers on my kitchen windowsill, a Kelly cottage and bridge down the road and a Fedden still life on my table. Wallbank sheep stand creamy-brown against the snow with a lowering Fell sky above the fields, and Lowry matchstick people scurry purposefully around the town.

Contained in this book are just a few of the stories about some of the paintings and some of the people who have appeared on the gallery stage over the last two decades or more. I have laid on private views for more than two hundred exhibitions and invited interested people to enjoy the art and meet the artists. This book is yet another private view; a retrospective private view which invites the reader into the hidden workings of the gallery, into the world of art and artists and into my life as a gallery owner.

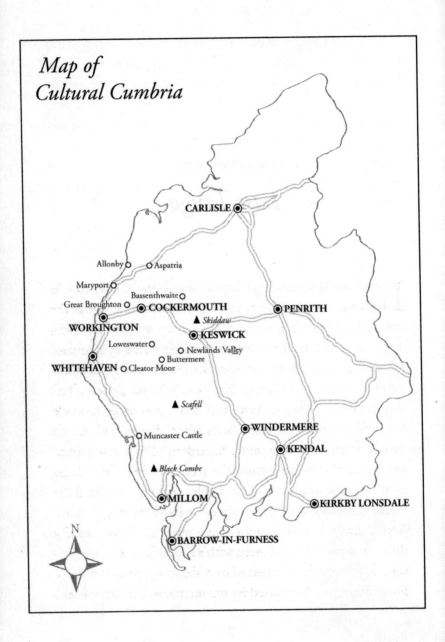

Map of
Cultural Cumbria

CARLISLE

Allonby Aspatria

Maryport

Bassenthwaite

Great Broughton COCKERMOUTH PENRITH

WORKINGTON ▲ Skiddaw

KESWICK

Loweswater Newlands Valley

Buttermere

WHITEHAVEN Cleator Moor

▲ Scafell

▲ Muncaster Castle WINDERMERE

KENDAL

▲ Black Combe

MILLOM KIRKBY LONSDALE

BARROW-IN-FURNESS

N

Last Tango

I first saw Melbecks Farmhouse on a bitterly cold day in January 1986. I didn't realise how significant it was at the time. The house sits on the 500-foot contour of the northern slope of Skiddaw, the third highest mountain in England, which rises dramatically from Bassenthwaite Lake and dominates the slate-grey town of Keswick. We had chosen a bad day to view it. The thin veneer of snow over solid ice made the network of single-track lanes which dipped and curved their way upwards even more hazardous. The house looked austere and uninviting from the front, dwarfed by a huge attached barn which was semi-derelict and overwhelmed the house and its separate little white-rendered milking parlour. Round the back and out of the biting wind, it showed a totally different aspect: more homely, with a rickety lean-to conservatory and rough yard protected by a sheltering group of trees. Everything was dominated by the mountain that soared into

the sky above us, shimmering bright white against the grey snow-laden sky.

I was with Michael, my husband of twenty-five years. Both Northerners, we met at university in London, got married ridiculously young by present standards and spent most of our married life in exile in the south of England. Michael was ambitious and had moved up the executive ladder quickly and judiciously, and since that meant staying in the south then we did. Now our chance to move north had come at last and we were excited at the prospect. This was to be our last move. In life's great game of musical chairs, this was where we wanted to be when the music stopped. This would be for ever.

Our Georgian house in Bristol was on the market with no shortage of potential buyers, and Melbecks Farmhouse was the first house I had found for us to view. It had a studio and planning permission to convert the barn into accommodation for painting holidays. My background was art and I was giving up a graphic design business to move, so I was looking for a new venture that was art-related.

We were greeted at the farmhouse door by a young Japanese woman and her daughter, who must have been nine or ten, with an oval face, almond eyes and intelligence beyond her years. The lean-to conservatory was cluttered with boots and climbing ropes, crampons and ice axes and skis and sledges. Then, as we passed into the large sitting room, with slate-paved floor, enormous stone fireplace and huge oak dining table, I saw the paintings on the wall and

caught my breath in astonishment. Facing me was a textured semi-abstract board which drew me immediately into the wild understated landscape it depicted. It was so deeply fissured that I felt I could almost climb it; I could see handholds in the crevices and overhangs. My eyes filled with tears; embarrassed, I tried to remind myself that it was the house we were viewing, but failed.

As we went from room to room – each room containing another magnificent piece of art, all undeniably by the same hand – I felt as if I was being torn apart. I was uncharacteristically silent, desperately trying to concentrate on the house until we finally got to the milking parlour, now a studio. There was an old Pither stove in the middle of the room and unfinished paintings stacked against the wall. By a messy table full of paints, brushes and dirty paint rags, stood an easel with a half-finished piece of work. I could feel the presence of the artist so strongly that I could no longer contain myself. As casually as I could, I asked, 'Who's the artist?'

'Oh, that's my husband,' the woman replied, equally casually.

'So where are you thinking of moving?'

'We're not sure yet – maybe Edinburgh or Bristol – a place which will be good for Emma's education.'

'I don't think your husband will be able to paint like this in a big city,' I couldn't help saying.

She turned to face me with large deep eyes. 'My husband is dead,' she said in a flat expressionless voice.

I realised too late that the 'we' had referred to her and the child. She seemed much too young to be a widow.

We left shortly after and took off to the comfort of the village pub. I stared disconsolately into my half-pint of lager, overcome with sadness. There were so many unanswered questions in my head. What was a young Japanese woman doing living up a mountain with a small child? Was her dead husband Japanese too? He certainly painted in a minimalist way, but the agent hadn't given me a name. How had he died? And what would happen to all the paintings stacked about the place? One thing I did know – I wanted to buy at least one of those paintings. And, despite all the drawbacks, I wanted to buy the house as well.

The next day found me at the estate agents in Keswick trying to find out more. The agent looked at me as though I should know. 'That's the house of the climber Bill Peascod,' he said. 'He died on a mountain a few months ago.'

Of course, I had seen it on the national news. He had been climbing in Wales with the legendary Don Whillans when he suffered a major heart attack. Earlier in the year I had watched a television programme, part of a Channel 4 series, which had filmed him re-enacting a favourite climb, using only the equipment that had been available to him on his first ascent. Bill had chosen Eagle Front, a difficult climb above the Buttermere Valley, part of the fascinating ridge which stretches from Haystacks along High Raise and High Style to descend above Sour Milk Gill to the little hamlet of Buttermere. This climb is difficult because it is in a north-facing crevice which never gets the sun so it is always wet and slippery, a climber's nightmare. Bill had first climbed and named this route as a young

man decades earlier, wearing Woolworths plimsolls and carrying a hemp rope.

Four hours later, back in Bristol, my first stop was George's bookshop in Park Street. Yes, Bill's autobiography, *Journey after Dawn*, had been published shortly before his death and they had a copy on the shelf. I rushed back home with it, sat at the kitchen table and read it through at one sitting, sometimes with tears streaming down my face. What a story and what a man! Now I wanted his house even more.

Bill was from Maryport, a mining town on the west coast of Cumbria. His mother had died of tuberculosis when he was nine. He left school at fourteen and followed his father down the mine. Though he could see the Cumbrian Fells in the far distance from his home, he had never ventured very far beyond the town until a life-changing day in 1938 when, aged eighteen, he came off the night shift and decided to get on his bike instead of going to bed. He set his handlebars towards the fells and pedalled like crazy. At Mockerkin, he climbed on up over Fang's Brow, where suddenly the whole of the Loweswater Valley opened up before his eyes. He sped down into that magical valley, incredulous at what he had discovered, as though he was the first man ever to find it. He abandoned the bike and scrambled up the nearest wall of rock. When he reached the top he found he could see Crummock Water and Buttermere as well as Loweswater, with range upon range of fells as far as the eye could see. He was hooked. Until then climbing had been the preserve of middle-class university

graduates, but Bill soon joined up with other working-class lads like himself and they spent all the time they could spare pioneering and naming new routes.

In 1953 he decided to take the opportunity offered by the Australian government of a £10 passage to start a new life on the other side of the world. He was offered a mining job in Wollongong, an industrial town of steel and coal on the coast south of Sydney. On the map it looked very much like West Cumbria, with mountains in the hinterland within a few miles of the coast. Imagine his dismay when he discovered that the mountains were covered in rainforest and virtually unclimbable. He and Margaret, his wife, tried to make a new life there. They had married when Bill was twenty-one and she a year younger, and had a son, Alan, who grew up to be a potter in Australia. But Bill was homesick and missed Cumberland every single day of the thirty years he spent in exile there. It was then, in those early days in Australia, that he took up painting to fill the void left by climbing, producing first small, tight watercolours and then expanding into the huge boards I had seen. One day he accidentally set fire to a painting and watched in fascination as the oil melted and congealed into interesting patterns and textures. The 'Burnt Paintings' became his signature and he began to attract notice in the art circles of Sydney and Melbourne. His paintings sold well and won prizes but, he recalled, 'on a more personal front, it sadly has to be said that things had not gone so well between my wife Margaret and myself. No one can point to a spot and say this is what went wrong. There was just a slow erosion of

our relationship over the years and a great deal of unhappiness on both sides.'

Bill's artistic success allowed him to travel, and it was on one of his travelling scholarships to Japan that he met Etsu, a young art student in his class in Kyoto. He was as old as her father but they fell in love and married, and she returned to Wollongong with him. The first time he brought Etsu to the Lake District on holiday, her eyes widened in surprise. 'You haven't been painting Australia!' she said. 'This is what you have been painting all these years.' And she was right. He sometimes painted specific Australian mountains such as Mount Kembla and Threadbo, but that was to satisfy his dealers and the Australian art market. When he could, he gave general titles to his paintings – *Snow Mountain*, *High Ridge*, *Windy Day* – and these giant minimalist boards were full of nostalgia and love for his native landscape.

Bill and Etsu returned to Cumbria in 1980, for good. After a long search they came upon Melbecks Farmhouse in a sad state of neglect and disrepair. It was only a short walk from the village of Bassenthwaite, which had a lovely little school for Emma, and the magnificent views and the fact that they could step out of the back door onto one of the highest mountains in England overrode everything else. They bought it and set about renovation with enthusiasm. Bill soon renewed links with the climbing fraternity, whose members, old and young alike, treated him with enormous respect. His name is still legendary amongst them.

In his autobiography he describes Melbecks Farmhouse

with deep emotion. I read how they had built the chimney and fireplace with local stone, renovated the oak and sandstone floors and entertained his climbing friends with Etsu's wonderful food. I read about the cowshed studio and the little copse with a beck where badgers, red squirrels, foxes, buzzards and occasional wild deer roamed. He wrote:

After we bought Melbecks I was surprised to find that as well as owning the land in front of the house and the garth behind, we were the possessors of nearly two acres of woods. Chapel Beck, a beautiful bubbling stream runs between high rocky banks throughout the length of the coppice. Someone said to us at the time, 'The only thing it might be good for is growing Bluebells!' – a comment that has proved to be a decided under-statement . . . From our windows, between a sycamore and a tall, youngish oak, I can see the top of Skiddaw. It is a mountain which is so easy to underestimate. Only since I have got to know Skiddaw in a season of moods do I realise that there is more to the peak than its height . . . I have walked Skiddaw on all its sides – in the sun, on the tourist route and on New Year's Day with five-year-old Emma, across an icy summit, where we had to take great care that the icy blast did not whisk her off her feet . . . Those who only know Skiddaw as a backdrop for the gasometers of Keswick are missing a great deal. Come and see it from Bassenthwaite village – as a sleeping giant – or approach it from the north across Uldale Moor and notice how, suddenly, the mountain has slimmed into the gracious pyramid of some faraway Scottish peak and how the Ullock Pike range has,

equally sharply, been drawn out into an exciting outline of curves and rises, pinnacles and folds.

When you have done this you will know why I paint this so often.

After a disturbed night, I rang the estate agent the next day and we made an offer of the asking price, which was generous to say the least in view of the state of the place. The fact that the only bathroom was a freezing shower cubicle on the ground-floor verandah and the water came from the stream and so was rather unreliable made it even more generous, or, actually, a bit daft. To my surprise this offer was greeted with coolness. I was puzzled and deflated. The following weekend I called on Etsu on my way to the hotel to see how the land lay. She was unaware that we had made any offer but was absolutely delighted. She found Melbecks unbearable without Bill and couldn't wait to get out of this cold, inconvenient house with all its memories. Monday morning found me at the estate agents again, demanding to know why my offer hadn't been put to Mrs Peascod. I pointed out that we had sold our Bristol house and would be moving out in two months, that Etsu was very keen for us to buy the farmhouse and that we had offered the asking price.

The estate agent still looked doubtful. 'Mrs Peascod is a bit foreign,' he said. 'She doesn't understand how we do things round here.'

I found this rather offensive.

'I'm not sure I do either,' I said pointedly, and then realised

that he probably wasn't being racist and no doubt classed me in the same category. All outsiders were a bit foreign to him, I supposed.

'You'd better explain,' I said.

'We've had another offer,' he told me. 'It's better than yours. I was going to put both to Mrs Peascod this week – unless you want to go higher?'

'Who are these other people?' I asked suspiciously. 'Have they sold their property? Mrs Peascod is anxious to move out quickly.'

'I'm not at liberty to say,' he answered smugly.

I found the agent easily dislikeable. He had a false obse-quiousness, with an underlying arrogance and a nasty habit of rubbing his hands together as though in glee. He appeared to enjoy the power he exerted over people's lives – their futures.

A few days later he rang to say he had put the offer to Etsu but she was going to wait and take the highest. The next few weeks found us upping our offer every few days and the other party doing the same, until my nerves could stand it no longer. I dared not call on Etsu again. It seemed improper in the cir-cumstances. Fed up, I rang the agent to tell him we were pulling out. Instead he suggested we go for a 'best and final' by sealed bids the following Friday. This we did – and guess what? Their best and final was very slightly higher than ours. The agent said he really shouldn't be telling us this, but a thou-sand pounds more would secure it. After a weekend spent biting our nails, we both lost our patience.

'In my understanding,' Michael told the estate agent icily, 'a

best and final is exactly what it says it is. If their offer is higher, so be it. They must have it, and I totally disapprove of the way you've handled this. If you were selling the last house in Cumbria, I wouldn't buy it from you.' And we got up and walked out. We had gained the moral high ground but had lost the house we so badly wanted.

I was devastated. Our furniture went into storage and we rented a house near Cockermouth. I made no attempt to contact Etsu – I was too sad and embarrassed. Yet I was still haunted by those wonderful paintings.

We made several attempts to buy other houses in the area but were repeatedly defeated by the capriciousness of the system. The way the estate agents conducted a sale was a fusion of the worst features of the Scottish and English systems – a mixture of suspense and secrecy. Offers were submitted, chewed over and rejected until a process of bidding up was entered. This was nerve-wracking, and we lost several good houses. Most spectacularly, we were gazumped on our day of exchange by a man from Manchester in a Silver Dawn Rolls Royce. The vendors and the agent just rolled over and conceded at the sight of the car and the apparent wealth it signified. *Fools*, I thought bitterly. *Is there no honour left in the world?*

It was an ordinary Wednesday morning in June when the details of Castlegate House flopped through the letterbox of our rented bungalow. Michael opened it, shrugged and dropped the contents in the bin.

'No good,' he commented dismissively. 'Too big and

there's no way we want another Georgian heap, is there? Anyway it's in the middle of town.' And he went to work.

From the photograph on the front of the brochure, the house was very big and very pink, double-fronted like a giant doll's house with hideous Tyrolean shutters at all the front windows. I read on. It was Grade 2 listed and starred – an important place, mentioned by Nikolaus Pevsner, who in his architectural guide to the area described Cockermouth as a 'gem town'. It was the same price as the house we had just sold in Bristol; you certainly got more for your money up north. I made an appointment to view that day, out of desperation as much as anything else. I was not hopeful.

The house was run down but impressive, with perfect Georgian classic proportions, Adam ceiling, plasterwork and fireplaces. There were brass bell-hooks in every room and a battery of bells in the old kitchen, graded so that the servants would tell by the tone which room was summoning them. As I toured the house my heart sank. I too would need a battery of servants to keep this place going, and that would be after the army of builders needed to make it comfortable. I all but dismissed it, not realising the best was yet to come. Although the house stood close to the road, when one entered there were glimpses of a garden down the hall. Now I opened the door and stepped out into paradise – the most marvellous walled secret garden I had ever seen. Nearly an acre in size, it was perfect, with formal lawns, arches and flower beds full of old fragrant roses whose drifting scents almost unbalanced me, and a thriving kitchen garden with

soft fruit bushes and strawberries and – oh joy! – an asparagus bed. We had always wanted an asparagus bed, but had never lived anywhere long enough to establish one. In the middle of the orchard stood a walnut tree whose laden branches swept to the ground, releasing a heavy nutty scent. It was perfect.

But the house was too big. Our children had grown up. What would we do with eight big bedrooms, three receptions, a huge cellar and various ante-rooms, attics and pantries? How would we heat and furnish it, and even decorate it? Our small collection of paintings would be lost in this huge place.

Then, suddenly, I had an idea that stopped me in my tracks. *Look at those walls . . . the proportions of the rooms. This would make a fantastic art gallery.*

I'd always wanted to run an art gallery. Could I make this work?

I'd never written a business plan before, but the Midland Bank at the bottom of the hill had a useful how-to leaflet, and by Saturday it was written, this historic document which still sits in the old safe under the stairs and is aired occasionally when nostalgia takes over. I made an appointment for a second viewing – this time for the two of us. We parked in the town and did some shopping until it was time. I then casually mentioned a house I'd like us to look at together. Michael was intrigued – until, halfway up the hill, he guessed where we were going and stopped dead like a cat which has seen its basket and suddenly realised it is being taken to the vet.

'I don't want to see that great wreck,' he said firmly. 'It's a waste of time. It's too big and too much work.'

'I know,' I replied. 'But it's only a few more yards and I've made an appointment. We shouldn't be rude, should we?'

'Why did you do that?' he asked grumpily. 'You must know it won't do for us.'

'Let's just look, shall we? Can't do any harm.'

'I'm sick of looking at houses,' was the reply.

'It has a lovely garden,' was my only, lame defence.

The back door at the end of the hall was open, letting in a shaft of sunlight and the heavy scent of roses. It was a magnet. Michael seemed to sleepwalk through the dark, dirty green hall and out into the sunlight.

'I've always wanted a walled garden,' he said dreamily and set off towards the vegetable area, where he discovered the soil was dark and friable river alluvium.

Inside, his inner businessman returned. The wine cellar, the garage, the parking impressed him, but he argued that the house's sheer size and run-down condition tipped the balance against it.

'Every house is a compromise, you know,' I said, trying to sound reasonable.

'Yes, but not as big a compromise as this,' he answered curtly. 'It'll cost a fortune to run it properly, never mind renovate it. You shouldn't have brought me here, because nothing is ever going to compare with this garden, is it?'

'I have a plan,' I said in a small voice.

We sat on a seat in that magic garden and I got my plan out

of my bag. Michael's eyes widened as he read it. I had facts
and figures, financial projections and client lists. He was a
graduate from the London School of Economics, but never-
theless he was impressed.

'Can you make it work?' he asked, with a skimpily con-
cealed eagerness in his voice. 'You would have to do it all, you
know. I would do the garden but would have no time for any-
thing else. It would be down to you. I know you can probably
handle the builders but a listed building is much more restric-
tive and where are you going to find artists? You don't know
anyone round here.'

I smiled inwardly at the total turn-round, but when I realised
I had won I was overcome with fear. Fear of failure and fear
of losing Castlegate House.

But we didn't lose it. We moved in September 1986, I
applied for change of use to an art gallery and opened for busi-
ness the following July – 7 July 1987, an auspicious day. The
rest is history, as they say.

The opening was nerve-wracking. It was the heady decade
of privatisation, and Margaret Thatcher and her underlings
were selling off anything they could lay hands on. Gas, water
and electricity had all gone private, as the people of Britain had
eagerly bought shares in companies that already belonged to
them. At the time Michael was a director of National Bus, and
had already turned around the finances of several bus compa-
nies. We had come north because he believed it would be good
to find a small bus company and get a management buyout
bid together. In eighteen months he had turned the ailing

Cumberland Motor Services into a successful concern making a healthy profit. Two weeks before I opened the gallery he had to submit a sealed bid to buy the company. But he had done the job too well, and the opportunity attracted attention from bigger players. I was hanging the opening exhibition when he rang to tell me that they had lost out to Stagecoach, then a little-known company from Perth. When the new owners arrived, they made it clear that they assumed they had bought Michael along with the company. But he hated the prospect of working for them, and became depressed and introverted. On the day of the gallery's opening he hadn't slept and was silently brooding. He went up the garden and lit a bonfire and spent the afternoon stoking it up. Our three children kept trekking up the garden to talk to him and returned each time shaking their heads. It probably didn't help that our youngest and only daughter chose that afternoon to tell him she was moving in with her boyfriend. His mind must have been in turmoil.

But the opening was a huge success. It was scheduled for half-past two on a Sunday afternoon, but family and friends had begun to arrive from Friday night, and I was glad I had got the exhibition hung two days before. I had found work from about twenty painters as well as ceramics and sculpture, and I really enjoyed arranging it. The Adam Room is a perfectly proportioned double cube with a rare, totally unspoiled plasterwork ceiling by Robert Adam. With its polished wood floor and white walls, this room gave the perfect understated backdrop for the paintings, showing that modern work can look beautiful in a period setting.

In a frenzy of marketing, I had persuaded all the local papers to run articles about the gallery, showered all Cumbria's attractions with posters and leaflets, and sent invitations to every mover and shaker I could identify. As the time of the opening approached I was not only exhausted but extremely nervous. Would anyone turn up? Would they like the work? Would they buy?

I was amazed. They crowded through the door dressed in their finest, enjoyed the wine and chat – and, most importantly, they bought! Many people commented on how lovely it was to see good paintings in a domestic setting, and the locals were delighted to gain access to a house they had long admired but never entered. At that time there was no other commercial gallery in Cumbria mounting exhibitions like this, and there was obviously a demand there to be fulfilled. It was better than I had ever imagined in my most optimistic moments. I spent the afternoon fighting my way through the crowds with the red spots that marked a sale, and soon I had sold almost everything on the walls. There was a real buzz in the place and I knew then it was going to be a success. But I had to keep it going. Could I maintain the momentum? And could I cope with Michael's depression? We had a subdued celebration with friends that evening.

A few weeks later, on a Wednesday afternoon, I saw Michael's car pull in and heard him enter the house and slam his briefcase onto the kitchen table. I excused myself from the people in the gallery and went through.

'I've resigned,' he said. 'I can't work for those people. I am so sorry.'

I was dismayed. Michael had always been the main bread-winner, the security of the family. I had told him I would need five years to get the gallery into a position to pay the mortgage and living expenses. But I knew now that I had to make the gallery work from the beginning. It was no longer an interesting and exciting project. It was our livelihood.

Fortunately, the gallery was an immediate success. I spent a lot of time tracking down artists and persuading them to show with me while at the same time building up the mailing list and putting together an impressive programme for the future. This was not easy, because I needed the good artists to attract the right sort of buyers and likewise needed the buyers to attract the right artists. All the time I had images in my mind of those wonderful paintings I had seen at Melbecks that winter's day. I had tried to contact Etsu to see if I could buy a few paintings or give Bill Peascod a retrospective but I couldn't trace her. I discovered that she had moved out of Melbecks more than a year after we had made our final bid and had left no forwarding address with the people who had eventually bought the house. I could find nobody who knew where she was.

Then in November 1988 she unexpectedly rang the gallery. I was overjoyed.

'Where are you, Etsu?' I asked. 'I've been trying to find you.'

'I'm in Edinburgh. I just heard that you have a good gallery

and I'm looking for somewhere in Cumbria to hold a memorial exhibition for Bill. What do you think?'

I was in the car and up in Edinburgh the next day. Over a delightful and elegant Japanese meal, eaten sitting excruciatingly sideways on the floor of her basement flat in the West End and surrounded by those paintings which had made me cry, we both decided that it was better Michael and I had bought Castlegate House instead of Melbecks. She told me, giggling, how the water supply dried up in summer and the bathroom froze in winter. Rather than waste time dwelling on what might have been, we instead set about planning the retrospective.

In the process we became great friends and the exhibition took place the following September. Melvyn Bragg opened it, Chris Bonington spoke about Bill with sincere affection and all the climbers I'd ever heard of were there – legendary figures such as Joe Brown, Don Whillans, Ginger Kane, Bill Birkett and many more. There were no paintings for sale because Etsu wasn't ready to let go of anything of Bill's yet, so we had to get sponsorship and, appropriately enough, the Coal Board came up with it. Even so, we ran at a loss that month. But it was worth it.

As a result of the show, I managed to buy a few Peascods from local people who were lucky enough to own them, with a view to gathering enough for another exhibition. But once again Etsu had disappeared. She had moved away from Edinburgh and covered her traces. She was, and still is, very good at doing a vanishing act.

*

One night in the autumn of 1993 at 2 a.m. – or thereabouts – my bedside phone rang. Cursing and drowsy, I picked it up. It had to be an emergency.

'Chris, guess who this is?' said the voice with a slight foreign accent that I couldn't quite place.

'I have no idea,' I said shortly. 'Who is that?'

'It's Etsu!' she cried.

'Etsu, it's the middle of the night. Where are you?'

'I'm in Australia and Bill is speaking to me.'

'What's he saying?' I inquired, wearily. Bill had now been dead for eight years.

'He thinks he should have another exhibition of his work. I have found all these receipts for work lodged in major galleries in Australia. Many are on loan so they must belong to me. Are you in next Tuesday?'

I madly tried to recall my diary for next week. I found it hard to take her seriously. 'Why?' I asked warily.

'I'll get to you by lunchtime and we will talk about it. Goodbye.'

'What's going on?' asked Michael grumpily.

'It's Etsu – she's in Australia and she's coming to see us next Tuesday.'

'I'll believe it when she walks through the door,' my cynical husband replied, and he turned over and went back to sleep.

But that is exactly what she did. At 12.30 the following Tuesday, she walked in, designer-clad from head to toe, a Louis Vuitton briefcase of papers in her hand. What she had

told me was correct and, as far as I could see, the works, listed on the headed paper of major galleries, definitely belonged to her. They were probably mouldering forgotten in vaults and storerooms. I was more than a little interested.

'I think you should come out to Australia and help me get them out,' she declared firmly. 'When can you come?'

It was November and we were due to close for our winter break on Christmas Eve, reopening on 1 March. We would normally have a trip planned and booked already, but for some odd reason that year we didn't. We hastily planned an itinerary which involved breaking our flight in Singapore, travelling the length of Malaysia into Thailand and flying on to Sydney in early February. Etsu insisted we stay with her there and to our total amazement was at the airport to greet us when we landed at six o'clock in the morning. She immediately took us to the wholesale fish market, via the Sydney Harbour Bridge, for breakfast. It seemed surreal to be sitting on benches al fresco at ten o'clock on a February morning eating a breakfast of fish and chips in a temperature of 84°F.

The next two weeks were a whirl of travel and negotiations, but we were putting a remarkable exhibition together. The highlight for me was our trip to Wollongong, where we stayed with Les and Jill Zietara, friends of Bill and Etsu – a GP and his wife who had also emigrated to Australia on the £10 offer about the same time as Bill. A large barrel of whisky was situated on their bungalow verandah from which we were encouraged to help ourselves at all times. These were happy days with rather hazy memories. A tame kangaroo made

frequent visits, loping up through the avocado grove which Les had recently planted. We met the curator of the small art gallery there who remembered Bill with affection and showed us some of his early watercolours painted in the immigrants' camp where he and his Maryport wife were initially housed. They were pregnant with loneliness and yearning. We saw some of the early burnt paintings – huge boards which Bill had put to the flame so that the paint bubbled and congealed into surprising forms and textures. It was an enchanting visit.

It was after this that I had my first premonition. It came during a trip to the rainforest above Wollongong. We had already trekked through a rainforest on that trip, in Malaysia. Within minutes we had been drenched in sweat, and the forest floor was alive with leeches that, sensing our approach, reared eagerly up like a little forest to get on board a human and feast on their blood. Despite every effort, they outwitted us, getting down our socks and boots and even up our trouser legs, whereupon we had to sprinkle salt on them so that they would loosen their hold and drop off, without leaving bits of themselves embedded in our skin. So when we knew we were visiting a rainforest in Australia, we got togged up in the same gear. When we appeared for breakfast in full body cover, carrying a bag of salt, our hosts roared with laughter. We hadn't realised the Australians have sanitised the rainforests, building raised wooden walkways so one gets the gain without the pain. We walked to a waterfall and I hung back to take a photograph of our group. Through the viewfinder I looked at Michael as he walked along in shorts and T-shirt and was suddenly filled

with fear. He was shrinking. I still have that photograph and it wasn't my imagination. I was filled with a grumbling disquiet.

A few days later we went to a concert at the Opera House in Sydney. The acoustics are superb in that magnificent, iconic building. The music soared. The orchestra had been dressed by a leading Australian fashion designer, and, rather than the dull black of our European musicians, they were a chiaroscuro of pinks, purples and blues. The music matched the orchestra in liveliness and challenge. They played Scarlatti and Rachmaninov and we came out on a high. There was an opera taking place in the other concert hall and it was relayed live to a big screen on one of the piazzas. We stopped to watch. I was entranced, lost in the whole experience. When I looked round again just a few minutes later, Michael wasn't there by my side. He had been wearing an elegant white linen suit – quite conspicuous – but now he was nowhere to be seen. I went into a panic and began to run around looking for him, convinced somehow that I would never see him again. It was irrational and uncharacteristic and lasted for at least fifteen minutes. All this was played out to the haunting sound of *La Traviata*. What a relief when he finally turned up, coolly amused at my hysteria. I threw my arms around him and held him so tightly that he laughed and pushed me away. To this day I still can't listen to that particular aria in *La Traviata* without being overcome with a feeling of impending loss and loneliness.

We sorted out all the paintings with Etsu and discussed packing and shipping with an exhibition planned for early the

following year, 1995. It would be a selling exhibition this time. Etsu was hard up and we couldn't afford to put on another profitless show.

We arrived back in England weary and jet-lagged. The twenty-four-hour flight from the east coast of Australia is tedious. Looking down out of the window after four hours flying, I was disheartened to see we were still over land – still over Australia. On our return I quickly bounced back into a normal sleep pattern and energy levels but Michael couldn't recover from it. He was losing weight alarmingly. The doctors thought he had some tropical disease picked up in Malaysia or Thailand. Tests were carried out, samples were sent off to Liverpool's hospital for tropical diseases but all came back negative. In the end, after several weeks, his weight loss was so dramatic that he was admitted to hospital and cancer was diagnosed. By the time the huge crates of paintings that we had packed in Australia arrived at the gallery, he was dead.

It was October 1994 when the paintings arrived at Castlegate House. The lorry pulled into our car park and I just sat on the wall while the men unloaded the crates and I wept. Michael had missed seeing the culmination of our work by just three weeks.

I threw myself into the gallery as the antidote to my appalling grief. Everywhere I looked there were reminders of the person now lost to me. We held a memorial event in his walled garden. All our artists contributed one piece to an amazing exhibition about the garden and the sculptor Gilbert

Ward carved a memorial stone and set it in the old wall. But I found the sympathy of others unbearable. I decided I must find another house – a small place where I could retreat and relax. Also I kept expecting Michael to walk through the door; I imagined I saw him in the garden working among his vegetables. I saw him everywhere.

It took a long time to find the right place but it was worth the wait. It is in a little valley below the north face of Skiddaw and looks out across the field to the farm where Bill and Etsu lived and to his milking-parlour studio. From the garden I can hear the church at Bassenthwaite chime the hour, the half and the quarters. Bill's grave with its simple Cumbrian slate gravestone is in the churchyard. When Etsu last visited she showed me the place at Melbecks Farmhouse where she and Bill and little Emma had made handprints in the fresh concrete of the yard all those years before. Red squirrels scamper past my office window gathering hazelnuts to bury in the immaculate lawn. A cock pheasant jumps up on to my windowsill and taps impatiently at the glass. A pair of buzzards returns every year to the oak wood by our bridge to bring up another family. I have watched the young buzzards learn to fly, screaming with delight as they reach take-off point and soar high into the sky. Three young kestrels have learned to hunt in the field, swooping down on unsuspecting small rodents and rabbits, and a weasel regularly emerges from the land drain and furtively creeps along the stream bank looking for food. I watch woodpeckers and nuthatches on the bird-feeders and occasionally catch sight of one of the resident family of badgers on the

track when returning late at night under a sky filled with stars and planets, clear of light pollution. There were two otters playing in the stream around midnight one night, and a red fox creeps silently past the bedroom window in the early morning.

There is another Michael in my life now and we have a marvellous Peascod painting on the bedroom wall of the house we share, which sees from the window what Bill saw – the summit of his favourite mountain and the glint of Bassenthwaite Lake.

Hercules and the Farmer's Wife

It was the fifth time I had driven along the miserable moor-land road that morning. The November fog was as thick as lumpy porridge. The windscreen wipers were on double speed and making me dizzy. I was tired with peering constantly through the cloudy windscreen struggling to make something out. Sheep kept looming up alarmingly in front of me, their eyes glinting ghostly green in the headlights.

No sensible human being would ever think of living in a place like this, I thought to myself bitterly, and I decided to give up and go back down to the valley, where I could have a nice cup of Yorkshire tea and go home. Then I realised that I no longer knew which way was up or down or north or south, and had forgotten where I had started from.

'When you get to Clapham,' she had told me in her broad Yorkshire brogue, 'turn right and it's fifth house ont' right. First there's a house you can see, then there's a house you

can't see. Then there's a barn conversion that belongs to them from Leeds. Then there's Parkers' farm and then it's us.'

Simple really – just discount the house I couldn't see and it would be a breeze. The trouble was that I couldn't see any houses at all. In fact, I couldn't even see the road. I had scribbled her instructions down on the piece of paper now lying on the passenger seat but none of them made sense. When she had gabbled them off she had made the journey sound easy, but she had failed to mention that the houses were all sparsely scattered and set well back from the road. There could be several miles between each one for all I knew, and there probably were. As I climbed higher the mist had thickened into grey clouds of dense swirling fog. This was 1988, long before mobile phones and satellite navigation systems. I was on my own in an alien land.

I was looking for an artist called Karen Wallbank. I don't often follow leads from gallery visitors. Everybody has an aunt, uncle, friend or acquaintance who paints. After enduring several embarrassing encounters in studios where all I had wanted was a quick and painless getaway, I had quickly learned to disregard such dead ends and find artists by other means, which usually meant legwork. I trawled through exhibitions and art publications, Arts Council lists and college degree shows, although the last sometimes destroyed my will to live. When another darkened booth and flickering video presented itself – or, worse, a room full of student detritus – I just made for the nearest exit.

This was different, but I didn't know why. It wasn't logical. A very good picture framer in Kirkby Lonsdale had mentioned her. He did high-quality framing, restoring and gilding, and I respected his opinion. She was a farmer's wife, he told me, who had come in with one of her paintings and then been scared off by his prices. He fished out her phone number from among a pile of mount-board samples and passed it on to me. I felt bound to ring.

The initial contact was not promising. Her manner on the phone was diffident, almost monosyllabic.

'Hello,' I said. 'Is that Karen Wallbank?'

'Aye.' she answered suspiciously.

'My name's Chris Wadsworth and I have a gallery in Cumbria. I hear from Ian Higginbottom that you are a painter.'

'Well . . .'

'Could I come and see your work?'

'Aye . . . but I'm very busy.'

'How about one day next week?' I continued, bravely.

'Aye. All right then,' she conceded, and that's when she gave me the rather abbreviated directions that caused me so much confusion. I had the feeling she didn't want to be found.

So now I was lost and, feeling like the grey figure in Munch's *Scream*, I pulled off the road onto the verge to work out what to do. Should I let out a futile howl or just wait until I was missed at home and the search party was sent out? That could be a long time. Maybe it would be quicker to wait until the mist cleared – or maybe not. It could be a long wait either way.

After ten long minutes with Radio Three turned low and soothing, I saw the first sign of human life – diffused headlights feebly trying to penetrate the thick grey of the fog. A battered blue van emerged from the mist, coming towards me. I quickly turned the car round and followed. It might be the only vehicle of the day and it must be going somewhere. I unashamedly tailgated it, terrified I would lose it in the mist. After about a mile it turned right down a track which deteriorated quickly into potholes and puddles. Silhouettes of abandoned farm machinery kept appearing in my foglights like huge David Smith sculptures. Impulsively, desperately, I kept following the van until it stopped in a muddy farmyard, whereupon the driver's door opened and a man got out. He was small and slight with a rather pale, nondescript face – thin and screwed up. Slightly stooped, he closed the van door with a metallic clang and limped round to the back to open the doors and unload whatever it was he was carrying. He suddenly caught sight of me close behind, and jumped in surprise – he obviously wasn't used to strangers on the road.

Feeling foolish, I stammered, 'I'm looking for Karen Wallbank.'

'Aye,' he said slowly.

'Do you know where she lives?'

'Aye.'

'Where *does* she live?' I asked eagerly, hoping his vocabulary extended a little further than the evidence so far suggested.

'Here,' he replied in the same flat voice, inclining his head towards the farmhouse.

At that moment a young, heavily pregnant woman with long golden hair appeared at the farmhouse door. I assumed this was the painter's daughter. From the flat northern voice on the telephone I had created a mental image of a round, middle-aged farmer's wife with apple cheeks and apron.

'I've come to see Karen Wallbank,' I said defensively. 'She's expecting me.'

'Aye, that's me,' she said nervously. 'Come in.'

As soon as this lovely woman opened her mouth, I knew she was Karen. That flat passive voice and indifferent stare confirmed that she was disappointed I had succeeded in tracking her down. I followed her through the kitchen into the parlour with its big open fire and gleaming oak furniture. It was so welcoming I immediately felt a lot better. All around me on the walls were beautiful misty landscapes. I was so astounded and excited at the quality of those paintings that I barely noticed the litter of kittens that were skittering around the room, over the furniture, each other and me. In that warm comfortable farmhouse, in the middle of a wilderness of open moor, I could almost feel the wind and rain on my face as I gazed at the sheep grazing on the tussocks of grass in those Turneresque canvasses. One in particular held my gaze. It was huge and magnificently minimal – pale sheep on a pale textured canvas, and with just a few strokes of the brush she had got the sheep exactly right. This was a woman who knew sheep.

'I do like that,' I said cautiously, trying hard not to sound patronising. 'Where did you get a canvas as big as that?'

'Well,' she answered slowly, 'sofa needed recovering – springs were 'anging out of bottom 'cos kids had been jumpin' on it. So I got some 'essian to do it. I spread it out on t'floor and when I looked at it I decided to paint on it instead.'

That explained why the springs of the sofa I was sitting on were digging into me – but the pain was worth it.

'Is it an oil?' I asked. It was a silly but necessary question.

'Oh no – it's mainly Dulux.' She added diffidently, 'I use owt I can get to paint with.'

The hessian needed stretching properly and when I looked more closely I realised that the 'frame' was a bit of skirting board, with roughly mitred corners joined together with an industrial staple gun of the sort used by farmers for fencing.

'I could exhibit and sell these,' I told her. 'Would you want to do that?'

She gave me a pitying look, clearly totally unconvinced that I could want or sell her work. This, I realised, was not modesty but a total disbelief in her own worth. She was particularly alarmed when I said her pictures would have to be reframed.

'What will that cost?' she asked suspiciously.

I had the feeling she regarded me as a potential conwoman and guessed we had now got to the scam: I was going to ask for money.

'I will pay for the framing,' I said quickly, 'and then when they sell I'll deduct it.'

'But what if they don't sell?'

'I'm sure they will. Trust me. What makes you say that?'

'I put three in art show int' village 'all last summer and

nobody bought 'em. That one there,' she said, nodding at a small green landscape which had been placed mountless and askew with ragged edges in a clip frame too small for it. 'That one there has been in our 'oliday cottage for three years with ten pound on it and nobody's shown any interest at all.'

I wasn't surprised, but didn't say so. 'If I could take that one and reframe it,' I promised her, 'I will sell it for three hundred and fifty pounds.' I felt like a market trader.

'I don't believe you, but you can give it a try if you want,' she replied in the same flat voice, looking at me as though I was in need of professional help.

I came away with six oils and the little green watercolour. As I left with my stash of paintings, I asked her who the man was I had met in the farmyard.

'Oh that'd 'appen be my 'usband George,' she said, and, seeing my face, added: 'He's a lot older than me.'

Then she abruptly disappeared inside the farmhouse. I shrugged my shoulders and set off back down the bumpy track, headed for civilisation. On the long journey back up the motorway, my mind was full of questions. What was a beautiful young woman with an extraordinary talent doing up there on that isolated farm? Why had she married a little old man? What was the attraction? Where had she learned to paint? My curiosity antennae were working overtime but they could pick up nothing.

It took a week to get the canvasses stretched and framed, and they looked magnificent. Hung in the Adam Room as part of

the Christmas exhibition, they sold in a couple of days. The first two were going to live in a rather grand castle alongside a Gainsborough and some other distinguished family portraits. I rang Karen with the good news, which she received in such a totally unfazed manner that I wondered if she understood what I was telling her. Moving swiftly on, I casually asked if she had any more paintings.

'Oh aye,' she replied laconically. 'There's a stack more in barn wid' cats.'

My mind immediately went back to sitting in her parlour with that small army of kittens climbing up and down my legs, the furniture, the curtains. Horrified at the thought of all those little claws digging into the precious canvasses, I set off straightaway to get them. This time I found it first time.

A different reception awaited me this time. I gave Karen her cheque and was delighted to see her disbelief at the size of it. Even with the cost of framing and commission, it was several thousands. At last I had a reaction.

'George'll never believe this,' she said in wonderment, gazing at the cheque.

'Hey, it's your name on the cheque,' I said. 'You don't even have to tell him if you don't want to.'

I got a raised eyebrow in reply. 'So where are the other paintings?' I continued briskly.

'Oh they're in t' barn,' she said. 'Do you want to see 'em?'

It was a bright day but the barn was dark. Its only light came from the open door and a small dirty skylight curtained with cobwebs. It was a repository for broken appliances – dead

washing machines and tumble driers, plastic toys and bikes, and the detritus of the farm. Saddles and tackle were draped everywhere. The paintings were stacked haphazardly against an old table with yellow and green waterproof leggings casually slung over them, dripping gently onto the earth floor. One of the canvasses was leaning against the corner of the table and I could see even in the gloom that it was badly dented.

'Where do you paint?' I asked.

'Here,' she replied in the monosyllabic way of speaking to which I was getting accustomed. Every snippet of information had to be extracted with care and patience.

We carried the paintings into the farmhouse, where I could see them properly and spread them out. There were about thirty really good ones. Karen was watching me anxiously; at last I had her full attention. After some thought I gave her two choices:

'You know, Karen,' I said boldly. 'If you want to sell these as well, I could either trickle them through the gallery and make you a steady income, or I could wait until I make a slot in a few months' time and give you a solo show.'

After I had explained what that meant she had no hesitation. 'I'll go for the solo,' she decided swiftly. 'But it'll 'ave to be after baby's born and not be at lambin' time either. We've got our hands full at lambin' time.'

The baby was due in early January, and she already had two boys who were at school. It was a good decision. This was a woman with a practical brain as well as talent. What was she doing married to the little pale-faced man? He must have some

hidden talent and charm but I decided not even to speculate about it. I was consumed with curiosity but daren't show it lest I frighten her off.

I realised I would have to tease a CV out of her, and over a cup of coffee and a premature lamb nestling by the Aga in the warm kitchen she told me her story.

She had been born and brought up in Leeds and did well at school. She wanted to go on to agricultural college but her art teacher felt her talents lay more in art than biology. So at sixteen she went to Jacob Kramer College in Leeds where she studied art. One of the lecturers had a holiday house on the moors not far from where she lives today, and one holiday he sent a small group of students including Karen to the house for a week to study vernacular architecture. She laughed as she told me how she met George.

'I'd just seen the film *Far from the Madding Crowd* with Alan Bates. George is just like him, don't you think?' I nodded silently. I'd only had a brief encounter with the man in the blue van but he was nothing like Alan Bates. The metaphor 'Love is blind' came to my mind.

'I spent the whole week 'elping on the farm,' she continued. 'I didn't get much art work done and at the end of the week the lecturer came up to do an assessment and he made the comment that some people had learned a lot about vernacular architecture and others seemed to know a lot more about the local farmer – and he were looking at me when he said it. He must 'ave 'eard the local gossip. After that I came back every holiday and loved it.'

At the end of the course, at eighteen, she got an interview at Goldsmiths' College in London. One of her lecturers had put her application in because he didn't want her special talent wasted. Her father went with her on the train to carry her portfolio and give her moral support. Her father was proud and encouraging but felt just as intimidated as his daughter. They were out of their comfort zone, both of them, and before the interview they went into a nearby pub for a swift dram to settle their nerves. Goldsmiths is one of the country's leading art colleges and there is huge competition to gain a place. Karen was convinced she didn't stand a chance of being selected.

A few weeks passed and she was back on the farm working with George when the letter with the London postmark came to her home in Leeds. Her father rang to tell her it had arrived. Karen told him to open it and read it to her. Against all expectations except those of her perceptive teacher, she had been offered a place, and had to make an immediate decision about her future. It was a hard choice, but the lure of life on the farm was too strong and she decided to marry George instead. She told me she had no regrets, though farming three hundred acres with sheep and beef cattle is hard work and she does her share of it. She has her own horse and two sheepdogs which she reared and trained herself. Despite this very busy life and two children, soon to be three, she had never stopped painting.

'How does George feel about the painting?' I asked tentatively – I hadn't seen George again since that first brief encounter.

'Well, he sees it as a bit of a waste of time,' she admitted. 'He makes a joke of it but he sometimes tells me to go and do summat useful and paint gate.'

I hope to change that, I thought to myself. I didn't think I was going to like George very much.

I loaded the car with paintings, promising to return for the rest in a few weeks having first restacked them carefully out of the way of feline claws. When I returned for them, she had a little red-headed baby girl called Hannah, but still no sign of George. However, I was getting to know Karen better and she trusted me now, particularly as my cheque hadn't bounced.

'Where's George?' I inquired before I left. 'I still haven't met him properly.'

'Oh he's hiding,' she explained in her straightforward manner. 'He calls you that posh woman from the gallery and when he knows you're coming, he disappears.'

As the exhibition drew closer I became a little worried. What was I doing? Was I playing God – and enjoying it? Was I messing with people's lives? Would this show unsettle Karen? Would George be jealous of the attention she was going to attract? Had I revived any longings in her to go to college? Would she have any regrets at choosing the path she had? Would George see me as a threat? I started to lose sleep over it.

They arrived early for the opening. I heard the Land Rover come into the car park and braced myself. Karen came in first.

She was very nervous and was sure nobody would like the work, but she looked lovely with her long blonde hair and healthy complexion. When George came through the door, my mouth literally fell open. This was not the man who had guided me to the farm in his blue van. Instead it was a tall, dark, ruddy-faced chap with a lovely broad smile, about twenty years older than Karen but not totally unlike Alan Bates. I'm not good at concealing my feelings, and when I realised they had seen my surprise I had to explain. They both roared with laughter.

'She must mean Jack the potato man,' said George. 'I think he came round that day. And you thought that he was me?' he asked, looking at me challengingly.

'Hey – you've been hiding from me every time I've come up to the farm, you know,' I pointed out, meeting his gaze. 'So how was I to know what you look like?'

This really broke the tension and we made our way into the Adam Room where Karen's pictures were hanging. She stopped in the doorway and stood quite still, scanning the room in silence. Looking questioningly at me, she asked in genuine puzzlement, 'Did *I* do these?'

I assured her she had and she slowly moved forward as if she was sleepwalking, studying each painting as though it was the first time she had ever seen it.

I left her there when people started arriving. The red spots began to go up and I could hear George in the background saying proudly, 'My wife, the painter . . .' Then I knew we were home and dry.

A large painting of a hillside dotted with grazing sheep had a price tag of more than a thousand pounds. When the red spot went on that one I heard him exclaim, 'Good God, she's making more per head of sheep than I am!' And everyone laughed.

We had tea in the kitchen afterwards with a few artists and clients, and George sat proudly at the head of the table and poured the tea. Patrick Gordon Duff Pennington of Muncaster Castle was there – a Scottish landowner, sheep farmer, poet and, most importantly to George, a member of the National Farmers' Union. He had bought three of Karen's paintings for his daughters, and he and George discussed at length the price of stock and land. As they left, George commented, 'I like this art lark. It's better than farming any day. You meet a better class of people, don't you?'

Whenever we have gallery parties, Karen and George always turn up and thoroughly enter into the spirit of the occasion. We had a fancy-dress party once to which everyone had to come as a painting; Karen was a Mondrian and George made a wonderful Laughing Cavalier. The art lark suited them.

One day, in the middle of Karen's first exhibition, a small man came bouncing in through the front door in a way that reminded me of Zebedee in *The Magic Roundabout*. It was as though he was on a spring. He made straight for the desk where I was sitting, with outstretched hand, and proclaimed: 'Hello, the name's Hercules.'

I found it hard not to laugh outright. I half expected him to say 'Time for bed' and bounce off, but instead I gave him a wide smile and said, 'We're showing paintings by Karen Wallbank at the moment. You're welcome to look round.'

'Oh, I'm not buying,' he answered, drawing himself up to his full height of about five and a half feet. 'I collect German Expressionists.'

There was no answer to that so I just let him wander round the exhibition. He was virtually buzzing with latent energy, and I decided to leave him alone – the hyperactive can wear you out very quickly, pulling you into their frantic aura. But then he suddenly went very quiet – so quiet that I thought he had slipped out of the room or even fainted. I looked through the crack in the door and he was standing quite still. After a long time he reappeared in front of me looking dazed.

'I collect German Expressionists,' he repeated.

'Yes, you said,' I responded dryly.

'But I like these,' he continued eagerly – surprising himself at the confession. 'I saw a poster in the hotel. That's why I came.'

It took about ten more minutes to sell him one and another half-hour to sell him the second. Over a cup of coffee in the kitchen he confided that he was a brain surgeon. How do you respond to information like that? It's not easy to arrange a fanfare of trumpets without more warning, so I didn't. However he wrote a large cheque and left, a happy man. The following Saturday he was back and stayed most of the day, chatting to visitors and praising Karen's work fulsomely to all and sundry.

An architect friend came in and was immediately cornered by Hercules. When he finally escaped, having bought a painting, he came to me.

'Who is that?' he whispered.

'Oh, that's Hercules,' I said airily. 'He's just a brain surgeon from Manchester. I think he's up for a job at the gallery.'

Brian Hercules really was a brain surgeon, oh ye of little faith. I checked the medical registers. He became a regular gallery visitor and thoroughly enjoyed selling things to people. He was good at it too. We talked idly about setting up a branch of Castlegate House in Manchester and he made some interesting proposals. After a year or so his visits stopped abruptly and I never saw him again. I often wonder what happened to him.

Karen went on to bigger and better things. I entered one of her paintings in the Laing Competition, a prestigious nationwide art award sponsored by the Laing Group of construction companies. Karen would never have got round to entering it herself, so I obtained the entry form, filled it in, signed it (yes, I did forge Karen's signature) and posted it. I then selected, framed and delivered the painting to Newcastle and was delighted when she won the regional prize. Her work went down to the Mall Galleries where she became the runner-up in the national final. She won a cash prize and the Laing Group invited her – and George – to come to London for the opening on an all-expenses-paid trip. They travelled first-class rail from Lancaster, stayed in a five-star hotel and were taken to

48

the gallery, which, as its name suggests, is situated in The Mall, in a chauffeur-driven car. Karen said she felt like the Queen. She met the chairman of Laing, who must have been a little bemused when she told him that none of it was anything to do with her and it was all down to me. When he asked how she managed to paint and farm she answered, 'Oh, Chris does it all really. She stretches the canvasses, orders the paint, frames 'em, titles 'em and sells 'em. I just paint 'em.'

In a way this was true. I felt rather insecure selling paintings created in Dulux on upholsterer's hessian, and from that first exhibition onwards I had ordered properly stretched canvasses, good paper and good oil paints. This meant I slept better at night, free from a recurring nightmare about selling a painting and then the paint falling off a few years later, leaving a blank canvas. Karen still reverted to her old ways from time to time, though, and sometimes I would be faced with a collection of work on a mad plethora of materials in all sizes and shapes – rarely square – which I had to somehow sort out. Sometimes a piece could only be described as 'mixed media'; she had probably dropped it in the yard in transit while the paint was still wet and so it now bore traces of cow dung and horse hair among the paint. But at least she now had a proper indoor studio. They had built an extension with a light and airy work space from the proceeds of her sales.

After Karen's competition success I got a call from Border Television, who wanted to do a programme about her. I drove the production team down to the farm in convoy; I didn't want

them lost for three days on the moor! The cameraman got very excited when we stopped to turn up the track to the farm. He suggested in the interests of spontaneity he should film me driving up to the farm as I had done on that first foggy day, to greet Karen and go into the house with her. I readily agreed and he followed me with the camera. I drew up at the door, wildly hoping that she had remembered we were coming and hadn't gone off on the quad bike or her horse. I needn't have worried – Karen came out to greet me in unbelievably clean jeans and crisp white shirt. She looked gorgeous. I got out of the car, greeted her with a few air kisses and we went inside together, at which point I just collapsed laughing. I couldn't help it. The cameraman was devastated. He couldn't understand what there was to laugh about. But the normally chaotic porch with its lines of wellies, waterproofs, muddy boots and general junk had been transformed. There was a highly polished antique chest I'd never seen before whereon stood a vase of beautifully arranged flowers. Beside it was a large bowl of fresh brown eggs and above it hung an oil painting, the paint hardly dry, by one 'K Wallbank'. It was the eggs that set me off. Nothing could be more different from the scene which normally met me. The power of television is awesome! We did a second shoot and I managed to control myself. George managed to get himself included in the outdoor shots – what a difference from the man who confessed he used to hide in the barn when 'the posh woman from the gallery' came. Karen sheared a few sheep and showed off her horse, as well as her paintings, and it made a really lovely piece of film.

'I wonder what I'd be doing if I'd gone to that posh college in London,' Karen said to me one day.

I don't know the answer to that but I do know one thing. She wouldn't be painting like she does now.

George is now in his seventies and the two boys, Jack and Tom, run the farm. Red-haired baby Hannah is eighteen and has had learning difficulties since birth. The last seven years, since Hannah left the shelter of the sympathetic village school, have been very difficult for Karen; Hannah's form of autism is very demanding, and she has had to be educated at home by a visiting teacher. These problems eventually put a stop to the painting. It is impossible to paint without a quiet mind and full concentration.

Karen has been indulging in what she refers to as globe-trotting, although I couldn't quite picture her in south-east Asia or India with a back pack, clutching a Lonely Planet guide. It was with some relief that I discovered she had in fact been enjoying European package tours, taking Hannah with her.

Now Hannah is eighteen and attends a day release centre. She is musical and enjoys singing. So Karen can pick up her brushes in the quiet of the day, and is finding huge satisfaction painting again.

I took to the moor road again last January, the day after Hannah's eighteenth birthday, with some degree of apprehension. I found the road no better; the sculptural pile of dead farm machinery which marks the approach alongside the

rough track was even bigger and the hens had been joined by a fearsome cock called Kevin, who chases and pecks anyone within his domain. But the welcome was euphoric. George greeted me enthusiastically at the door. He was just leaving to buy what he referred to as 'fancy cows', but he had waited to see me first; what a difference from my early visits! Karen was in good spirits and enjoyed showing off her handsome new horse. The parlour was as welcoming as ever with a large stack of paintings leaning in the corner facing the wall. We gossiped over coffee and filled in the missing years. The paintings stood silently, waiting. I longed to see them, but hardly dared look.

At last I could wait no longer. 'Aren't we ever going to look at your paintings then?' I asked.

'You mightn't like 'em,' she said defensively; but eventually she turned each one round in turn, tentatively. And thankfully the old Karen was still there in the misty landscapes, hidden valleys and swirling skies.

I could see she was apprehensive. My opinion really matters to her, which is a humbling experience. With a sense of *déjà vu* I suggested a solo show a few months ahead, and her face lit up with excitement, just as it had done nineteen years before.

She is re-charged. As I write I am getting wonky images of work in progress on a daily basis by e-mail – yes, she is computer literate now and has a digital camera. Her photos are hit and miss and I sometimes get bits of George in the frame as he has to stand and hold them upright in the mucky yard, often in howling gales. I fear that some of the larger canvasses might turn him into a reluctant hang glider. And Jack the potato man

is still about. I have just received a very wobbly photograph of a Wallbank masterpiece leaning precariously against his blue van (George obviously wasn't available that day) with a note to say Jack drove off before she could remove the painting so it has gone a bit 'mixed media'. I am bracing myself for more 'mixed media' paintings in the upcoming show. Should I be scrupulously honest and label them 'The Farmyard Series: oil, mud, straw and cow muck on canvas'?

CHAPTER THREE

Kings, Queens and Commoners

We had just finished a fine supper. After a hectic day we felt relaxed and happy. Maybe the aperitif and good bottle of red had helped this general feeling of sleepiness and bonhomie. The telephone broke the silence.

'Hello,' I said. 'Castlegate House. Who is that?'

'It's Philip. Philip Turner,' said the voice a little tetchily.

'Hello Philip,' I replied warmly. 'What can I do for you? Have you sorted out your train ticket yet? When are you coming up to stay?'

'I'm at Penrith station right now,' he said recriminatingly, 'and you're not here to meet me. You said you would be.' His very English public-school voice was a little slurred.

I was horrified. 'But you didn't give me a date when you rang last week. You said you needed to change the ticket and you rang off. You said you'd ring me back when you had got it sorted. I had no idea you were coming today.'

From the general mutterings at the other end of the line, I quickly decided not to pursue that one. I swung into action mode.

'Right, Philip,' I instructed him briskly. 'Cross over the road outside the station and you'll see a pub – the Railway Hotel I think it's called. Go in there and I'll come as soon–'

'I am in there already,' he interrupted. 'I've been here two hours and you never came.' It was becoming clear why his voice was slurry and truculent.

'All right – stay put and I'll be with you in about forty minutes.'

I grabbed the car keys and set off. 'Just going to Penrith to collect a sculptor,' I called to Michael as I flew out of the door. He appeared to be waving at me as I pulled out of the car park so I waved back and put my foot down. After about a mile I realised that he was probably gesticulating not waving goodbye and trying to remind me that I'd had a few drinks. I slowed down. I was probably over the limit. Damn! What should I do? Curse the man – why couldn't he get a taxi? It was I who was doing him the favour. Why hadn't I learned my lesson?

A friend at the magazine *Art Review*, knowing that there was a spare studio flat at the gallery, had approached me a few months before to see if I would help revitalise a very good sculptor who had, in her words, run out of steam. Well, Castlegate House wasn't a benevolent home for washed-up sculptors, was it? I had been non-committal, cautious. A few

days later some catalogues arrived by post. They showed the work of the sculptor and it was good – beautiful bronzes full of strength and integrity. I began to weaken. After all, the flat was empty and doing nothing. I decided to inspect him first before committing myself, and made an appointment to meet him on my next visit to London. He had a very smart address – one of the best streets in London, adjoining the Thames, very close to the Tate Gallery – now Tate Britain.

It took me a while to find the right house in the terrace. They were all so big and most were unnumbered. *Too posh for numbers*, I thought. I went back to the beginning of the street and counted along until I reached an end corner house that should be the one. Glancing up at the high brick wall that enclosed the garden, I was startled to see two figures perched atop the wall peering jauntily down at me – a pair of lifesize plaster sculptures that exuded a delightful cheeky energy. I had found the right place.

Their creator, Philip, was quite old, possibly in his late seventies. As he showed me his studio, full of beautiful and distinctive pieces, he had a good rant about the London galleries. He had a suspicion that his main dealer was hanging on to some of his best bronzes. 'Waiting until I'm dead,' he commented, bitterly and possibly quite unjustifiably. He showed me more of his witty, light-hearted figures, this time pointing down into next door's garden from the dividing wall between the two properties. 'I've put them there to annoy the neighbours,' he explained. 'Damned merchant bankers or something. Make too much money. Don't like 'em.'

I decided at that moment to invite him up to the studio in Cumbria and he accepted with pleasure. He would come in about a month when the weather was warmer – May is usually a good month in the Lakes – and I agreed to meet him at Penrith railway station.

Michael was less keen on the idea. An earlier artist in residence had been not only demanding and disruptive, but chaotic to the point where we had the police round three times during the eight weeks of her stay. It had not been a happy experience.

She arrived in a wreck of a car which had broken down several times on the 300-mile journey (as she proudly told us, she had certainly got her money's worth from her AA subscription). I wouldn't have risked driving it to Tesco. On the evening of her arrival we invited her down for supper with innocent hospitality. The bottle of wine Michael chose to serve, a Sicilian red, set her off with a fantastical tale of being imprisoned by a Sicilian lover and his cousin in a castle near Palermo for over a year and forced to do all the chores by their aristocratic (mafia?) grandmother. As she recounted the story to us, she had gradually saved up money from the housekeeping, retrieved her hidden passport and escaped on a bus to the airport, pursued by her now ex-lover on a motorbike. It was entertaining but a little hard to believe, but we did later get solid confirmation that this was absolutely true from a member of staff at Carlisle College of Art who came round for supper a few weeks later. Apparently his girlfriend had been kidnapped at the same time by the cousin and he

had gone out to rescue her. He described arriving in the centre of town on his motorbike and the veil of silence that fell as he made his inquiries. Nobody knew where the castle was – they had never heard of it.

The day after her arrival we gave our new resident maps, directions and her own set of keys and inducted her into the gallery security system. Several hours later, as we entertained an Arts Council officer in the garden, she burst in on the conversation in a panic to say she had lost the keys. This was bad enough, but she followed this with the news that she had rung the Cockermouth police and had then enlisted lots of ramblers, who had rushed off in all directions trying to trace her steps and find them. Most worrying of all, to me, was her revelation that she had told everyone she encountered exactly where the keys came from. We then rang the Cockermouth police to tell them this bad news. They were sympathetic. Abandoning the Arts Officer, Michael sensibly took our artist's hand and said, 'Come on; let's start right from the beginning. Let's go to your car and search thoroughly and then drive down to Buttermere and you can tell me exactly what you did and where you went.'

'It's no good,' she wailed. 'We've all looked everywhere. I think somebody must have picked them up.'

They got no further than our car park. The keys were lying there on the ground in the gravel. She then remembered that she had put them on the car roof while unlocking the door of her very aged vehicle, forgotten them and driven off.

Her sister arrived unexpectedly the second week, in distress

after splitting up with her husband. It was like living in a play by Ibsen. She moved in. She just took it for granted and used our phone and facilities as though they were her own. One afternoon they both arrived back from a painting session flustered and crying, closely followed by a policeman. We were quickly becoming familiar with the police force of Cockermouth, and they with us. The sisters had parked the ancient wreck of a car in the Surprise View car park – the most famous vista in the Lake District, featured on innumerable calendars and cards and notorious for car thefts. Despite the explicit notices – 'THIEVES OPERATE IN THIS AREA – DO NOT LEAVE VALUABLES IN YOUR CAR', they went off walking, leaving a large amount of cash and jewellery belonging to the sister in the boot, which had a faulty lock – in truth, it didn't lock at all. We were in despair.

We got rid of the sister but the artist was booked for an exhibition and was doing some surprisingly good work so we persevered, counting off the days till her departure. The worst thing for me was getting up in the morning and going down to the kitchen to make tea and finding her lying in wait for me with some odd complaint or problem that she demanded I deal with. But we had passed the point of no return. Surely nothing else could happen?

It did. A few days later she arrived back at the gallery with a local teacher, followed (yet again) by a police car. She had driven halfway up Skiddaw on a steep narrow track unsuitable for any vehicle let alone hers, and her car had skidded off the path onto a precipitous slope and burst into flames. She had

escaped just in time, and the passing teacher had spotted the burning vehicle, called the police and kindly brought our artist back to us. She was shaken but blasé, and clearly did not accept any of the responsibility (or irresponsibility) for driving on unsuitable tracks. She was more concerned about her car and whether it was recoverable.

She did leave at last. A friend collected her and all her belongings and we celebrated her departure with champagne rather than Sicilian red. She came back for the opening of her show, by which point she was barely speaking to me. She objected to the hang and objected to the potter who was showing alongside her. I had done nothing right. But we sold every one of her paintings, so somebody must have done something right. The day after the exhibition closed she was back again, claiming that she was broke and demanding her money straightaway. I showed her the large heap of neatly wrapped paintings stacked in the hall awaiting collection and payment, and told her the sale proceeds would be hers within the month.

My calming words had little effect. Finally, Michael cracked. He pointed out to her that she had had eight weeks of free accommodation, during which she had caused us an enormous amount of trouble, and warned her that she had better leave right now.

She retorted by saying she couldn't afford the petrol to get back south, and insisted she would not leave until we gave her some money.

This was the final straw.

'Well, you'd better make yourself comfortable,' Michael

suggested, indicating a chair in the gallery, 'because you'll be waiting quite a long time.'

Eventually she left.

After that, I drew up a contract for artists exhibiting at the gallery, which has subsequently been used by the Arts Council as a model for other galleries in the north. But since then I had not considered ever letting anybody else occupy the flat – until now.

When I got back from London and my meeting with Philip, Michael reminded me of the misery we had suffered the previous time. 'If you drop a brick on your foot,' he argued, 'and it hurts, you remember not to do it again. Don't you? Yes?'

I took his point, but then he hadn't seen Philip's work or met the man. Once he met him, realised how civilised he was and saw all the lovely things he would make for the exhibition in the garden, he would surely change his mind.

Now I was on my way to Penrith, driving under the influence to meet our guest. I couldn't think of a way of getting in touch again and telling him to get a taxi. So I drove very carefully all the way and it was an hour later when I reached the pub car park. Slumped in the corner of the saloon bar was Philip. Dressed in jeans and a little denim-studded jacket, a rucksack on one side and a large canvas bag of tools clinking at the other, he looked weary and unkempt, quite unlike the man I had met in London.

'Oh, there you are,' he slurred and got up unsteadily.

'The car's outside,' I said briskly. 'Come along.'

I folded him up into my little car and set off, my head now as clear as a bell. I glanced sideways at my passenger. His face looked very dirty. What was it? I glanced again. It was all the black under his nose and on his top lip. He looked like Hitler. Whatever was it and what was Michael going to say? I had the feeling it might be about learning curves.

We drove in silence for a while and then he started ferreting about in his jacket pocket. 'What on earth is he up to now?' I thought, glancing quickly sideways again. 'Michael's going to really love this.'

'Do you take snuff?' asked Philip, proffering the little tin he had finally unearthed from one of his numerous pockets.

I declined politely, and he began to snort the powder in the tin very noisily up his nose. So that's where the black was coming from. The sniffing and snorting was awful.

Back at Castlegate, I introduced him to Michael as briefly as possible before whisking him up to the flat.

He rose late the following morning, finally appearing in the gallery about midday. 'Hello Ducky,' he greeted me. 'Where you would like me to work? Am I to be exhibit A?'

It took a while for me to understand what he meant. I wasn't running the sort of gallery that had a tame working artist on display fielding questions from the public (usually amateur artists) about how they achieved their results.

'Oh no,' I said. 'You won't be on show. I thought you might like to work quietly in the yard away from the public.'

He looked disappointed at this. 'I'll need some materials if I'm to get going.'

'Right. What do you need?'

At that moment Michael appeared.

'Hello Cock,' said Philip cheerfully. 'How about you and me go down the old builders' yard and pick up some stuff?'

They disappeared, returning later with a car full of chicken wire, sand and cement. Philip disappeared for his siesta and peace returned to the happy gallery.

He reappeared at midday the next day. His eyes lit on Wendy, my very pretty gallery assistant. He immediately became animated. From then on Wendy was always addressed as 'Sweety', I was 'Ducky' and Michael was 'Cock'. The very posh English accent had completely disappeared and was replaced with a mixture of Cockney and Estuary.

Having chatted up Wendy for a short time he disappeared into the town, ostensibly for the newspaper (the *Daily Telegraph*, of course), but didn't return until the middle of the afternoon. After a siesta, he reappeared and finally set to work in the yard, whereupon he kept going until about eight o'clock. This set the pattern. He found a friend in the town, a man of a similar age whom Wendy and I always referred to as the Pink Panther on account of the bright pink tracksuit he always wore as he loped along the main street. When he came in the gallery she would quietly hum the theme tune mischievously. These two octogenarians met in the Black Bull every lunch time and beyond and generally verbally re-fought the battles of the Second World War in which they had both been involved. They made a strange spectacle, one in pink and the other in studded denim, talking of fights, adventures, lovers and scrapes like a pair of teenagers.

Surprisingly, Philip got a lot of work done between his long lunches, siestas and enthusiastic pursuit of all the women who crossed his path. His chat-up line was that he needed a model, but the women of Cockermouth were far too canny to fall for that one. Once he offered the attractive woman who owned the flower shop at the bottom of the hill a boil-in-the-bag kipper supper, apparently his one and only signature dish – now who could resist that? Well, she did, quite easily, which surprised him but not us. He didn't give up ever. He was convinced that my beautiful young assistant, Wendy, would take her clothes off and sit for him. He travelled in hope.

The top of the high wall that divided the yard from the old Georgian formal garden began to fill with figures, mostly nudes, which (as it turned out) he was perfectly capable of creating from memory. We discouraged him from siting them on the outer walls overlooking the street or car park; they would have made a great Friday-night target practice for the local youths when the pubs turned out.

A Penelope appeared among the Penelope roses and a very regal king and queen were placed side by side on a garden bench. The queen had a very haughty look. 'I think they've had a row,' said Philip. 'Don't you think so? She's not speaking to him. Wonder what he's done to upset her.'

I could see what he meant. Visitors began sitting next to them on the bench and held conversations with them, much to Philip's delight. He wanted interaction and began to leave the gate open between the garden and the yard where he was working. He rushed into the kitchen one day and asked who

the attractive American woman was. I looked out of the window. It was the film producer Ken Russell's wife, a professional photographer.

'Do you think she'll sit for me?' he asked plaintively. But she turned him down as well. What a shame.

When Philip left, strangely enough, we all missed him – especially the Pink Panther. He had become an event – a talking point – in the town. Many people asked about him and still recount stories about his philandering. I sent him cheques for work sold and rang him when his friend the Pink Panther died a few years later. But since then I have heard nothing at all. He would be very old now so I assume he and The Pink Panther are together happily playing war games in some cosy pub in the sky.

Meanwhile, the king and queen had been bought in the summer by a man from London who came up in September to collect his royal purchases, driving an immaculate big black saloon that came snaking sleekly into our car park. After coffee and chat it was time to load up the figures. But they wouldn't fit in the boot. Despite their pedigree, they were not cooperative – unbending could be the term best applied to them. There was much debate about what to do and in the end the only solution was to spread plastic on the back seat and strap them in as passengers. As dusk began to fall, they looked splendid sitting there haughtily. The Bentley was a most fitting vehicle for them.

'Have you far to go?' I asked politely. 'Are you staying in the Lakes tonight?'

'Oh no,' he replied. 'I'm staying in Blackpool.'

That's strange, I thought to myself. *He doesn't look a Blackpool sort of man.* Then I looked at the immaculate suit and hand-made shoes, and light dawned. 'You must be at the Tory party conference!' I exclaimed. 'Are you staying at the Imperial?' He nodded, sorry to be losing his anonymity. 'And you're in the underground car park?'

Michael and I looked at each other. This was only a few years after the IRA had managed to plant a thirty-pound bomb in the Brighton Grand Hotel with a timing device set to go off during the conference. It had devastated the Conservative Party, killing and seriously injuring cabinet members and MPs and missing the Prime Minister only because she was working in her sitting room in the early hours. Security since had been forensic, hysterical and thorough. We had visions of a security guard patrolling the car park in the small hours and catching sight of these two figures in the torchlight. There would be a full-scale alert. We mentioned this. He saw what we meant.

'I know,' he said brightly. 'Do you have some plastic bags? We could put them over their heads.'

We shook our heads very firmly. 'That would be even worse,' said Michael, horrified at the idea.

'Well. I'll get them carried up to my room.'

'No,' we both said, emphatically shaking our heads, 'that won't do either. You will have to see the security people and we will type you a notice to leave on the windscreen. It could be tricky.'

He left. The car pulled out into the darkness, the two figures silhouetted against the sky.

The king and queen enjoyed the party conference by all accounts, once the initial undignified security checks had been made. They were not arrested and finally made it to the country garden in Buckinghamshire where they now live a quieter life. Flowers were planted in the hollows on the tops of their heads where their crowns should be, and rumour has it that they have made up their differences and are on speaking terms again.

Pursuing Percy

The crematorium was as cold and lifeless as the corpse in the coffin. The mourners were few and huddled together at the front.

The vicar began. 'We are gathered here to celebrate the life of . . .' – there was a slight hesitation – 'Robert Percy Kelly.'

There was no sign of a reaction from any of the seven mourners.

In the absence of any known relatives of the dead man, the funeral had been arranged by David Ralli, a gentleman farmer, and his wife Jacquie, who had befriended Percy ever since he had come to Norfolk twelve years before. David had been with Percy when he died of throat cancer in Norwich hospital aged seventy-six. He had two last requests, which they had understood and promised to honour: he wished to be cremated as Roberta Penelope Kelly, and to have his ashes scattered hundreds of miles away by Loweswater

in Cumberland. That was his favourite place on all the earth.

The Rallis had struggled to find anyone connected to Percy to invite to the funeral. They could only find two friends – Ena the mole-catcher and a young man who rode a moped and lived in the middle of a field. David had visited Percy in hospital, bringing in supplies and requests for things needed from his little cottage; pencils, crayons and paper. Percy's dearest friend Joan David, with whom he had faithfully corresponded for the last ten years, was sadly absent. She was just recovering from a hip operation and couldn't travel.

So it was all set; the vicar had been briefed, flowers ordered, music and hymns selected and a light buffet lunch prepared at the Rallis' home. They were kind and generous people, and they had been very fond of Percy despite his eccentricities.

As the mourners were gathering in the lobby of the crematorium, three strangers entered: Percy's twin brother John and long estranged son Brian, accompanied by Brian's wife Doreen. They had driven down from Cumbria where Percy was born. John and Percy were not identical twins; in fact, they were totally different. Percy was the dominant twin who had always taken the lead. John was a mild and gentle man; quiet, unconfident and socially ill at ease in company other than his immediate family in Workington. Not one to write a letter or telephone, for twenty-five years he had barely seen his brother, to whom he had looked up with admiration.

Percy's son Brian was similarly uncommunicative. An only child, he hardly seemed to have featured in the life of his father at all, and he had not seen him since he was eighteen. He

had left school as soon as he could and joined the merchant navy. When he left it a decade or so later, and returned home, his father had gone. Neither made any attempt to find out where the other was. Brian then got a job in a factory at Silloth, where he met and married Doreen later in life. A sensible redhead, Doreen already had a family of her own and a measure of cheerful independence, and she needed it.

The unexpected arrival of this small group in the lobby caused some consternation. Having quickly got the introductions out of the way, David and Jacquie were faced with a problem. Realising that Percy's relatives were probably blissfully unaware of his gender confusion, they decided that this was not the right time even to begin to explain. It would be better to change the name back to Robert Percy on the vicar's prompt sheet than to let them assume they were at the wrong funeral.

The vicar was being swiftly briefed when Ena the mole-catcher burst through the door. 'Is this Roberta's funeral?' she blurted out loudly in her strong Norfolk accent.

Jacquie nodded assent, glancing uneasily at the relatives, who fortunately hadn't noticed the discrepancy. The service proceeded and it was a minor miracle that the mole catcher didn't notice either. She still believes to this day that Percy was a woman. That was always how he was to her, and no one wished to disabuse her – that would be much too complicated.

After lunch the Cumbrian contingent decided they would like to see Pear Tree Cottage, Percy's home for the past fourteen years. A will had not yet been found but David and Jacquie felt that Brian should see his father's house. Doreen was in

Jacquie's car, the men in the other with David. Knowing that this was going to be a tricky conversation, Jacquie started gently. She realised that Percy's transvestism would be obvious to anyone looking round the house.

'Did you ever meet your father-in-law?' she asked, knowing well what the answer would be.

'No,' Doreen replied. 'I wish I had but Brian isn't one to write letters and keep in touch with people. I don't know anything about his father at all. He's never talked about him.'

'He was an interesting man,' Jacquie ploughed on. 'He liked dressing up, you know.'

'Oh that's nice,' Doreen commented, and they went the rest of the way in silence.

I never met Percy Kelly. It wouldn't have been a successful meeting anyway; I realised that from the start. But I remember vividly the first time I saw a painting of his. That was what sparked off my grand pursuit of an elusive and volatile quarry.

On my first viewing of Castlegate House in 1986, I was shown into the library. There was the most satisfyingly beautiful painting hanging high on the wall above the bookshelves. It was Whitehaven Harbour. I caught my breath – I couldn't help myself. I don't usually like topographically correct, hard-edged paintings – I prefer them less explicit, full of emotion and colour that leave something to the imagination. But this was exquisite. It was painted from above as though the artist had been serenely hang-gliding above the scene or had mastered the art of levitation. There was just enough detail to

intrigue but not enough to be fussy and confusing. Whoever had made that painting could certainly draw. It was hung too high for me to see the signature.

'Who painted that?' I asked as casually as I could, trying to conceal my excitement.

'Oh, that's by a man called Percy Kelly,' replied the owner, equally casually, and then moving on.

'Where does he live?' I persisted. 'That's a good painting.'

'He's from Workington,' she said shortly and, seeing my raised eyebrow, added, 'he's a postman or something.'

Oh well, I would have to make do with that. It was probably enough for me to trace him when the time was right. In the next few months I travelled great distances and visited dozens of artists and exhibitions but not once did I see or hear of Percy Kelly. I made enquiries and consulted telephone directories, Arts Council databases and the electoral roll – but no joy. Kelly is a popular name in West Cumbria, being close to the Isle of Man where it originated. It was frustrating. Visitors to the gallery were always quick to recommend artists and I was inundated with hopeful artists hauling work in through the door. Slides and CVs arrived with every post, but no clue as to the whereabouts of the one I wanted most. I began to ask people if they had heard of him and in most cases met with blank looks, but occasionally there was a strange reaction. Some people admitted to knowing of him but then became uneasy and tight-lipped. There was some secret here to which, as an outsider, I was not party.

It was the wife of a local doctor who accidentally blurted it out. A few years ago he had run off with somebody's wife – an

ophthalmic surgeon's wife, no less. The surgeon was popular and they had three children and a nice house. Everyone was shocked that she should run away with a penniless artist taking the children with her. They had disappeared, and no one knew where they were. Well, at least I now knew the reason for the reticence. But where on earth should I begin to look? It was an impossible search. They could be anywhere. I had to put the problem to one side and get on with running the gallery, but it remained like a hyperactive ant running about in my brain, giving me no peace.

A few months after opening the gallery, I received a set of photographs in the post of some impressive pots. They were large, hand built and roughly textured with glinting seeds, fossils, shells and stones embedded in them. These were so beautiful and imaginative that I immediately wanted to exhibit them. They were *raku*, a process whereby the pot is fired in a sawdust kiln, and they whispered integrity. The accompanying letter said the potter had heard about the gallery and would like to exhibit. I glanced at the address. Her studio was in the far reaches of Pembrokeshire. I rang her and told her I liked her pots, but that I wasn't sure how she was proposing to get work to and fro.

'Oh, I come up to Cumbria a lot,' she replied. 'In fact I'm coming next week. That's why I wrote. I have friends nearby. May I bring some pots to show you then?'

'Oh yes please,' I agreed enthusiastically. 'Bring as many as you can.'

She sounded lovely. I asked her to lunch the following Wednesday.

Chris Hawks – that was the potter's name – was a tall, good-looking woman in her late forties, well spoken and self-assured. We got on immediately and enjoyed talking about pots, art and galleries. She told me that she used to live in Cumbria – quite close to Cockermouth, in fact – and would like to return. She didn't like Wales very much.

'Why don't you come back then?' I asked.

'I can't,' she replied regretfully. 'I did something silly a few years ago. I burnt my boats.'

'Oh?' I said questioningly, waiting for elaboration. There was a long pause while she found the words.

'I ran away with somebody – an artist. I can't come back.'

The hairs on the back of my neck crawled. I looked her straight in the eye. 'Was that artist a postman?' I asked.

She started visibly, obviously uneasy. 'A long time ago,' she said, 'in another life, he was a postman. Yes.'

'Was it Percy Kelly?' I cried triumphantly.

Her face shut off. Her expression changed. Her voice became flat. 'Yes,' she said dully.

'Wow!' I gasped, stupidly failing to read her body language. 'I've been trying to find him for over a year. I love his work. At last I've found him. Is he here with you?'

'I've no idea where he is,' she continued in the same expressionless voice, 'and I really don't care. It didn't work out and I don't ever want to see him again.'

She got up, picked up the receipt for the pots, thanked me politely for lunch and left.

An envelope from one of Percy's thousands of letters to Joan David

It was a few months later that I met Joan David. In her six-
ties, she was petite and attractive, wearing stylish pink suede
pixie boots, a cloche hat and interesting modern jewellery.
She was lively, informed and enthusiastic, and I liked her
immediately. I had begun to write an article on the arts every
month for *Cumbria Life*, our county magazine. Joan had read
them all and decided to come from her home in Kendal to see
what was happening here in Cockermouth. She bought two
pieces of studio glass for her bedroom and casually inquired,
'I don't suppose you've ever heard of an artist called Percy
Kelly, have you?'

Two hours and three cups of tea later I had what I wanted
and more. Five years earlier Joan too had seen a painting by
Percy in a friend's house. But she had had better luck than me,
because that friend knew where he was and gave her his
address. He was in a little village in Norfolk – Rockland St

Peter. He had moved there from Pembrokeshire in 1981 with his wife — the potter I had met — and once they had settled down, she had left him. She could stand no more.

I didn't ask what she could stand no more of — that could wait. I must first get in touch with him and get some paintings from him. I wasn't sure where I stood in this. My heart was getting the better of my newly found business head. I wanted paintings for me. I wanted to possess them, to enjoy them. They would be mine. I have since seen this effect on other people many times, but was naïve enough then to assume possession would be a simple matter of negotiation, choosing, payment and escape with something wonderful. I could not have been more wrong.

Joan did warn me that he was very difficult to deal with. *Well, most artists are*, I thought smiling smugly to myself. *But I know how to deal with that now.*

She told me he was desperately poor and needed the money from sales very badly. I was prepared to go down to Norfolk immediately and organise an exhibition. I would give him an advance, pay for all the framing. I would stand on my head on a tightrope if that was what was necessary.

Joan warned me that I must not go to his home on any account. He didn't like strangers, he didn't like gallery owners and he didn't like to sell any paintings. I had to be more subtle.

Oh, I could be subtle, I assured her — well, on a good day when concentrating very hard on it.

Joan said I must write to him and the letter must be unctuous. He liked praise, flattery. I could do unctuous. I was an

expert in it. I could bow and scrape, gush and flatter with the best.

By way of preparation Joan invited me to lunch at her charming house in Kendal. I don't know what we had for lunch; I really didn't notice. She was an eclectic collector and serious patron of the arts. Her house was stuffed with wonderful things by a wide variety of superb artists and craftsmen. All three floors had been carefully thought out and her treasures arranged with instinctive taste and practicality. There were Kelly works everywhere, even in her kitchen. She had framed some of his letters and they were exquisite, each one a painting with words. After her friend had given her his address early in 1983, she had written to him asking if she could purchase a painting. By return she received an A4 sheet of writing paper with a painting of his house. She showed me that first letter. It was written on the watercolour explaining his circumstances and promising to maybe let her have a painting sometime in the future. This was not exactly specific but Joan didn't mind – she had a painting in her hand already.

> Pear Tree Cottage
> Rockland St Peter
> 24th January 1983

Dear Miss David

Thank you so much for your letter which arrived today. Your very kind and appreciative words about my work really touched me. It is so rare to hear such compliments and since I am experiencing the darkest period of my life I got quite a lift.

I would be more than pleased to do you a painting and as regards price simply pay me what you can afford. I am staging a weekend exhibition here sometime in June. However, if my health will allow, I hope to visit Cumberland around April time. I could bring one or two things to your home because I hope to stay a week or so. I will however give you a good warning.

I am at the moment endeavouring to complete an extension to the cottage where the aforementioned exhibition will take place. It will be a private show and I hope to get friends to pay a call. Here in Norfolk I am an alien in a foreign land. The Northern landscape is not appreciated.

I included the sketch because it does to some degree illustrate the local scene. Warm brick, red and orange pantiles, white and coloured bargeboards, clay outbuildings and barns painted black and white and often in the less 'settled' villages a nice untidiness which butterflies appreciate. In our garden we have a weed patch and a magnificent clump of nettles hidden behind the garage. The local inhabitants hereabouts are native born so there are few outsiders which is good because much of Norfolk and I dare say Suffolk has been ruined by modern building.

I will keep in touch regarding my visit to Cumberland and I must thank you again for writing to me.

Sincerely and kindly, Bob Kelly

Incidentally Fen Street is only a mile away. There is a letterbox which we often use strapped to a short pole and covered in Ivy. It is a quite charming way to post one's letters.

Joan was delighted and replied immediately, enclosing a book of stamps. She didn't realise then that none of the intentions expressed in that letter would ever be realised. And so began ten years of correspondence, most of it beautifully illustrated. His second letter to her began 'Miss David' and was this time signed 'Percy Kelly'. But his third, dated 20 February, was mysteriously signed 'Bob'.

Dear Miss David

In my previous letter I forgot to thank you for your lovely poppy postcard and your bright breezy script. How I enjoy your enthusiasm. It is difficult to realise not long ago I shared that same enthusiasm. I have a feminine side to my character which is and has been a curse. Today my days and nights are a perpetual nightmare. No doubt if I had been born normal I might not have possessed the same creative spirit.

. . . Oh I do wish the clouds would go away.

Kindly

Bob Kelly

Soon after that, at the beginning of March, his wife Chris left him and he was alone for the first time in his life, aged sixty-five. As a twin and member of a large family who had gone straight from living at home to his first marriage and then the army, he wasn't used to solitude; even when his marriage to his first wife had broken down, he had gone straight into the next one.

He became even more depressed and possibly suicidal, so

Joan decided to go down and see him with the friend who had introduced them. Just before this visit he asked her if she minded him signing his letters Roberta; she assured him she didn't, so in his next letter he addressed her for the first time by her Christian name.

<div style="text-align: right">

23rd May 1983 1.30
Dans le jardin

</div>

My dear Joan

I am so glad you approve of the name Roberta. It is pleasantly delightful when I hear it pronounced and it forms the right balance between male and female. I cannot think of another name which would suit me. I pray when we meet you will approve seeing me in the flesh . . . My family and Cumberland folk call me Percy – a name I never cared for.

And again on 27 May a short letter, written on a painting of his living room at Pear Tree Cottage.

I have never looked forward to meeting anyone so much before. I feel like a girl going to her first party.

From then on his letters were usually signed 'Roberta' or just 'R'.

He poured out all his troubles to Joan in these regular letters and she helped him with his problems rather like an agony aunt. His first big problem was the fact that he had no money. Joan naively thought the answer to this was easy, and advised

him to sell some paintings. She was keen to buy for a start. And she had friends who had seen his letters and heard the story and would buy as well. His cottage was stuffed with paintings – she knew that from her visit – and his first letter to her had indicated his plan to hold several exhibitions. He had exhibited his paintings earlier in his life, with a few early exhibitions in Cumbria, one in London, and others at Abbot Hall and Kings Lynn. But he would have none of that now. He made every excuse he could think up not to sell anything. He had been behaving like this for years and it had driven Chris mad.

It was Joan who helped Percy get the tiny supplementary benefit on which he was to live for the remaining ten years. She helped him change his name by deed poll to Roberta Penelope (to keep his initials the same as Robert Percy) and she sent him money, stamps, food parcels, paper and paints. He would write to her two or three times a week – often the envelopes would be decorated too. Joan produced lots of them from a big box and as I looked through them I began to realise what we were up against. This person had severe mental problems – but boy, could he paint!

Joan told me she found it hard to keep up her letter-writing sometimes, especially if she was busy or going away on holiday. But she realised how close he was to the edge and kept going, especially after he warned her that if he sent a letter to one of his friends and did not receive a reply within three days he never wrote again. Joan wrote to him from holidays – even from Canada, where her daughter lived, and the Outer

Hebrides. It would not have taken very much to totally unbalance him.

Early in 1984 Percy received a letter from his wife's solicitors asking for a divorce settlement and advising him that they were going to send a valuer to Pear Tree Cottage. This threw him into a complete panic, and he went into a frenzy of packing up and hiding paintings. Some were secreted in his coal bunker, so they ended up with half a ton of coal on top of them. Other caches were hidden under the bed and in the car. Joan pointed out to him once again, but more forcefully this time, that he would have to sell some paintings. Her friends Rosemary and David Mustoe, who lived in a beautiful large house at Troutbeck near Windermere, had offered to hold an exhibition for him. Joan promised to organise everything and invite all her friends. She went down to Rockland to see him and try to persuade him to take this way out of the crisis. She stayed in a B&B nearby, and recorded her visit as follows:

> Remembering my last visit, as well as taking food for PK, I took a basket of Ryvita, cheese, tomatoes, biscuits, gin and tonic as sustenance for the evening in case I had nothing during the day. I hid them in the wardrobe where Brigadier Garnier (owner of the B&B) kept his fishing tackle and shooting gear and I often wonder if he saw my basket of food during the day while I was out! There was nowhere near the B&B where I could eat. I was jolly glad of that basket, though PK did make a little more effort to feed me with semi-warm

stews which had been on the stove for days. I discovered on this visit that he kept extraordinary hours. He stayed up at night into the small hours and got up midday so I did my own thing in the morning and turned up at lunchtime. Inevitably no lunch!

On this visit he was dressed in flowing women's clothes – long skirt and blouse and a scarf tied round his head – always something on his head – in warm weather the scarf replaced the woolly hat. The colours were bright but an unusual mixture. He was brilliant in his use of colour in all spheres. He said his head was always cold. I began to realise he was a hypochondriac and had a number of elusive complaints. We drove to a village to visit the health food shop and as soon as we left the car he said he felt dizzy and sick and I had to help him across the road. As we walked down the street I suddenly felt helplessly hysterical because there I was walking round the shops with a woman and I began to wonder whether all the other lady shoppers were men dressed up!

'He did agree to the exhibition though,' Joan told me triumphantly. 'He simply had to – there was no alternative.'

From then on paintings began to arrive by post at her house in Troutbeck and she had to get them framed. Letters winged their way backwards and forwards while Percy kept changing his mind about what he should sell.

The exhibition was arranged for October. A few months before, in June, the valuer from the solicitors was due. On 6 June 1984, Percy wrote to Joan:

I have hidden some paintings and personal things in the coal bunker. I made a lining out of corrugated sheeting and the coalman, when he came, carefully topped up the bunker with coal.

I have already re-dated the Westmorland painting 1984. I shall have to lose the Normandy painting and the drawings that were returned from Abbot Hall. I do wish you were not so far away dear friend. I shall parcel up as much work as I can and post it off to you. I shall list the ones for framing. I must try and dispose of the box of work you brought down in March. I would go quite mad if some alien handled them.

. . . In the meantime I have removed all the important paintings from the extension to the bedroom. I shall put them between the bed mattresses temporarily. This leaves the Abbot Hall box but I shall seal it all up and wrap it in a large plastic sheet and put it in the trailer ready for off. Isn't it awful because I had some of the best work out on the bench for inspiration. I love having things round me when I work.

The exhibition was a success. Joan told me how her friend David Mustoe had driven down to collect him and had to wait while PK barricaded all the doors when he left. I was curious to know whether he had come as Percy or Roberta. She fished about in the box for the letter of 12 September.

I am glad you think I should come north as Percy (to acquaintances, Bob to friends) . . . If I travel by car I shall be Roberta and then change according to circumstances. I always

used to be quite formal at Private Views – tweed jacket and slacks, but in October I shall wear more artistic attire. I have a lovely cotton top. It is Indian and has a super neck. It is paired with a medium long skirt . . . Shoes are the main problem because the top is ideal with sandals but I haven't got a suitable pair.

. . . The only male garment I possess is a windcheater. I do think life is easier these days because bi-sexual clothes are commonplace. My head has been so much better since April so I am hoping I can dispense with wearing two woolly hats, one inside the other.

. . . Of course as Percy I shall have to wear a hat to keep my hair up in place and more importantly to keep my head warm – must be a weakness of mine.

Joan and I had a chuckle about this. I was dying to know more. In the end he arrived as Percy, which made David Mustoe feel more comfortable.

Joan wrote about his arrival.

They arrived late afternoon and I shall never forget seeing them disembark. PK descended from that beautiful car with an incredible amount of luggage of all shapes and sizes – cardboard boxes etc. – general chaotic muddle. The last item to be handed out was a cage containing a budgerigar – Pepi – who was also to be my guest though I had not known it till that moment. The next few days were occupied with hanging with the help of the Mustoes' gardener.

. . . All week he (PK) was dressed in plus twos, a sweater and a bobble hat. I think he slept in that hat. I must confess that I hated the idea of such a messy person sleeping in my dainty pink and white guest room. However it survived. PK had brought tools galore with him and I remember my fury one night when he sat up late long after I had gone to bed dismantling one of Fenwick Patterson's beautiful frames and replacing it with one of his own messy bits and pieces.

Joan and I got to know each other much better that day. Before this our meetings had been at the gallery, and to be with her surrounded by PK's paintings and letters was a much more intimate experience. This was the beginning of a lifetime's friendship. We worked out a plan of campaign for persuading PK to have another exhibition in Cumbria and I left with my brain feeling like a tumble-drier full of small things on the delicate programme.

Joan prepared the ground by sending PK a few copies of *Cumbria Life* and drawing his attention to my articles. This hit stony ground – he was unimpressed by the artists featured and said so vehemently. He failed to notice me, the writer, at all. She tried again, writing to tell him all about me and the gallery, and I followed this up with a gallery programme and a fulsome letter praising him and all his works. We were unashamedly calculating but we both had his interests at heart. He was ridiculously poor and was sitting on a fortune if only he would sell some of his paintings. But his replies were disappointing. To Joan he expressed surprise at anyone opening a gallery in West

Cumbria – he was convinced I must have a private income (if only!). To me he replied formally in his habitual pompous style.

3rd December 1987

Dear Chris Wadsworth,

Thank you so much for your letter and the nice things you said about my work. Unfortunately I don't wish to hold any more exhibitions primarily because I am in receipt of a supplementary retirement pension not qualifying for the statuary one having been self-employed and therefore I am not allowed to earn money. But there is a second reason. My health is not too good and I am confined to a small area in and around the village of Rocklands. Any further, I have to be chaperoned so I could never get up to Cumberland.

I did have an exhibition, a private one near Windermere in 1984 but Mrs Joan David arranged it and did virtually everything. She staged it so I would make sufficient money to obtain tenure of my present cottage. Failure meant being dumped on the street as it were but someone was looking over me so sufficient money was gathered together.

Today my income is quite adequate for my needs and I am not a believer in acquiring monies that just waste away in a bank so I can accept my present situation quite readily.

Sincerely

Percy Kelly

This letter was written on A4 and decorated with a print of Allonby. It was a start, but it illustrated his self-delusion. He

really didn't have enough to live on and Joan was always help-
ing him out. She told me that he had been taken to hospital
recently with a diagnosis of malnutrition. They kept him in for
a week or two feeding him. He washed the plastic plates and
trays that his food came on and, with the paints that David
Ralli had taken him as requested, he decorated them with birds
and flowers. Chris has since assured me that she would never
have turned him out of Pear Tree Cottage, and, knowing her
as I do now, I am sure she was speaking the truth.

I wrote to him again at Joan's instigation – and in the hope
of getting another 'Painted Letter'. The result was disap-
pointing. He stated quite firmly that he would rather starve
than sell one piece of work, and I believed him. This was bad
news. The only reason for hope was his last sentence:

> But I know when I depart this world people will stop and
> wonder at the beauty and truth that I have portrayed.

Ah, so that was it. He wanted recognition after his death –
the very opposite to most artists. This wasn't false modesty –
it was a state of mind. I replied with even more enthusiastic
praise, if only to keep the correspondence going and get
another drawing.

Joan and I discussed the situation at length. PK had told
Joan that he had made a will and he wanted her to have the
paintings after his death because she would know what to do
with them. She certainly would. Her main concern was to pro-
tect his work, now scattered untidily all over his cottage on

every conceivable surface and in stacks of wooden bread trays, and thereby preserve his name for immortality. Her plan was to set up a trust and try to buy a space in Workington or Allonby in which to mount a permanent exhibition. This would be funded by several selling exhibitions at my gallery and grants which I would help to secure. We would have to be patient. To assuage my longing for a PK painting she would often come to see me with a little something – a drawing or small watercolour that he had enclosed in one of his envelopes. She was the most generous and understanding person I have ever met, and by 1993 I had my own small PK collection.

By March of that year Joan was gearing up for a hip replacement operation when Percy was taken ill and had to go to hospital. He was seventy-six, and he had cancer of the throat. It was a Sunday in July that same year – the gallery's sixth birthday – when she rang to tell me he had died. When David and Jacquie reported that PK's son and twin brother had turned up at the funeral Joan was amazed – PK had never mentioned the existence of either.

A proper will was never found, although there were several false starts found hidden in boxes and under the bed. The Norfolk solicitor who had worked on PK's second divorce had tried to persuade him to make a will but had never seen one. The solicitor who had successfully helped him to change his name by deed poll to Roberta Penelope Kelly years before knew nothing of a will either, though PK had discussed it with

her at length. It was part of his personality disorder that he never finished anything – except his work and his letters. People with exceptional gifts often have a balancing flaw and procrastination was Percy's. All his life he had been like a cat who was clever enough to catch a mouse, and then at that triumphant moment when the mouse was there under his paw he became distracted and allowed the mouse its escape, only to pursue it again and again. The cottage was full of Heath Robinson-esque drawings planning how he might reuse the materials he scavenged from the tip and elsewhere – utterly beautiful drawings which made up in ingenuity and aesthetics what they lacked in practicality. Of course none of the ideas he conjured up were ever put into practice.

Percy was well aware that he had been born with a special gift, but he squandered it. He seemed to believe that thought and intention were enough to achieve something, without actually pursuing the necessary action. He had made innumerable attempts to record his life story, but each time he got to about the age of twenty-three, or sometimes well before that, he would put the papers to one side and start again. I later found at least a dozen of these handwritten accounts, which were quite repetitive and abruptly and frustratingly stopped mid-sentence. So it was with his will, even when there was so much at stake. PK's work was everything to him and yet he failed to secure its survival after his death. He started a will stating that he wanted to leave small legacies to his twin brother John and to the Salvation Army and then it tailed off. The thought of his own mortality was probably too much for

him. So, as his only progeny, his abandoned son Brian inherited everything by default.

Although Joan was in poor health, she was spending her time frantically trying to secure the preservation of all the work she knew was in Pear Tree Cottage. This was difficult at long distance from her bed but she was unstoppable, a master of forensic detection. She rang me one day shortly after PK's death and stated, out of the blue, 'Brian's mother, PK's first wife lives near you.'

'Really? Where?'

'Oh I don't know that – yet,' she replied. 'But I'll find out. She goes for coffee every day at Norham Coffee House down the road from you. You could go and see her there. She's remarried. Her name is Ark.'

'A.R.K.' I spelled it out. 'As in Noah's?'

'Yes, that's what I was told. Funny name but it's something to go on.'

'You should have been a private detective,' I teased. 'I'm sure you would have been a huge success.'

For Joan on her sick bed, unable to move or drive, I was willing to do anything. I was not particularly enthusiastic about the idea of undercover surveillance, but I decided that in the cause of friendship and art I would have to do my best. I promised her I would go early the following week and join the ranks of ladies who lunch and report back.

As it turned out, I didn't need to. The following day, Saturday, I was innocently enjoying a coffee and the *Guardian* cryptic crossword in the gallery kitchen when my assistant

Wendy came bursting in and closed the door behind her. She had her significant look as she leant with her back against the door

'You'll never believe what's happened now!'

'What is it?' I asked, seeing her pink cheeks.

'It's Percy Kelly's first wife. She's here in the gallery.'

'What's she like?' I asked, immediately sensing something odd. I was really curious.

'You'd better come and see,' she replied cryptically, and she opened the door with a flourish and ushered me out, gesticulating towards the Adam Room.

I took a deep breath and advanced into the room, arm outstretched in greeting, my best smile in place. 'Mrs Ark!' I exclaimed. 'How lovely to see you.'

'The name's Park,' she enunciated in an offended tone.

Oh dear – bad start. Joan's hearing must be deteriorating.

The woman in front of me was unusual. She was in her seventies and was wearing a white baseball cap over bouffant chestnut hair. She must have been very pretty as a young woman, and she obviously still took a lot of pride in her appearance. Her face was expertly made up and she sported a huge pair of sunglasses. I later discovered she had an eye condition which made her sensitive to light; she could never go out in sunlight and always had to wear the dark glasses and peaked cap. She was not afraid of bright colours, though, and she cut quite a dash with her pink anorak and white and gold sneakers.

The other people in the gallery were giving me sidelong

glances, interested in what would happen next. 'I'm so pleased you've come,' I continued. 'I love your first husband's work.'

'Mmh – art,' she said grimly. 'I've had it up to here. *You* didn't have to live with him,' she went on, pointedly. 'As an artist he was all right, I suppose, but as a man he was useless.'

The gallery had come to a halt. People were milling round fascinated, pretending to study objects and paintings very closely while they waited for the next gem. What would happen next?' Was this performance art?

At this point I noticed she was carrying a plastic bag with what looked like small paintings in it. I was transfixed. 'Would you like a cup of coffee?' I offered. 'Do please come through to the office' – and I ushered her out of the door. Behind me I could feel a sigh of disappointment and resentment from the swelling crowd.

We had a long conversation in private about Percy. She was an attractive and intelligent woman. Although they had divorced twenty-five years before and she was happily remarried, there was still a bitter resentment there, and it seeped out like creosote from a leaky tin with a fluttering of eyelashes and eyes raised to heaven. I couldn't take my eyes off the bag. Finally, as she got up to go, she saw my look.

'Oh,' she said, 'you might be interested in these drawings.'

She handed me the bag and I took out two amateur pencil drawings of a woman. They were not by Percy Kelly, and they were not very good.

'Are they worth anything?' she asked. 'That's why I came – to show them to you.'

Do you have anything by Percy?' I inquired in return, as gently as I could.

'Well, I did,' she replied. 'He wrote to me nearly every day during the war and there were lots of drawings in the letters but I burnt them all – couldn't bear to look at them.' And with that she left.

A drawing of Pear Tree Cottage that headed one of the many refusals I received from Percy Kelly

Meanwhile Joan was still plotting. She was recovering well and she had run Percy's son Brian to earth – no mean feat, given that he was ex-directory – and reported that he seemed secretive and suspicious. She felt that he should come to the gallery where he could learn the importance of his father's collection, and she was attempting to achieve this with some tricky

manipulation. It wasn't easy, but she finally persuaded him to agree to meet her at the gallery the following week. The legalities of the estate were progressing well and she felt there was no time to lose. We were both terrified that Brian might decide to clear out all the rubbish in Pear Tree – and there was plenty of it – and maybe have a bonfire . . . we daren't even think about it. Our priority was to ensure the work was safe, and preferably back in Cumbria.

Joan scripted and choreographed the meeting to the extent that we had to have a rehearsal beforehand. The plan was that she would greet Brian and make him feel more comfortable, and then I would appear smiling and offer coffee or tea. At this point she would disappear, because she felt he could probably only cope with one of us at once. I must say I was inclined to agree with her. Collectively we were formidable.

Brian was tall and handsome, with chiselled features that permanently bore a puzzled expression. He enjoyed the attention but was deeply suspicious of the two of us. The art world was totally new to him and he was unsure as anyone would be in an unfamiliar environment; no doubt I would have felt the same in his place of work. However, I was quickly to find that Brian was unsure about everything and incapable of making any decisions at all. This insecurity was deep-seated and was not helped by this new responsibility that had been thrust upon him, although given the circumstances and the lack of any paternal interest most of his life this was perhaps not surprising. I was very gentle. I simply pointed out the importance of his father's work and how it must be preserved. He left

without indicating any surprise or opinion at all, but he did tell me he was going to Norfolk again the following week.

I was left with a terrible feeling that he mistrusted me, that he didn't believe anything I said and that he had no intention of doing anything at all about his father's work, which he saw as bits of paper and rubbish he couldn't distinguish from all the other rubbish he had to clear up before he could even try to sell the cottage. After he had gone, Joan reappeared and I confided my feelings of unease. I was not convinced that we had in any way succeeded in our mission. Joan was beside herself with worry, and I could tell she was visualising the bonfire in the garden. She was also annoyed with Percy for giving her this problem. His work was everything to him – the most important thing in his whole life and he had failed to secure even its future.

'Why on earth didn't he make a proper will and get it signed?' she sighed. 'He could write beautiful letters and paint wonderful pictures but this failure is beyond the limit!'

She left depressed, angry and frustrated. I knew how she felt. I felt the same.

Two weeks later Brian turned up at the gallery unannounced and told me the work was coming to Cumbria. He was going to sell Pear Tree Cottage, clear it out and bring the paintings to Cumbria. He was much more positive than at our first meeting. I was relieved and delighted to the point of euphoria. Wait until Joan heard about this remarkable change of mind. I wondered what had brought it on. I immediately offered to go down to help but was vehemently turned down.

'How are you going to get them here?' I asked.

'In the back of the Mini,' came the surprising reply.

'What?' I was horrified. 'Brian, they won't fit. They'll be damaged.'

He was unmoved.

'And what will you do with them then?' I asked, holding my breath.

'Happen I'll keep 'em under my bed.' I was hoping he was teasing me, but he didn't seem like the sort of man who made jokes. I think he was testing rather than teasing me. He had made his mind up to let the paintings come to the gallery but was not going to concede too easily. He wanted to see my reaction. Maybe he was winding me up. It was always difficult to tell with Brian.

His wife Doreen was with him this time. She was a sensible, practical woman who was not overwhelmed by the gallery or me. She saw the folly of what he was proposing at once. I had an ally.

'Brian,' she told him, 'you can't do that.' She looked at me. 'We live in a council house,' she explained. 'It's full of Brian's machines. He wants to be an inventor.'

Putting this intriguing statement to the back of my mind for later, I carried on.

'I could get them brought up from Norfolk for you,' I suggested quickly.

'How?'

'I'll send an art carrier. Then they'll be properly handled.'

'How much will that cost?' Brian interjected. 'It'll be too expensive.'

'I will pay,' I assured him, 'if you let them come here to the gallery where I can photograph and catalogue them. That'll take some time. Then you can decide what to do with them. There are no strings attached, Brian, no pressure. The decision will be yours, but I think there should be a proper record of this important collection.'

I held my breath . . . and he agreed.

Only years later did I discover what had brought about his change of attitude.

The auctioneer was an expert in the twentieth-century fine art department in an auction house in London. He escaped the pressure of the big city at weekends by retreating to his cottage in Norfolk for a spot of fishing. It was a lovely August Saturday and he was just sorting out his fishing tackle when the telephone rang. It was his school chum David Ralli – PK's old friend – and he wanted a favour. The auctioneer's heart sank.

'I have a young man here who has inherited his father's work – he was a painter,' David explained. 'He's wondering what to do about it. Would you mind terribly having a look at it? Sorry.'

'What was his father's name?' the auctioneer asked.

'Kelly. Percy Kelly.'

'Never heard of him.' He hesitated. 'But bring it over. Can you come now? How much is there?'

'Oh, there are rooms full of stuff,' came the reply.

'Tell you what,' the auctioneer suggested quickly. 'Just

bring five pieces. That'll be enough for me to give an opinion on them.'

'Bloody Sunday painters,' he muttered under his breath as he replaced the telephone and braced himself for the worst.

David and Brian immediately picked out five paintings at random from one of the many piles littered about the cottage, placed them in the car and set off. The auctioneer was waiting impatiently, his fishing gear at the ready. Brian declined to get out of the car and go in. He was out of his comfort zone again. David greeted his old friend apologetically, thanking him in advance, and placed the rough pile of paintings on the kitchen table alongside the marmalade pot. There was a long silence while the expert looked hard at the paintings.

'I thought you were bringing me a Sunday painter,' he exclaimed. 'Who owns these paintings? Where is he now?'

'Brian Kelly. He's outside in the car.'

'Well, bring him in. I want to talk to him.'

Brian was summoned and came in looking as apprehensive as if he'd been called to his headmaster's office. To him these were simply pieces of tatty paper.

'These landscapes aren't of Norfolk,' said the auctioneer, addressing Brian directly.

'No sir,' replied Brian, subserviently and apologetically.

'Where was your father from then? Where are these land-scapes?'

'Cumbria sir, I think.'

'Right,' the expert said slowly. 'You do realise that these are very good paintings – very saleable – could become very

valuable. Cumbria – initially that's the place they should go. Now there's a very good commercial gallery in Cumbria. It's called Castlegate House somewhere in the north of the county I think. The woman who runs it is . . . Well, you could find out in . . .'

'I've been there,' broke in Brian, swelling with pride. 'I've met the woman who owns it. She's called Chris.'

And that is how the paintings of Percy Kelly made their way back to Cumbria.

As Brian wouldn't allow me to go down to Norfolk and supervise the loading of the paintings myself, I rang my regular art carrier and gave him instructions instead. I wanted the whole collection gathered from all over the house and the contents of the studio loaded and brought up to the gallery. Brian would be there to help, which was a worry because he knew so little about art or his father. The carrier couldn't put a price on the job and nor did I expect him to, but he did ask me for an insurance value. This posed a problem but I just pulled a figure out of the air.

'Forty thousand,' I said.

'OK,' he agreed. 'They'll be with you next Wednesday afternoon. We've got some stuff to come up from the Tate and the V&A. We'll divert off the M1 to Norfolk. No problem.'

When Wednesday at last arrived I was restless all day, constantly looking out of the window and trying to find something, anything, to occupy myself. We closed the gallery at five o'clock and still there was no van. I was beside myself with

worry and excitement by the time it finally pulled into the car park at eight o'clock. It was early September and still light. Jack the driver looked utterly exhausted.

'Have you had a long day?' I asked sympathetically. 'Come in and have some tea and a sandwich. Was the traffic bad?'

He was unusually taciturn, which I put down to tiredness. It had been a long day and a long drive. Once seated in the kitchen behind a huge mug of steaming tea, I again asked how he had got on.

'Terrible,' he answered gloomily. 'Took me all day.'

'Did you bring everything?' I asked anxiously.

'Oh yes,' he assured me, taking a great gulp of tea. Then he looked me straight in the eyes as he asked the question. 'How much have you insured it all for?'

'Well Jack, that's between me and the boss isn't it? Why do you ask?'

"Cos I want to know,' he replied truculently. I sensed an underlying agenda.

'Forty thousand,' I admitted reluctantly. 'Has something happened to it?'

He gave me a long look and slowly answered. 'It's a load of bloody rubbish. I doubt it's worth forty pounds.'

'What?' My heart seemed to stop. I leaped out of my chair.

'Come on Jack! Out to the van now! I want to see what you've brought.'

Out in the car park he opened the van's rear doors, revealing at one side a neatly stacked roll of tapestries coming from the V&A up to the Laing Gallery in Newcastle and, at the

other, four crated paintings from Tate Britain destined for the National Gallery of Scotland in Edinburgh. The space in between was full to bursting and unbelievably untidy. It looked as though he had raided the tip. Piles of wooden bread trays and fish boxes overflowed with piles of paper. Rusty paint tins spilled over the sides, and rolls of what looked like wallpaper sat among paint rollers, print dyes and paintbrushes. I could see a glue pot, paint rags and an old rusty saucepan. I couldn't believe it. Was this the total of a lifetime's work? There was nothing that even faintly resembled proper paintings.

I jumped up into the van and lifted the top piece of paper on the first pile that presented itself. I caught my breath. My pulse was racing and I suddenly had an awful headache. I sifted through the pile and my thoughts and dreams were confirmed. Tears began to flow and I couldn't stop them. Jack came over and touched my arm lightly.

'I'm sorry pet,' he consoled me in his lovely lilting Geordie brogue. 'I knew you'd be upset. Don't cry.'

The tears were tears of relief and joy – I felt like dancing round the car park. I was holding the most wonderful painting of Loweswater, signed 'Percy Kelly 1965'. I turned the next one over – Whitehaven in all its glory. This was what I had been working towards since I had first seen that painting of the harbour seven years before. More tears came. No words – just tears. Jack looked very uncomfortable. Dealing with weeping women wasn't in his job description.

'Jack,' I said eventually when I'd stopped dancing and shaking. 'You don't understand. You've done a great job today.

These are absolutely wonderful. Come on, let's get them inside. Now.'

It took us an hour to unload and two weeks for me to bring some kind of order to the piles of paper. By this time I had a sense of their quality and quantity. Joan was recovering from her second hip operation and asked one of her multitude of friends to drive her up for lunch at the gallery. She just couldn't wait to see the haul. There is a huge studio space at Castlegate on the second floor, and it was here that I had arranged all the work. The only problem was getting Joan up the stairs; even walking a few paces was difficult for her. But for Joan we would have done anything. She managed the two steps to the front door, at which point Michael strode forward, picked her up and carried her up the four flights of stairs. Luckily she was small and slightly built, and she found the experience hilarious. Michael deposited her gently on a couch in the studio and the show began. I held up works from different heaps in turn while she made comments and gave out orders. Wendy, Michael and Mavis, the friend who had driven her up, brought lunch up on trays and we had a marvellous afternoon. Joan was totally exhausted but deliriously happy when Michael finally carried her down to the car again.

I now needed to work out what to do with it all. I needed a plan, a strategy. It was time to talk to Brian and see what he had in mind.

His puzzled expression was still there – it was permanent. Doreen was with him – a steadying and sensible influence, I

thought. I saw her as my ally. We sat in the studio, surrounded by piles of paintings and drawings, now arranged in neat piles according to size and medium. We talked about Percy for a while because I wanted to steer the conversation to maybe setting up a trust, raising money for a museum with a permanent collection, involving the local council and the Arts Council and perhaps applying for European funding. When Brian went off to the toilet, Doreen suddenly asked a question which caught me totally by surprise. If I had thought for a thousand years about all the questions I might ever be asked by Doreen or Brian or anyone, I would not have come up with this one.

'Chris – do you know what a dildo is?'

'Why do you ask that?' I ventured cautiously, somewhat flabbergasted.

'Well, we found a lot of them at the cottage.'

'What were they made of?' I asked.

'Wood,' she replied. 'They were carved in wood. They were really nice. I think Brian's dad made them. Every one was different.'

'How many are there?' I asked casually, as though I wasn't interested. Of course I was!

'Ooh, there were ever such a lot,' she answered. ' Must have been twenty or thirty with beautiful carvings on them.'

'Where are they now?' I asked in a whisper, trying hard not to giggle like a schoolgirl.

'Brian burnt 'em– with the frocks and the shoes and stuff like that,' she said. 'Did you know about all that?'

I nodded. I was glad we were able to talk about it so easily.

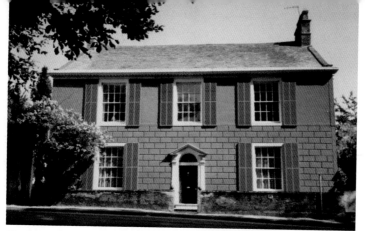

Castlegate House: the estate agent's photograph. It was very large and very pink – with Tyrolean shutters. I was almost put off and Michael certainly didn't want another Georgian heap.

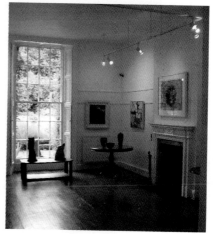

The gallery with a view through to the garden.

The walled 'secret garden' that sealed the deal: Castlegate House in springtime.

Daybreak at Twynham
Bill Peascod
Mixed media on board (152 x 110 cm)

© The Estate of W. Peascod

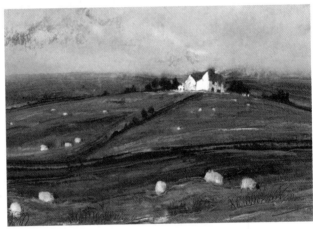

Hill Farm
Karen Wallbank
'Mixed media'
(70 x 49 cm)

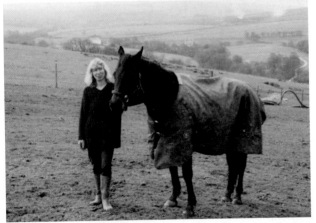

'Farmer's wife'
Karen Wallbank
and her horse.

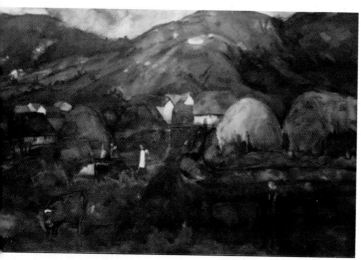

Cumberland
Sheila Fell
(50 x 80 cm)

Reproduced by kind permission of Anna Fell

Philip nurturing his beloved Penelope, among the Penelope roses.

Despite her artist's highlife in London as a Royal Academician and Lowry's troubled muse, Sheila Fell's heart never left Cumberland. *Adrian Bailey*

Whitehaven Harbour
Percy Kelly
Watercolour and ink (60 x 40 cm)
© The Estate of Percy Kelly

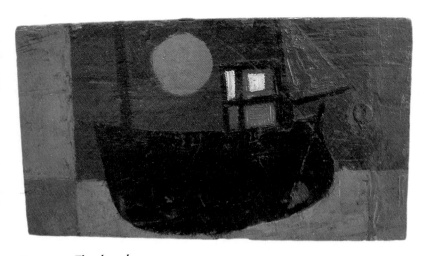

Boat on a Floorboard
Percy Kelly
Rescued from a disastrous framing and now hanging safely in the kitchen at
Castlegate House.
© The Estate of Percy Kelly

A beautiful example of the illustrations that adorned Percy's emotionally charged letters to Joan.
© The Estate of Percy Kelly

Percy's letters were a welcome distraction for his step-daughter Kim while she was away at boarding school.
© The Estate of Percy Kelly

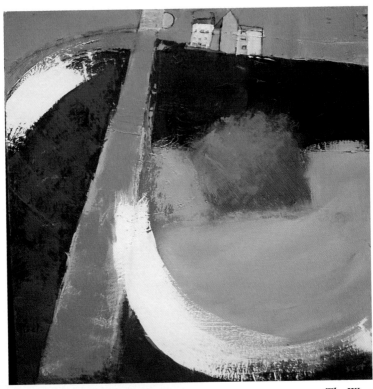

The Wave
Marie Scott
Oil on canvas (80 x 80 cm)

The irresistible Hideo at
work sculpting a sphere.

Angel's Tears
Winifred Nicholson
Oil on canvas
(51 x 46 cm)
© Trustees of
Winifred Nicholson

Cowles Fish and Chip Shop
L. S. Lowry
© The Estate of L.S. Lowry

The Striped Cat
Mary Fedden
Oil on canvas
(60 x 40 cm)

The Purple House
John Wynn
Watercolour
(18 x 24 cm)

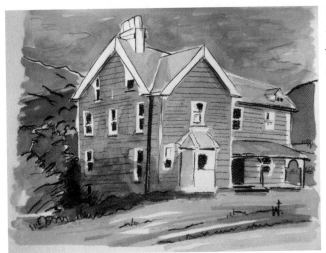

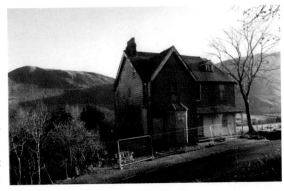

The inspiration for
The Purple House:
a forlorn and derelict
Rigg Beck.

Picture section designed by David Fletcher Welch

But my heart dropped. What an exhibition that would have been – 'The Dildos of Percy Kelly'. I could just imagine it at Tate Modern, with the dildos all mounted on plinths. It would have rocked the art world – it might have outdone Tracey Emin and Damien Hirst at their most outrageous. But now they were reduced to ashes!

But back to the business in hand. What should we do about this precious collection of work? I determined to put the dildos behind me (as it were) and steer the conversation back to the important question of the paintings and their future.

'So, what do you want to do about the work, Brian?' I asked, looking at him steadily and directly.

'Sell 'em,' he answered with uncharacteristic decisiveness. 'That man from the auction place in London. He said they were worth a lot. I want to sell 'em.'

So be it. At that point I had no idea who the man in London was, but I was in no position to argue. Pointing out that it would be sheer folly to put the whole lot on the market straightaway, I advised caution. A series of exhibitions with two years between each one would be sensible. I realised that he probably wouldn't be able to sell the cottage very quickly in view of its poor state of repair and the years of Percy's unique approach to house renovation. It wasn't exactly a desirable residence with a queue of eager buyers.

Brian told me he hated his job at the factory and would like to retire; he was in his late forties. I felt a heavy responsibility coming my way and urged him to be cautious. We made a

ten-year plan. I promised to catalogue, number and photograph every piece of work, make duplicate copies for him and mount an exhibition the following May at the gallery. After that we could then reassess his life plan.

On the morning of the opening of the exhibition, the queue began very early, and by ten o'clock it stretched right down the hill. Few of the people waiting so patiently had ever heard of Percy Kelly, but I had sent out a beautiful invitation and made a very good catalogue to go with it. It seemed there were many like Joan and me who had found love at first sight.

In cataloguing the collection, I had come up against two big problems. The first was how I should title each work. There was no indication of location in most of them, and the few that were framed had rough frames that had been recycled many times, with the result that the labels on the back usually bore no relation to the painting. I recognised the obvious ones – the West Cumbrian harbours, for instance – and could title those accordingly, but I gave the rest more general titles like *House by the Bridge*, *Cottage in the Wood*, *Village Street* and so on. There were an awful lot of bridges, all different; Percy liked bridges. The paintings set in the Lake District National Park were easier to identify because the profile of the fells stays constant and the buildings remain mainly unchanged because of planning restrictions, but the villages outside the park were very tricky. I spent days cycling around little places in West Cumbria with intriguing names

like Crosscannonby, Blennerhasset, Bullgill, Threapland and Plumbland trying to identify settings, but failing because there had been so much development over forty years. From my own point of view it was the quality of the work that mattered and its location was irrelevant but, understandably, people who own a painting often want to know exactly what it depicts. (Ironically, in 2005, after all those original paintings and drawings were sold, I gained access to a heap of PK's sketchbooks that I never knew existed and it all became much clearer. He had set off early each morning and sketched his way round a succession of places. He had made notes on the drawings and sometimes given a clue as to where each location was, and thus I was able to trace exactly where he had been that day, what the weather was like and how he was feeling. If I had only those at the beginning, life and titles would have been so much easier.)

The second problem was pricing. There was no precedent to guide me because Percy had sold so few paintings in his lifetime. I tried to be fair to Brian, to Percy and to the people who were buying and settled on a middle mark.

There were exactly one hundred paintings in that first exhibition. The crowd fell upon them and in two hours there wasn't a single one without a red spot. Joan, her son Robert and his wife Sue bought several, despite having quite a lot of very good ones already. Kelly paintings can become addictive and can damage your wallet.

Audrey was there and so were Brian and Doreen. They were amazed and pleased when all the pictures sold. It was an

incredible afternoon. At the end several clever people came up to tell me that the fact everything had sold showed I had priced them too low. Well, if they hadn't all sold they would probably have told me they were too expensive. It was a no-win situation and one in which I will never know the correct answer. However, I felt happy that the local people had had the opportunity to buy at reasonable prices while PK was virtually unknown, because I now knew that he was going to be big.

Afterwards the family, Joan and I had tea in the kitchen. When everyone else had gone Joan and I just smiled at each other. We had won through: PK's work was back where it belonged, and we thought he would be very happy with the situation.

Brian himself was given a large cheque with which he was delighted. I thought, and hoped, that it might change his rather humdrum life. My solicitor, at my request and expense, drew up a very fair formal contract between us. This was crafted to protect both of us because most of what had happened up to that moment was based on mutual trust.

The next solo PK show two years later saw a local businessman on the doorstep at five in the morning – alone. One of the town's butchers had just retired and couldn't get used to lying in bed in the morning, so had got into the habit of getting up and going for a walk. He was surprised to see John on the step, but after he explained what he was doing the butcher went off home and came back with a fine bacon buttie and a flask of tea to help him along. By eight o'clock there was quite a crowd and by the opening at two o'clock there was another

stampede. I was getting accustomed to stampedes by now. I was training the staff in crowd control

Our tenth-birthday exhibition in 1997 attracted a lot of attention and also our first all-night queue. I used PK's *Birthday Flowers* on the invitation card and everybody wanted to buy it. The people who wanted it most badly waited all day Saturday on the doorstep and then paid their daughter and her boyfriend to keep their place overnight. They bought the painting at 2.30 the following afternoon and they have never regretted it. The Kelly exhibitions always deliver a degree of drama.

For the next exhibition the first person in the queue took his place at one in the morning. At 2 a.m. the police patrol car stopped

'Are you locked out, sir?' inquired the officer.

'No,' the man replied.

'Do you live there?'

'No.'

'So what are you doing on the doorstep?'

'I'm queuing for a painting.'

'Oh. What time does the gallery open?'

'Two o clock.'

'What?'

'Tomorrow afternoon.'

They left him alone huddled in his duvet, scratching their heads and went to fight real crime.

Between those exhibitions, as Percy's reputation has spread, his paintings have been acquired by important collectors, galleries and the British government, as part of their permanent

collection, but most importantly by people all over the world who simply love his work.

We held the fifth and final PK exhibition in August 2000 and, sadly, Brian died during it. He was fifty-four. He and Doreen had divorced the year before and he had no children, so he left everything to Audrey, his eighty-year-old mother, Percy's first wife. There was very little left of his father's work. I had staggered the sale of work over the years, and it was virtually all gone apart from some original prints and my own personal collection, which I had added to each time we had an exhibition.

A year after Brian's sad death I took a call from Audrey. She and I had become friends by then. She was devastated at the loss of her only child, and I felt for her.

'Chris,' she began, 'We're clearing out the loft space in the bungalow. And we think we've found some PK paintings.'

I was round in a flash but was a little disappointed with the piece of very dirty, irregularly shaped hardboard that her husband Bob handed me through the trapdoor in the ceiling. I feared this was going to be a repeat of the amateur drawings she had approached me with at our first meeting years ago. I went up the ladder to take a look. There was a box with a pile of similar dirty pieces of hardboard in the corner. It was very heavy. I took one piece out and was unimpressed. It was just very dark oil.

'I don't think Percy worked in oils, did he?' I asked doubtfully.

'Oh yes he did,' Audrey replied. 'But not a lot because the smell of turps made me feel bad, so I used to make him work in the outhouse with them. I could still smell it so I put a stop to it altogether.'

I daren't even think of all the oil paintings we had lost because of that.

'Can I take this to the gallery?' I asked, choosing a piece at random. 'I don't think it's a PK but I'll clean it up and let you know.'

The best way of cleaning an oil painting, provided you are absolutely sure the medium is pure oil paint, is with a soft cloth and weak mild detergent. I placed the small piece of hardboard on the draining board at Castlegate and rubbed it very gently with a J-cloth and diluted washing-up liquid and the results were astonishing. A painting began to emerge like magic, very dark except for a white barn which stood out starkly. It was signed PK and it was wonderful. I rushed back and got the box of twenty-six of varying sizes – some on canvas – and spent a few exciting hours liberating some wondrous things: *Red Barn*, *The Lighthouse*, *The Red House*, *Winter's Day*, *Village Street*. Each one was beautiful. I took them to a specialist framer in Edinburgh, who encased each one in a plaster slip and dropped it into a hand-gilded frame. They looked fantastic. I took a few to show Audrey as soon as I got them back. She was unable to go out by now; her eye condition had worsened, and she spent her days in a twilight world with the curtains drawn.

'Ooh, they do look good,' she exclaimed. 'I've got another

one in the kitchen. I've never been able to hang it. It's propped on the side. Do you think you could get it framed like this for me?'

'Yes, of course,' I said 'Can I see it?'

She went into the kitchen and came back with a piece of wood which she placed in my hands. I immediately recognised it as a floorboard. It was about a foot wide and eighteen inches long, and had clearly been sawn off a plank. It was a bit warped and knotted. When I turned it over, there was the Percy Kelly boat and orange sun – a recurring theme in his work.

'I can't frame this,' I told Audrey. 'It's a floorboard.'

'Yes I know, 'she replied petulantly. 'But I want it in a nice frame like those there.'

'It won't work,' I explained gently. 'Framing will spoil it.'

But she insisted, and, for the sake of keeping the peace, I reluctantly took it off to Edinburgh when I went to collect the next batch. Sian the framer took one look at it and said, 'It's a floorboard.'

'Yes, I know,' I said despondently.

'I'm not going to frame this,' she said. 'It will ruin it. I'm not going to spoil such a glorious painting. I'll put rings in the back and string it so she can hang it.'

I took it back to Audrey, who curled her lip.

'I'll hang it in the kitchen for you,' I offered hopefully.

'No,' she said. 'You'd best sell it with all the others.'

'What do you want for it?' I asked quickly. 'I'll buy it myself.'

The deal was done there and then and the boat/floorboard hangs in my kitchen now. As for the rest, they were snapped up in ten minutes at the opening.

I kept thinking about this collection of oils and wondered how Audrey had managed to hang on to them after the divorce, knowing Percy's total retentiveness about his work. I felt that I knew him so well now that I understood how his mind worked, and he couldn't possibly have forgotten about them. I knew I was being nosey and might be on sensitive ground, but I decided to ask Audrey anyway.

She sat in her darkened sitting room, wearing her dark glasses with the curtains drawn against the sunlight, and, in her quiet voice, she told me of her most extraordinary experience.

When Percy came back from the war in 1946, Audrey told me, he returned to his job at the Post Office. He found it hard to settle down again and said he was depressed. He took a lot of time off sick, which he spent wandering in the hills and lakes all day, drawing and painting. He took up yoga and eventually drew himself out of his deep depression; he said later that he'd had a nervous breakdown. Audrey told me she didn't believe he had; she thought he was just malingering to avoid doing any work. Rather the hypochondriac, he was obsessed with himself and his health and was convinced he had something wrong with his eyes. This immediately resonated in my head with a Post Office official receipt from that period that I had found among his things, on which he had written:

I find that I am seeing colour with such intensity that it is
making it difficult for me to adjust my colour sense. It is a
wonderful experience and were I not an artist it would give me
untold pleasure. But I can never walk the countryside relaxed.
I am forever searching and my mind races along like a
turbulent mountain stream. Perhaps like the stream, I shall
find peace when the water runs more placid.

After much thought and anguish, Percy resigned from the
Post Office and he and Audrey took over a sub-post office in
Great Broughton, a small village near Cockermouth. Audrey
did most of the work, of course, even though she also had
to look after their young son, Brian. Percy wandered off
each day drawing and painting. He met the poet Norman
Nicholson at an exhibition of etchings at The Settlement
in Maryport and they immediately struck up a friendship.
Norman took him to meet a woman called Helen Sutherland,
a P&O heiress who lived in a beautiful house above
Ullswater. She was dedicated to supporting and educating
working-class artists, and Percy was perfect material. It was
in her house that he saw, for the first time, the work of
Ben Nicholson, Barbara Hepworth, John Piper, Winifred
Nicholson, David Jones the calligrapher, Eric Gill and many
more artists of that period. It was a revelation to him, and
worlds he had never imagined opened up in his imagination.
He decided to go to art college, and to facilitate this he and
Audrey gave up the sub-post office, sold up and moved to the
small village of Allonby on the West Cumbrian coast. Percy

couldn't get a grant for college because he was considered too old at forty so he got several jobs working night shifts at Dovenby Hall, a psychiatric hospital nearby where Audrey already had a job as a clerical officer. For the next ten years she was the main breadwinner, because when Percy finished his four-year National Diploma in Design in 1966 he became a full-time artist.

Audrey was becoming quite agitated telling me all this. I couldn't yet see the how the oil paintings came in, but encouraged her to continue because it was an interesting story anyway.

She then began to re-live a particular day. It was winter 1970 and she returned from a busy day at the hospital hoping that Percy would be back and had at least lit the fire, although she wasn't particularly optimistic as he tended to forget time existed when he was drawing. He had been keeping very irregular hours recently and coming back very late. Audrey knew he couldn't be out drawing and painting in the winter dark, and she suspected him of using art as a cover for all sorts of other activities, even fearing he was having an affair with someone he had met at college.

It was dark as she let herself in through the front door. 'I could see the fire was lit through the door into the parlour,' she recalled. 'So I was really glad. I pushed the door open and went into the room and was startled to see a stranger sitting by the fire alone. It was a woman I didn't recognise and she had her back towards me. I then saw she was wearing my Jaeger

grey knitted dress and I felt really scared. I took a few steps back into the doorway because I felt frightened. I was going to run and get a neighbour. I thought she might be a ghost. I couldn't imagine how she had got into the house. I plucked up courage to speak and said, "Hello, who are you? What are you doing in my house?"

'The woman turned. She had something in her hand. It was a wand of mascara. The woman's face was heavily made up and she smiled a sickly smile and spoke in a silly high voice. "Can you help me with this?" she said to me. "I don't know how to put it on." She stood up, holding out the mascara towards me, and I noticed to my horror that she was wearing an old pair of my high-heeled shoes and had cut the backs out to make them fit.

'It was at that moment that I realised with shivering incredulity that this woman was my husband Percy. I thought I was going to throw up. My head was pounding and there was a ringing in my ears. I just wanted this person out. Out of the house and out of my life. I ran to the door and opened it to the cold night air. I stood to one side holding it wide open.

'"Get out!" I screamed. "Get out. Get out. Get out!"

'He went. I don't know where he went. I didn't care. I shouted after him, "Get your things tomorrow while I'm at work. I never want to see you again. You are disgusting!"

'The following morning I rang the village locksmith from work and asked him to come and change the locks. Percy had been back and had filled up a car load of his possessions. He

had an MG so there wasn't much boot space at all. There was a lot left but it was too bad. I never saw him again. I couldn't bear to look at him.'

When she finished her story we just sat in silence for a while, both absorbed in our own thoughts. Despite today's more liberal attitudes, helped by Grayson Perry, Turner Prize winner, potter and happily married transvestite, I think I would have felt the same if I had been confronted so suddenly in that way.

I knew the rest. It is history. Percy wasn't satisfied when his own doctor told him that there wasn't anything wrong with his eyes. He went to see an ophthalmic surgeon privately. He was given a choice between a consultant in Carlisle and one in West Cumbria, Audrey told me. He chose the nearer and it was to change the course of their lives. He wrote in his diary later:

> I went to see the consultant privately at his home. He told me there was nothing wrong with my eyes as well but I fell in love with his wife and we ran away together.

I asked Audrey how she had felt about this.

'I could have stopped it,' she said. 'I only had to say one word.'

'Then why didn't you?'

'I thought I'd let her find out,' she replied bitterly. 'I thought I'd let her find out.

*

It was five exhibitions and almost a decade after I first fell in love with Percy's work that I took a call from Joan's son Robert, inviting me to come down to his home in Kendal because he was going to open Joan's wooden sea chest. Joan died in 2000, just after her eightieth birthday. I miss her a great deal. I miss her loyal support and I miss her sensible judgement and advice. We shared a lot over the years since we first met in the gallery.

The chest contained at least a thousand letters from Percy to Joan, from 1983 until his death in 1993 – most of them illustrated and some of them up to thirty pages long. He had spent his last lonely years pouring out in words and pictures the story of his life to her: his struggles with appalling poverty and confused sexuality, the breakdown of his marriages and his inability to sustain relationships, his bleak depressions and his personality disorder. Joan had shown me a few of his letters but I had no idea that there were so many. It was overwhelming. Her son and daughter were wondering what they should do with them and entrusted them to me for an opinion.

I returned home from Kendal with a car boot full of letters. It took me three solid months to read them all through. I took batches of them with me on long train journeys. Percy came with me everywhere. He was taking me over body and soul. That was when I suggested a book, *The Painted Letters*, and an accompanying exhibition, to tell the story of Joan's wonderful support of Percy. Joan and I had discussed this possibility often. From the beautiful 'finished' letters she showed me, it

was obvious that Percy hoped that they would be published one day. In a letter sent to her at the beginning of their friendship he wrote:

> Don't you think it is rather sweet that in our declining years we can find joy in a letter box garlanded with ivy leaves? I will tell you a secret. I intend to do two good paintings of this delectable post box. I will send one to you and thus immortalise 'our' box. I can see in the year dot this area will be thronged with inquisitive tourists making a kind of pilgrimage. It is written dear friend.

I had reservations about publishing letters that were so personal. But this and other statements that I found when reading them gave me carte blanche to produce the book as a tribute both to Percy and to Joan and her tenacity. She had confessed to me that she had almost given up on him several times in those ten years. He was very demanding, self-centred and erratic. Obsessed with his health, he wrote in detail and at length about his problems. She told me many times that if he had lived any nearer she would not have been able to continue writing and supporting him. She sometimes found it hard to find things to write to him about and he rarely commented on anything she had told him about herself or her friends and family. She mentioned one day in a letter to him that her neighbour, Sami, had been diagnosed as terminally ill; she hoped that someone else's suffering would catch his attention and maybe distract him from his own. It did – he

responded immediately, sending Sami lovely drawings and little handmade booklets. She was delighted at first, but when these things kept on coming, begging an instant response, she couldn't cope and asked Joan to call him off. He immediately stopped writing but was obviously offended and never asked Joan about her neighbour's welfare again.

After the *Painted Letters* book and exhibition I once again thought this was the end of the work and the end of the story. But no. Shortly afterwards I met PK's stepson, Andrew. He now lives and works in the US and he came to the gallery with a collection of paintings and prints which had been given to him and his two sisters by their mother Chris, the second Mrs Kelly. During the period they were married, from 1971 to 1981, PK's transvestism became more overt. He began to publicly wear women's clothing in St David's, Pembrokeshire, where they then lived, which must have affected their social life and must have been a difficult and confusing situation for his young stepchildren in the local schools.

Chris couldn't bear even to look at these paintings. She felt guilty about dragging her children off to live with Percy and had decided to give them the paintings to keep or sell as they wished. Chris's decision to leave her comfortable life for Percy is hard to understand, but he was a charismatic and good-looking man with an amazing talent, and she fell in love with his work rather than with the artist himself. She thought they could set up a little gallery in St Davids and sell his paintings, but it never happened. In the ten years they were married she, like Audrey before her, was the breadwinner. She also helped with

all the building projects. It was the poverty, PK's hypochondria and the constant breaking down of his self-maintained old cars that led to their divorce, rather than the transvestism.

They now all wanted the work to be sold. I had already arranged an exhibition of works by L.S. Lowry which wouldn't fill the whole gallery, so I was able to hang a room with their collection. In fact it worked very well. The works of the two men sat together very easily and it made a marvellous sell-out show.

There were some of PK's sketchbooks among the step-children's collection which filled in lots of gaps in his artistic story and gave me titles and clues to some of his paintings. Recently his elder stepdaughter Kim, who lives in Australia, emailed some images of letters she had received from PK in the 1970s. As the eldest child, she was deeply disturbed when her parents split up. She was sent off to boarding school when she was twelve, and Percy wrote to her regularly. These are amongst the most wonderful and charming of his letters, both visually and verbally, perhaps because they were sent to a child.

Dearest Kim

T'anks for your most informative letter from St. Trinians.

It is very cold here . . . the sun shines but without warmth . . . it is very uncomfortable, even the deer are demanding food . . . funny to see them sat round the table whilst dear, kind Chris serves them with endless rounds of toast . . . and eating my flapjack . . . Crumbs . . . wot a life,

poor Andy & Nikky do not get a look in . . . in fact all they get is a look in . . . we grow thinner and thinner!!! If you can spare the odd loaf . . . do send a food parcel . . .

I have started on the large townscape the bridge, little houses, the river, a church and well patterned fells. We all send our love 'tis a sad thing that you should be so far away . . . do read this with a background of soul searing strings* . . . still we all have a cross to bear and the days will slowly go by ere you return once more to bring tales of long ago.

Your fond and rather crazy stepfather – BOB

With love from everyone xxxxxxxxx

*violins

PK had the uncanny ability to enter the mind of a child. Kim describes him as like Willy Wonka in *Charlie and the Chocolate Factory* – full of fun and ideas but showing his dark side sometimes, a man of extremes. The letters he sent to her are also very tender and caring and tell us a lot about their life in Wales, their happy times and their struggles to generate an income and build an extension to accommodate them all in their tiny house, which lacked most modern amenities.

So Percy Kelly has supplied us with a record of his life in word and art form. It is a sort of diary. His handwriting is beautiful and his command of language is impressive, particularly considering he left school at fourteen.

I am no longer surprised by anything new in relation to Percy Kelly. I have no doubt there are still more secrets to be uncovered. My role is that of detective, curator, guardian, protector and recorder of the genius that was Percy Kelly – the artist I never met.

Cumberland Fell

I went to Aspatria the other day. A small town just a few miles away from the gallery, Aspatria is also the birthplace of painter Sheila Fell. I was on a mission to find out more about this enigmatic artist whose work I admire and who died so tragically young.

I began at Brayton Road at the north end of the town, the setting for many of her potato-picking paintings. These were thickly textured oils, with indistinguishable figures bending and blending into the rich earth. Carts and tractors emerge from the mud against a backdrop of distant mountains. Her aim was to create not romantic landscapes but depictions of the reality of life in this working community, telling of poverty and the hard life of miners and farm workers balanced against the hard beauty of the solid dark fells.

Today the view towards the mountains is interrupted with a forest of stately white wind turbines, and the potato-pickers'

field has been obliterated by a new housing estate. Building is still in progress, marked by a massive bright white sign at the entrance. 'SHEILA FELL CLOSE DEVELOPMENT' it announces, ironically.

It was a bitterly cold, grey day. The town is set high on Beacon Hill, exposed to the biting wind. Trapped between the industrial coast and the beauty of the Lake District National Park, Aspatria is not a pretty town in itself, more like an industrial suburb with streets of back-to-back houses relieved by pigeon lofts and allotments. But it commands panoramic views over fields and mountains to a better life beyond.

The house where Sheila was born is on the main drag, just round the corner from Brayton Road, in Queen Street. Number 69 is part of a small terrace with neat front gardens, sitting by the railway tunnel, which crosses the busy main road under a diagonal bridge. This is the main coastal road to Carlisle and the heavy traffic thunders continuously through. There is nothing to stop for. At the end of the terrace, I expected to see the Primitive Methodist chapel Sheila often painted, but it has been demolished and replaced by a modern, detached house. The wooden shacks at the back of the terrace where her father kept his pigeons are still there, though. Glancing up at the window of number 69, I imagined Sheila gazing out of it at the countryside beyond. Many years later, she wrote in the magazine *Breakthrough*:

I slept in the back bedroom where the family bible was kept, full of pressed wild flowers, and my father's black box of ebony hair

brushes. The front bedroom was my parents' room and above these ran the attic, with a skylight and pale washed walls. In the evenings it would be full of sunlight and the smell of fruit, as it was here my mother kept Christmas apples and the yearly hoard of pickles, chutney and jam.

Sheila was born in that front bedroom, on 20 July 1931. To commemorate this event, a little further up the street, on the wall of the Methodist chapel, is a plaque erected by the town council. It reads:

1931 IN MEMORY OF 1979
SHEILA FELL RA, FRSA,
WHO WAS BORN AT 69 QUEEN STREET,
ASPATRIA ON 20TH JULY 1931,
AND DIED IN LONDON ON 15TH DECEMBER 1979.

~

SHEILA FELL WAS ONE OF THE FINEST BRITISH LANDSCAPE
PAINTERS OF THE 20TH CENTURY. SHE LOVED CUMBERLAND
WHICH WAS THE SOURCE OF HER INSPIRATION.
SCENES OF ASPATRIA AND ITS PEOPLE ARE PORTRAYED IN
MANY OF HER WORKS.

Oh, Aspatria is proud to claim her as one of its own.

Beyond the austere Methodist chapel is the imposing red sandstone Victorian Gothic church of St Kentigern, where Sheila was christened by her proud parents. The churchyard is massive and well kept, and there are fresh flowers on many of

the graves; even those of people who died decades ago. Family is everything here. But I was unable to find a Fell grave. I suspect Sheila was cremated or buried in London, but surely her parents (and perhaps grandparents) would be buried here – they had lived here all their married lives. Maybe their graves are unmarked.

After an hour I gave up looking and started walking round the town. Opposite the church is The Lindens, where the doctors Dalzell lived and worked. They let Sheila use their attic studio when she was visiting her parents – space was short at 69 Queen Street, and they were enthusiastic patrons, building up an impressive collection of her work. Their semi-detached stone house, set back from the main road, would at one time, like so many of the other properties around, have been an imposing building. Now it is dilapidated. The flat-roofed dispensary, clumsily built on at the front, is closed and derelict, the word PHARMACY still faintly distinguishable through faded peeling paint. The large detached Georgian house further down the road with a magnificent classical portico and pilasters is now boarded up and unsafe – the Ozymandias of Aspatria.

The massive car park in the centre of town was empty; 'Parking free' stated the optimistic notice. But as I continued up the road I was greeted by everyone I met. Inside the Co-op, the Spar shop, the grocers – their windows all obliterated with posters offering cheap alcohol – I found smiling open faces. Despite being blighted by its industrial past, this is a place of friendliness and warmth.

*

Sheila Fell's life reads like a fairy story. The tragedy is, it didn't end 'happily ever after'. It begins like this. Once upon a time there was a husband and wife called John and Ann Fell. They were good people: honest, hard-working and very poor. They lived in a tiny rented terrace house in a small town in Cumbria. Looking back on her childhood, Sheila wrote:

> When I was a child, the industrial collieries around Aspatria, with their chimneys, winding houses and slag heaps all huddled together, were still functioning. The inhabitants of the little rows of dwellings worked either in the mines or on the land. The life of the village was punctuated, day after day, by the ritual going to or coming from work. I can remember watching the miners strung out along the road or crouching on Walter Willson's corner with bait boxes, shivering against the morning cold. Farm carts ricketing past the house, full of hay or turnips, and cows threading their way from milking sheds to grazing fields. And then, in the soft black evenings, when one by one the lights would glow from the windows of the houses, the next lot of men would turn out for the night shift, everything silent except for the moaning of the wind blowing off the sea across to the mountains and the stirring of cattle in the barns.

There were five working pits in Aspatria after the Great War. John Fell had worked in Number 5 pit for six years, ever since he had left school at fourteen. He joined the Border Regiment when war broke out in 1914, serving in France, where he suffered badly from chlorine gas poisoning. Though

his health was poor, he knew no other way of earning a living, so had to return to the pit despite the silicosis which made his lungs audibly crackle like brown paper. His wife Ann was a seamstress. Between them they just about managed to get by and survive.

In 1931 they had a baby daughter and they christened her Sheila Mary. Despite their poverty she was a happy child. Her parents sometimes regarded her fondly, as parents do, trying to imagine how she would grow up and what she might become. She was a bright, imaginative little girl who loved fairy stories and spent a lot of time colouring them in her story books. She was going to surprise them. She was going to turn their mundane lives upside down.

John Fell was dogged by pit closures. The industry was contracting and the pits nearby were becoming uneconomic. Each time a pit closed, he had to find another. When Sheila was five he was made redundant yet again and had to travel much further afield to find work. In desperation he took a job in the pit at Whitehaven, twenty miles away, and had to stay in lodgings during the week, only returning to Ann and Sheila at the weekends.

But, to their delight, in the way of most good fairy stories, their ugly duckling began to develop into the most beautiful, intelligent and talented young woman. At eleven she went off to grammar school, the Thomlinson School for Girls in Wigton, where she excelled in all the arts subjects. Having passed her School Certificate, she had to make serious decisions about her future. It was not straightforward. The good

fairies gathered around her, each vying for attention. Her dancing teacher wanted her to make a career in ballet. Her headmistress, noticing her aptitude for languages, advised her to go on to university and read English, while her music teacher impressed upon her bewildered parents that she had a brilliant career in music ahead of her if she wished to pursue it. But her parents certainly didn't put any pressure on her, even if the teachers did. They were just proud to have such a beautiful and sweet-natured daughter. They were also very worried about money. John's health was deteriorating.

It was Sheila's art teacher, Catherine Campbell Taylor, who won the battle, pointing Sheila in the direction of Carlisle College of Art. She encouraged Sheila all the way and was to become a lifelong friend, one of the most trusted people in Sheila's life.

So, at the age of sixteen, Sheila Fell arrived at Carlisle College of Art. In *Breakthrough*, she recalled:

> My first day at Art School was spent in a cold depressing room surrounded by stuffed birds in glass cases and black print-ing presses, copying a basic design carefully from a book. The other students seemed so sophisticated and terrifying. I didn't dare to speak to anybody.

She was eager to begin a painting course, but the college thought differently. In those unenlightened postwar days, they tended to steer the female students in the direction of fabrics, which were considered more useful for a woman who would

inevitably marry and have a family. The City of Carlisle had a strong textile tradition and Sheila was sent to Morton Sundour, one of several large textile mills in the city, to learn about textile design and printing. She hated it. She wanted to paint and, after two years, aged eighteen, having passed her Intermediate, she applied to St Martins College of Art in London, and was accepted. This was the beginning of a life dedicated to landscape painting – the landscape of her childhood.

Sheila arrived in London nervous and shy, with a grant of £100 a year. She took a room in Glenloch Road, Hampstead. Later, looking back, she wrote:

So I settled in London, bitterly homesick for years; drawing, reading, living on nothing but little food and grandiose ideas, taking various jobs, longing for holidays as all students have ever done and will always do. Food parcels arrived regularly from my mother containing meat pasties, gingerbread and hard-boiled eggs. My room cost 30 shillings a week which only left 10 shillings for food, soap, stamps and materials. The teacher at the art school, sick of seeing me wearily drawing week in week out, borrowed paints and brushes one day from the other students in order to help which made me terribly ashamed and slightly like a charity. Things were difficult at home. I was sent every penny which could be spared but even with this effort it was difficult to keep the wolf at bay. The year I took my diploma at the age of 20 had been a tense one for my parents as my father was taken seriously ill and had been ordered six months complete rest. They didn't let me know about this until much later.

In the 1950s, the avant-garde London art world was moving into abstraction and expressionism with the Euston Road Group, the Kitchen Sink movement of brutal realism and the emergence of the Angry Young Men. Sheila was homesick and found comfort and challenge in painting her native Cumberland landscape. The picturesque style common to Lakes painters was not for her; she wanted to create not pretty romantic interpretations but dark, solid, brooding places reflecting the grimness of life in her part of the country. She painted the earth and the people as part of the land, subsumed into the thick soil. The distant mountains were solid with a thick richness of paint, with a foreground of figures, hayricks and carts, working people getting on with their ordinary lives. The skies were heavy, moving and dark, turbulent as the sea. Her teachers at college were Vivian Pitchforth and John Napper and fellow students and friends were Frank Auerbach, David Kossoff, Euan Uglow, Craigie Aitchison – men who were pushing back the boundaries of modern art. But her mentors were of a different era. In an interview in *Painter and Sculptor* in summer 1961, she explained, 'One has one's family of artists around one. The people whose work one loves. It's like sitting in the kitchen at home only instead of relatives one has the paintings of Cezanne, Daumier, Van Gogh and Permeke.'

Back home things were getting harder. Her father's legs had been crushed in a pit fall and he was now too ill to work. Her parents faced a struggle for survival.

Sheila, however, would never live in Aspatria again. A

travelling scholarship in 1954 took her around Europe where she tried to paint, finding Greece more to her liking than anywhere else. And as she became less shy and homesick, the suitors began to compete for her attention.

Sometimes, I can only imagine, extreme beauty that transcends good looks must be difficult to cope with. But it gave Sheila confidence. She took a job behind the bar of the French pub in Dean Street in the heart of Soho (regarded as a wicked place in those days) to eke out her grant. It was the watering hole for a bohemian, unconventional crowd. Arty, boozy and promiscuous, they included outrageously colourful characters such as George Melly and Francis Bacon. These were exciting times, and the life Sheila led was very different from the moral rectitude of West Cumbria and light years beyond the imagination of her parents. She went home frequently to gather material, and the contrast in lifestyle and attitudes between Aspatria and London was more marked with every visit.

Her great breakthrough came in 1955, a few years after she left St Martin's, when her work was noticed by another of the good fairies who turned up at just the right time. Helen Lessore was the owner of a well-respected commercial gallery, Beaux Arts in Bruton Place, Mayfair. She usually dealt with high-end, established artists but offered Sheila an exhibition the following year and furthermore, understanding her situation, paid her an advance for canvasses and paints to help her get enough work together. This was a wonderful opportunity and one that Sheila relished. She set to work with enthusiasm.

But the best was yet to come. One day during the exhibition a taxi drew up outside the gallery and L.S. Lowry got out. Enter the Fairy Godfather. He had been advised to come by a colleague who thought he would enjoy it. He arrived in bad humour; he had stepped out of the cab into a puddle and was not amused. It was not a good start. 'I wish I'd never come,' were his first grumpy words to Helen Lessore.

Once inside and smoothed down, he changed his tune. Impressed by what he saw, he bought two large canvasses and three small ones. Not only that, but he told Mrs Lessore he would like to meet the artist. They met at Tottenham Court Road Tube Station. He was worried they might not recognise each other – fat chance. He was sixty, extremely tall and becoming well known by then. His heart must have leaped when he caught sight of her, for she was exactly the prototype of the women he liked. Immediately enchanted, he took her to a Greek restaurant in Bloomsbury for lunch, where she ate an enormous amount for a woman with such a slight and delicate frame. His long gangling figure, dressed in a dirty, shabby mac, must have made a strange companion for the ravishingly beautiful, elfin-featured, diminutive young woman, with her huge brown eyes heavily emphasised with black kohl. But there began the friendship of a lifetime.

Lowry collected and befriended several young women in his lifetime. They became his companions – nothing more – and they were all of a type: petite, slender, with long, dark hair and large dark eyes. As far as we know, Lowry, a self-confessed virgin, never had a sexual relationship with a woman.

This was probably due to his upbringing and in particular his mother, who had been convinced she was expecting a girl and never recovered from the disappointment of bearing a son. His mother's opinion mattered more to Lowry than anything else in his life, even though she belittled him and regarded his painting with scorn.

However, he did enjoy the company of attractive young women. He painted many portraits over the years of a young woman called Anne, who may or may not have been an imagined figure. Lowry put out lots of conflicting stories about girls at college and a friend who died, but despite the best efforts of his biographers none was ever substantiated. Sheila Fell fitted the Anne description, which was a lucky break for her because he became a lifetime supporter. It was almost on the same level of being bought by Charles Saatchi today – on such patronage careers are built.

Lowry gave Sheila confidence and support in painting landscapes at a time when they weren't fashionable. He asked to meet her parents and in 1956 travelled up to Aspatria for the first of many visits. While there he offered financial help to Sheila: three pounds a week by banker's order. Sheila was then twenty-five, and it is a reflection of Lowry's old-fashioned ways that he asked her parents' permission to give her money. He really enjoyed himself with the Fells. Theirs was the sort of background in which he felt most comfortable, and Aspatria was his sort of place – friendly, with no airs and graces. He stayed with them many times, once arriving in carpet slippers in a taxi which he had hired all the way from Manchester. In

the simple, humble way of working-class people at the time they were very honoured that such a great and well-known artist had taken an interest in their daughter – they never questioned his integrity.

Lowry got on very well with John Fell – they shared the same jokes, often repeating them over and over again. His favourite was the one about the rugby match between Aspatria and Workington. The referee came from Aspatria and when asked to whom he would give the free kick he immediately replied, 'To us, of course!' This always sent Lowry into fits of laughter, no matter how many times he had heard John tell it before, to the extent that sometimes he had tears streaming down his face. The level of the friendship is shown in the rather prosaic letters he wrote to them.

<div style="text-align: center">

THE ELMS,

STALYBRIDGE ROAD,

MOTTRAM-IN-LONGDENDALE,

CHESHIRE.

</div>

6 January 1965

Dear Mr and Mrs Fell

Well, at long last, I sent that photo to you at the end of last week, and expect that you will have got it by this time. It is the best, and the one I liked the best.

I wasn't able to get to Sheila's show. I ought to have gone to London for a number of reasons, but simply couldn't make it. I am getting no younger alas.

You had a good Xmas and New Year I hope and expect, with Sheila at home, and I hope too that you are all well and free from colds and that Mr Fell is being a good boy.

I look forward to seeing you all again later on when the weather is more like.

Thank you for your card.

And remember me to Mr Askew – I look forward to seeing him again before long.

Best wishes to you both.

Yours,

L S Lowry

The Fells didn't own a car so Sheila had always painted scenes within walking distance of her home, but when Lowry arrived, he would hire a car and they would drive into the country. There Sheila would create a rich rural image while Lowry would produce one of his trademark grimy industrial scenes, or simply sit and watch her paint. It was Lowry who persuaded Sheila to paint the industrial harbour town of Maryport, which he knew from his friend Geoffrey Bennett. He loved its rundown dilapidation, its dark industrial buildings, and drew and painted it many times. Sheila's many paintings of Maryport Harbour and the beach at Allonby were a result of these trips. She had never been drawn to paint the sea before, though she had been painting the land as if it were the sea. Her snowscapes are particularly impressive – she had a real affinity with pure drifting snow.

Sheila was now enjoying real success and after another

successful show at Beaux Arts, she bought the house at 69 Queen Street for her parents. They no longer had the burden of rent.

It was Lowry who encouraged her that same year to apply to become (like him) a member of the Royal Academy. 'Now Miss Fell,' he advised her, solemnly. 'If ever you are asked to become an RA take my advice. They are very nice chaps and they make a very good cup of tea.'

Lowry, of course, was talking the Royal Academy down. Founded by King George III in 1768, it is an ancient and very exclusive club into which it is notoriously difficult to be accepted as a member. Sir Joshua Reynolds was its first President and still stands outside in the courtyard of Burlington House, in Piccadilly, immortalised in bronze, waving his paintbrush and palette in welcome. There are only ever eighty members at any one time, of whom fourteen must be sculptors, twelve architects, eight printmakers and the remaining forty-six are the painters. When an academician reaches the age of seventy-five he becomes a Senior RA, thus freeing up a space for a new, younger member to be elected. This is achieved through sponsorship by at least two existing academicians, submission of one's work to the committee and surviving two gruelling interviews before judgement day. But the ordeal is worth it, because once elected you are part of a world of artistic privilege. You have 'made it'. An Academician can command higher prices, show six works in the popular Summer Exhibition every year, is invited to dinners and parties, has the use of the Academicians' room

in Burlington House and is invited, in due course, to hang one of the rooms for the Summer Exhibition after which (for some inexplicable reason) he or she will go to Buckingham Palace for an audience with the Queen. It is a place of tradition and precedence.

Sheila became an Associate in 1969 and then a full Academician in 1974, a great achievement in those days when there were so few women Academicians. Frederick Gore, the President, who lobbied on her behalf, commented that Lowry and she were 'bound as painters by a desire to speak with simplicity'. After her death, Giles Auty, writing for the *Spectator*, made a similar comparison: 'Her vision is to the countryside of Cumberland as that of L.S. Lowry was to its industrial townscape.'

Lowry's friendship with Sheila was different from that with the other young girls he befriended, none of whom were so talented artistically. He liked an exclusive relationship with each of them, and if they showed any sign of 'infidelity' he usually dropped them. Despite his primary interest in Sheila as a painter, at times his possessive instincts still surfaced. After his death, Tilly Marshall, co-founder of the Stone Gallery in Newcastle and a long-time supporter of both Sheila and Lowry, wrote:

> He always said she [Fell] was the best living landscape painter but by that time he was upset with her because he had convinced himself that she was married. There was an incident when he called to see her in Redcliffe Square and he heard movement but

she didn't answer the door. He started complaining that she was drinking too much but he was delighted when her pictures sold so well. After his death Sheila said she had managed to keep the secret of her private life from him – particularly the existence of her daughter Anna – but he had known all along.

It is interesting that Lowry's perception was that if Sheila had a child, she must be married. This was the prevalent attitude at the time; the Swinging Sixties took a long time to percolate through to the northern provinces.

Lowry was a significant influence on Sheila's life and progress as a painter. Sheila wrote that, without his friendship, her life would have been infinitely poorer – he had kept her plodding on when times were bleak. He was a great source of encouragement as well as humour, but it was only at their last meeting that he turned to her and asked, 'Do you mind if I call you Sheila?'

Lowry died in 1976, aged eighty one, in the same month as Sheila's father. This must have hit her doubly hard. She adored her father. The portraits she did of her mother show a hard, stern, uncompromising woman, but those of her father with his pigeons have a totally different feeling, a warmth that is utterly lacking in the former.

Three years later, Sheila Fell died herself. The coroner's report of 22 January 1980 gave a verdict of accidental death. She was forty-eight, and she had been drinking heavily. Hunter Davies had interviewed her for *The Sunday Times* just a few days before. The article was running through the presses

on the night she died, Saturday 15 December 1979. It finished with these poignant words:

> I also intend to live till 104. I've promised myself I will. That's what keeps me going when I worry if I'll ever have time to do all the pictures in my head.

This young woman, who appeared to have everything – talent, success, beauty, friends – died so suddenly, and with so much still to offer. What cut the fairy story short?

As I strolled through Aspatria I thought about how familiar it would be to Sheila Fell and how different from her life in London. This is what the critic Giles Auty referred to as her 'land of childhood certainties' This was the landscape she always painted and to which she always returned. She felt secure here. But she couldn't live here. Her parents were Methodist and teetotallers and she was already becoming dependent on drink from her early days in London when she was so homesick. Marriage, probably the aim and the fate of most of the young women (and their mothers) in Aspatria at that time, does not seem to have entered the frame. She had many suitors but no Prince Charming and there was no fairy-tale church white wedding to close the story.

Sheila's life was the antithesis of that of her parents and the community in which they lived. Her heart and art were in Cumberland but her life was in London. The two were incompatible. As an interview with her in *The Sunday Times* of 3

July 1966 recorded, 'She now likes London because it's anonymous . . . but she can't paint London.' In the same interview, Sheila explained, 'I like Cumberland best when it rains, when it's cloudy and dark, which of course is 70 per cent of the time. You get the sort of light you get nowhere else.'

In 1957 she gave birth, in London, to a baby girl, Anna Rose. The father was a Greek sculptor, Takis Vassilakis. She didn't want to marry him. She didn't want to marry anyone. Her narrative series of paintings made at this time entitled *Wedding in Aspatria* demonstrate quite clearly her attitude to marriage. They are dark and foreboding. The small bride and groom are placed awkwardly at the bottom among the gravestones while the church and pit heads dominate under a turbulent sky. This is chilling stuff. For Sheila, the compulsion to paint came before everything else. It was the most important thing in her life.

After her death, a memorial service was held at St James's, Piccadilly. Her daughter Anna, who was by now a professional musician in her early twenties, arranged the music. The Reverend William Baddeley conducted the service and Sir Hugh Casson, President of the Academy, read the lesson; Sir Lawrence Gowing gave the address. The list of mourners reads like an extract from *Who's Who*. It includes Nicholas Mosely, James Fitton, the Asquiths, and Royal Academicians Sandra Blow, Craigie Aitchison, Frederick Gore, Donald Hamilton Fraser and many, many more. Afterwards the congregation milled about outside in the churchyard. There was a noticeable preponderance of very

tall, handsome men: Lords, Viscounts, Right Honourables, artists, architects, surgeons – the crème de la crème of eligible bachelordom. They were overheard commiserating with each other.

'But I asked her to marry me,' one lamented.

'Me too,' said another sadly.

'I asked her three times,' remembered a third. 'She turned me down every time.

In the spring of 2005, I fulfilled a long-term ambition and mounted a major exhibition of Sheila Fell's work. With over fifty paintings, it filled all three rooms of the gallery. It had taken several years to plan and set up. First I had to acquire enough paintings to sell to cover the expenses of the show, which were considerable. I then had to source and borrow a variety of works to put together a balanced, attractive and informative exhibition and catalogue. Owners were extremely generous, glad that Sheila was getting some recognition, that she was not forgotten. Since her great retrospective in 1990, which began in Lowry's Salford, went on to the Royal Academy and afterwards travelled the country, there had been no major show and nothing written about her of any significance.

People poured in to Castlegate House to see her – including Sheila's daughter Anna, who came to the opening. We sold almost everything, which meant I could heave a sigh of relief and enjoy the next six weeks without worrying about money. The people of Aspatria came in force, full of anecdotes and proud to be associated with her. I met the man who had driven

the taxi that Lowry hired to take him and Sheila about on painting expeditions; he was full of stories which he proudly related. I met next-door neighbours and lots of people who claimed to have been at school or college with her, to the point where I began to treat some of their claims with a certain amount of scepticism. Some of the claimants were men, whereas the school had been girls-only at that time. Had she lived, Sheila would have been seventy-four in 2005, but many of those claiming to be her contemporaries were nowhere near that age.

Every day of that exhibition brought new surprises. I couldn't wait some mornings to open the doors and let in this constant procession of interesting people.

I was working in my office upstairs one day when my assistant, Angie, came up to tell me that Sheila's teacher was in the gallery, and she thought I might like to come down and talk to her. I looked at the CCTV screen and saw an elegant woman in her sixties. I was cautious.

'Did she say what she taught?' I asked.

'Art,' Angie replied.

'At Thomlinson Grammar School, Wigton?'

'Yes.'

'She isn't old enough,' I snapped, irritated. 'She'd be in her eighties now.'

'She's ever so nice and she's come a long way,' pleaded Angie.

I went down expecting disappointment, introduced myself and asked her name.

'Catherine Campbell Taylor. That was my married name when I taught Sheila.'

My mouth fell open. 'But you're not old enough,' I protested.

'I'm eighty,' she said with a huge smile. 'My appointment at Thomlinson School was my first teaching post when I finished at college.'

I had found one of the good fairies – in fact the goodest fairy of them all. I could hardly believe it. This petite woman was really beautiful, with delicate bone structure and short, fashionably cut silver grey hair. Her dress was classic and immaculate, and her skin and deportment that of a much younger person.

Of course she loved my mistake and confusion – show me a woman who wouldn't! After two hours' solid chat in the kitchen, I had gleaned a wealth of missing knowledge. Not only had Catherine taught Sheila, they had kept in touch throughout Sheila's life, and Catherine had been a frequent visitor to Redcliffe Square. A few months later she returned for lunch and brought Sheila's letters, which we pored over together excitedly.

A huge oil painting dominates the kitchen in which Catherine and I sat chatting that day. The title is simply *Cumberland* and Sheila Fell painted it in the 1960s. At eight by five feet, it is believed to be the largest canvas she ever worked on. Painted in rich oranges, yellows and browns, it depicts a haymaking scene against a backdrop of the Cumberland fells, with people

working in the fields, old-fashioned orange hayricks and an unusual cluster of houses. The simple title – just one word – epitomises the feel and character of this wondrous landscape. Visitors often ask me where it is, but I don't know, and I don't think it matters one bit. It could be Under Skiddaw, it could be the village of Lorton, but it's not important. It is the quality of the work and the feelings that it evokes that matter. When Sheila went on regular visits to see her parents, she gathered material in her sketchbook and in small paintings which she worked up on large canvases in her London studio. This meant that she 'edited' the landscape as she went along, her main aim being to make a good composition. Her paintings are rarely a true record of a particular place but an amalgam of several features; giving the emphasis to the things she deemed important.

She was filmed painting *Cumberland* in her London studio. It was the first film a young BBC trainee called Melvyn Bragg ever produced. Fresh out of Oxford in 1963, he was given the assignment for a programme called *Monitor* and chose to juxtapose the artist Norman Cornish, a Durham miner, with Sheila Fell, a miner's daughter. Every time I see that clip of Sheila painting *my* picture and talking about it to camera, I get a real thrill. It was also the painting that she took for her first interview at the Royal Academy in 1969. When she asked his advice on which painting she should take for her appearance before the Selection Committee, Lowry's mischievous side came out. He loved to be awkward and embarrass people.

'That one,' he said, indicating this huge canvas leaning

against the wall of the studio. Her studio was in Redcliffe Square in Kensington, so it is hard to imagine how she took it to the Academy in Piccadilly. It was far too big to fit into a taxi, I like to imagine she enlisted the help of the great army of male admirers who would walk on glass for her if it earned them favours. I can just picture my painting being carried through Knightsbridge and along Piccadilly by several tall good-looking fellows, accompanied by a ravishingly beautiful elfin-featured young woman.

Once she was accepted, Lowry allegedly bought the painting from her, but he didn't have room for it in his cluttered house in Mottram in Longdendale, which was full of the Pre-Raphaelites, sundry other paintings and clocks. So he lent it to his friend, the Reverend Geoffrey Bennett, who lived in a large imposing house in Chatsworth Square in Carlisle.

One day, when Lowry was visiting, they were sitting in the dining room where the painting hung above the fireplace when Lowry suddenly asked, 'Mr Bennett, what do you think of that cow there? Do you think it has only three legs?' He was indicating an animal to the bottom right of the canvas.

Bennett, an enthusiastic amateur painter, studied it carefully. 'Well yes, I think you are right, Mr Lowry,' he agreed.

'Oh dear!' said Lowry. 'Poor girl – it takes her three weeks to paint the leg on a cow. Let's do it for her.' (This was somewhat rich, given that Lowry was himself quite negligent when it came to the painting of quadrupeds. He once did a drawing of a dog and a cat on the back of a cigarette packet, dated 3 May 1962, in which the dog has *five* legs.)

Lowry painted another leg on the cow, but then he got carried away and much too enthusiastically added another cow and some more men, encouraging Bennett to join in. They stood back to admire their work, which was more than Sheila did when she later saw what they had done. She immediately got some turps and a soft cloth and scrubbed out the additions, removing the cow's other legs in the process and making rather a mess.

When Lowry died in 1976 he left this painting to Bennett. When Sheila's mother heard about this she went to see Bennett and told him that Lowry had never paid for the painting, so it must legally belong to her. Mrs Fell was an assertive woman and stuck up for her rights, particularly if she thought she had the moral high ground. She had also recently lost her husband. Still, I find it hard to understand why she contested the ownership. She had always got on well with Lowry, and the painting wouldn't even have gone through the door of 69 Queen Street. Maybe she felt that he should have remembered her or Sheila in his will after all the hospitality he had enjoyed.

Appalled, Bennett went to see the executors of the estate, who established that he was indeed the lawful owner. Mrs Fell had no proof that the painting had not been paid for and Bennett had no proof that it had. It was pointed out to her that trying to establish her ownership would be difficult and cost her a lot of money, so she reluctantly gave up. By this time Bennett was so upset by the whole affair that he just wanted to burn the cause of all the anguish, still fearing he was in the

wrong. Fortunately, his solicitor persuaded him against this course of action, and when Bennett himself died he left it to him in gratitude. The solicitor hung it in his office in Carlisle for eight years and then in Abbot Hall Art Gallery in Kendal for five years until his retirement. Then its size once again counted against it – it was too big to fit into his extensive collection at home – and he put it into a general auction in Carlisle.

I was away abroad at the time, unaware the painting had come up for sale. When I heard about it, I was disappointed to have missed it until I heard that it hadn't reached the reserve so it had been withdrawn from sale. I immediately rang the auctioneers to find out which Fell it was and asked for an image. As soon as I saw the photograph in the catalogue I recognised it, and what's more I knew who the owner was. I shot up to Carlisle to find it abandoned in the dark corner of the of the auctioneers' dingy storeroom. It looked very unappealing. It was no surprise no one had bid highly enough.

After a few days of negotiation it was mine. I hung it on a big wall in the old kitchen at Castlegate House and it has given pleasure to hundreds of visitors, not least to me, for the past fifteen years.

When I left Aspatria that day the winter sun was shining brilliantly behind the lowering clouds. As I climbed the hill to the ridge, it created a dazzling golden edging – a classic Sheila Fell sky. The dark blue-brown clouds moved restlessly as I watched, with orange-bright borders dancing like tinsel

against a steel-grey sky. It was a perfect metaphor for the artist's troubled life.

'Cumberland has never been painted as I would like to see it, so I should love to do it,' Sheila Fell once wrote. 'Cumberland is not like the rest of England. It is like no other place.'

The Man who Was Irresistible to Women

Degree shows at the major art colleges are as unpredictable as the students themselves. Drawing no longer seems to underpin the syllabus; ideas are king these days, and conceptual art is the in thing. But it is important to stay in touch with what is going on in the colleges, so I get along to a few each year. In the sculpture department's impressive porticoed space in the large hall of Edinburgh College of Art, overlooked by classical marble figures in various poses, I was in despair, looking at plenty of ideas and very little substance. The walled garden at Castlegate House is ideal for showing sculpture, but I always have the greatest difficulty in finding the right sort of work for it. Most professional sculptors either work on a big scale and earn their living from public commissions or make smaller indoor gallery pieces. The current

fashion for what are referred to as 'installations' doesn't work at all in the gallery garden, where we depend on sales to private individuals. Contemporary work looks good, but finding a living equivalent of Henry Moore, Lynn Chadwick, Barbara Hepworth or Elisabeth Frink is well-nigh impossible. And our usual domestic client won't really want an exploding greenhouse or a garden shed that turns into a boat or an unmade bed (I've got plenty of those in the house already). These are fine in public galleries but not at Castlegate House or in a client's private garden.

I met up with two friends at the college show. They're both printmakers *par exellence*, and we went off to the pub afterwards, where I had a moan about the lack of inspiring, saleable outdoor work. Carol's eyes lit up.

'Why don't you go and see Hideo Furuta?' she suggested. 'He's a wonderful sculptor – makes balls. I'll give you a warning though. You'll fall in love with him.' She had a wicked twinkle in her eye. 'He is totally irresistible to women.'

'Hey, it's sculpture I want,' I retorted swiftly. 'Not love.'

'Ha!' she laughed. 'You'll have both. This man is amazing. He's Japanese and he works in granite. He makes perfect spheres, free hand. You tell me anybody you know who can carve a sphere in stone.'

She was getting carried away. I was catching her enthusiasm.

'He is lovely and charismatic and you will love him,' she continued. And he lives and works somewhere down your way as well.'

'What makes him irresistible though?' I couldn't help asking.

'You'll see,' she said cryptically. 'I've seen him at previews and he is a woman magnet. They're like iron filings in his presence – they just move towards him as if by invisible forces. They can't help themselves.'

'You've obviously been pulled into his thrall then,' I joked, glancing at her husband.

'Oh yes,' she agreed, grinning broadly. 'Believe me, he is great. He has something that appeals to women. He is totally irresistible.'

'I wish I could bottle it,' muttered her husband almost inaudibly.

What woman could resist that build-up? I was hooked. She sent me his contact details the next day (after some swift prompting).

'Hey, and he's a terrific chef as well,' she added as the post-script to her email. 'If he asks you to lunch, and he probably will, accept. You'd be in for a treat.'

She was right about his location; he lived in Galloway in the Scottish Borders.

'Up the motorway, turn left near Gretna Green and you're there – not too far to go to find perfection,' I thought smugly to myself.

Dumfries and Galloway are little-known counties, largely unexplored and unexploited, and it was with mounting antic-ipation that I drove deeper and deeper into this dramatic landscape. It was a beautiful, fresh summer morning. The road

hugs the Solway coast most of the time, revealing sudden vistas of inlets, harbours and fishing villages. The distances were deceptive; it was much further than it looked on the map because the road was so twisty, and I had to dodge the heavy goods vehicles making their way to Northern Ireland via the Stranraer ferries. I was glad I had made such an early start. But, if a good sculptor lay at the other end, even if he turned out to be the Pied Piper of the spheres, luring unsuspecting women to the remote stone quarries of Galloway, it would be worth it. It was sculpture that was the incentive, I was telling myself, though I must confess to being not a little intrigued by Carol's description.

Hideo Furuta had given me precise directions on the telephone and – as Carol had predicted – had invited me to lunch. I found the small turn-off easily enough. High on the hill above Newton Stewart was the dilapidated house sited in his workplace, Kirkmabreck Quarry. Not far to travel to work, then! I parked outside and took in the view. The whole of Wigtown Bay lay before and below me, and to the west was Stranraer, with Ireland beyond. Why had I never explored this part of the world before? It was superb.

The voice behind me was soft and warm in greeting. 'You must be Chris,' he said, and I whirled round to see a wild-looking Japanese man. He was small, lean and wiry with a shock of dishevelled greying hair and white beard. His clothes were grey and dusty, and he looked as though he lived in a quarry, which of course he did. He bowed formally and ushered me politely into his extremely humble

and sparsely furnished abode, where we sat and talked and talked.

He was enthralling company, and I drew him out with questions, eager to find out what had brought him across the world to this little-known corner of Scotland. He told me he had been born in Hiroshima in 1949 and studied philosophy and aesthetics at university. Remarkably, he then worked as a quarryman in Japan for a year and became totally dedicated to carving granite. He had come to Britain in 1985 via Chile, Spain and Berlin and moved to Scotland in 1989, taking up a residency at Edinburgh University. I discovered afterwards that he had been awarded a much-coveted Research Fellowship by the Henry Moore Foundation in Leeds, which was established in 1977 by Henry Moore himself to promote the arts and particularly sculpture. Hideo had been to Cumbria in 1991 – taking up a residence at Grizedale Forest, another coveted residency. Grizedale Arts operate under the aegis of the Arts Council providing residencies for sculptors and artists of promise and ideas, but he would not have volunteered this information without prompting.

He was a quiet, humble man. As he talked it became obvious that he was not only a sculptor but an intellectual, philosopher, musician and mathematician, with a deep spiritual base. His intellect was impressive but he never once made me feel inadequate, although he could have done so easily. He had the ability to make anybody feel comfortable and valued. When he disappeared briefly to make coffee, I glanced at the open notebook on the rough table in front of me. It was covered in

mathematical signs and equations and I couldn't understood one small bit of it.

After real bean coffee, we went and sat in the quarry – his home. His medium was granite – not the easiest of materials to carve, since it is so intractable that a chisel just bounces off it. His first task every morning was the sharpening of his tools, which he described as almost a religious ritual. The quarry belonged to the Tarmac Company but they had given him the sole use of it, and he spent most of his time there working a seam of exquisite white granite. He would spend whole days and nights obsessively chipping away at this hard unforgiving stone almost as a penance. It was a spiritual act.

I looked at the variety of spheres lying around me in awe. They were perfection in all sizes. Very few people can even draw a perfect circle on a piece of paper without a compass or template; creating a perfect three-dimensional sphere freehand using only hand tools is almost impossible. But he had made many of them, which he then put into complex installations which were mathematically based and very satisfyingly balanced. He seemed to have an intuitive understanding of the symmetry and meaning of geometry and much more, of life itself, though I am sure he would have denied that last statement. He also made other geometric shapes – cones, cubes, pyramids and cylinders – though the spheres were obviously his favourites.

I sat there on a large rough chunk of granite, under a solid blue sky, surrounded by perfect spheres which were dotted about randomly. I was at peace with the world. If only the rest

of the world was like this . . . if only real life was as simple as this . . . Hey. Was this the Pied Piper syndrome setting in? I was being mesmerised, enchanted.

We returned to the house, where he again disappeared into the small side room while I watched the view and changing sky as if in a dream. A set of drums lay behind me. He must be musical as well – maths and music often go together. A plate of freshly fried tempura vegetables soon appeared, accompanied by a delicious dipping sauce which had quite definitely not come out of a jar. He left me with it – a dangerous decision, since the whole plateful disappeared in melting moments, light as air. To follow this came a vegetable stir-fry like no other meal I had ever eaten. It was so elegant, with a perfect balance of spices, just the right amount of fresh chilli and unusual flavours that I liked but couldn't name. There were tastes that were totally beyond any of my previous experience.

We talked about Scotland. Although he was Japanese and had lived in many other places, he felt that he belonged here. He told me about his son, Suguru, who was at Fettes, the famous public school in Edinburgh. He seemed able to penetrate my very thoughts, for when he saw me wondering how he could afford the fees he pre-empted my impolite unspoken question by telling me that he sometimes paid in paintings, an arrangement about which Fettes seemed to be happy. This man was certainly a charmer. I'd never heard of a school accepting paintings in lieu of fees. Maybe it was hypnosis.

We talked about the drums and he offered to play them in the quarry. I could feel myself being sucked into his aura. It would be drums rather than pipes that would be my downfall.

And then I needed the bathroom.

It was upstairs. It was primitive. It was worse than primitive. There was no mirror, no toiletries, no shaving equipment (obviously), no hot water and no soap. There was no shower, no towels, just a grubby unused bath. This was minimalism taken to an extreme. It was frugalism. The spell was broken, and I suddenly saw myself as I really was. I felt uncomfortably vain, pampered and worldly. Why did I want a nice soft fluffy towel? Why did I want to check my hair in a mirror? How frivolous was that? What a selfish life I led.

I pulled myself together to go back into the ascetic atmosphere downstairs. On the landing, I saw an open door and couldn't help glancing into the bedroom beyond it. The room was totally empty except for a rough narrow mattress on the floor, with a few rough grey blankets strewn on top and a hard-looking grey pillow peeped out of the corner. This was no love nest!

I went downstairs again and regarded Hideo objectively. I had a strong suspicion that he rarely, if ever, washed; he had clearly rejected the world of bodily comforts. I thought of my lovely centrally heated house, my soft bed with its white Egyptian linen sheets, feather pillows and crisp duvet. I thought of the large bathroom with its soft fluffy towels, its bidet, soaps, perfumes, unguents. I thought of the big bath and the power shower. I could never live like this. Standing there,

convinced my guilt was obvious, I felt as if he could read my mind. I decided to forego the drum recital in the quarry. The magic was over.

On the way back home I pondered on the question of what makes a man irresistible. I had found Hideo Furuta hugely impressive. His intelligence, his integrity, generosity, warmth and subtle humour drew me to him. His dedication to his work was all embracing. His asceticism was admirable but I could not help wondering if the women who found him irresistible had seen his bathroom. Then I immediately felt ridiculously materialistic.

I kept in touch with him through an occasional email and followed his progress on the internet and gallery grapevine. To my great sorrow he died of cancer aged fifty seven. But his installations live on.

He created *Juxtaposition*, which was installed in Saltwell Park in Gateshead and Regent's Park in London – eight granite spheres and four metal tables. At Ardrossan Harbour he installed a piece based on twenty granite spheres arranged like a chessboard, called *Position and Appearance*. And, not long before his untimely death, he redesigned Adamson Square in his neighbouring Creetown, where he was a well-known and well-loved figure. The people of Creetown had taken him to their hearts and regarded him and his son as honorary Scotsmen, which must have made him very happy.

That's the marvellous thing about art, and sculpture in particular. His granite pieces will live for ever as a testimony to

his short existence. He has made his indelible mark on the world.

I learnt a lot about myself from that meeting. 'Know thyself' is inscribed on the temple of Apollo in Delphi. I was glad to have known Hideo Furuta.

Twiggy

She subsided heavily onto a convenient chair in the large cool entrance hall, produced a handkerchief from somewhere amidst her voluminous layers of clothing and dabbed it ineffectively around her pulsating neck and forehead. With every breath, her flesh rippled visibly in those areas exposed – small fat arms protruding from the folds of her sleeveless flowered dress, the blotchy, dimpled flesh of her chest quivering, her swollen, shapeless legs hanging over her sandals. She would be a gift of a model for Lucien Freud. As her pulse rate subsided, she grabbed a leaflet from the adjoining table with her chubby fingers and fanned herself feebly, adding to the displacement of air caused by her arrival. I smiled encouragingly but decided that conversation wouldn't be a good idea. I quietly carried on with my work at the computer.

A good five minutes later a tall lugubrious gentleman entered the gallery. He was cool and unflustered. He walked

indifferently past the flapping woman on the chair who was slowly returning to room temperature and disappeared into the Adam Room with an embarrassed cursory nod in my direction before I could even open my mouth in greeting. He made me feel uncomfortable. My usual 'meet and greet' routine was obviously going to fall on deaf ears today. I returned to my task at the desk.

The previous day we had hung a new exhibition showing the work of four Scottish painters. The opening was to be on Sunday – two days ahead – but it was now an established custom to have two viewing days when clients could come in and consider their possible purchases quietly and without any pressure, before the inevitable mêlée of the opening.

The tall laconic man finished looking round in record time; he had barely looked at anything properly and without a word or sign made for the garden door and settled himself on a bench outside in the sunshine. He had an air of passivity, of never expending any unnecessary energy. There was an expectation of things being done *for* him rather than *by* him. Boredom hung about him like a heavy grey overcoat, and he seemed not to notice the butterflies in the buddleia, the heady smell of roses or even the friendly brushing around his legs of Jimmy, the ginger gallery cat who was invariably a favourite with visitors. A thrush was nesting in the mist of blue wisteria, darting in and out with bits of moss and sticks picked up from the lawn, as indifferent to this silent still figure as he was to her.

The woman eventually rose to her feet and began her tour

of the exhibition. Unlike the man now dozing gently in the garden she studied each piece carefully, leaning heavily on her stick for a long time in front of some of them. Once or twice she came back to the chair in the hall and questioned me closely about several aspects of the work and the artists exhibiting. She was sharp and intelligent, with a deep knowledge of art, but she was giving nothing away.

Suddenly the man reappeared, a black menacing shadow in the doorway against the strong sunlight. Impatiently, he asked how much longer she would be.

'Just give me a little longer, Sweetie Pie,' she pleaded affectionately. I smiled to myself at the inappropriate name. He simply inclined his head and she made one more laboured circuit of the gallery before they left without a word, he striding indifferently ahead, she waddling behind in a vain attempt to keep up.

Saturday's viewing was busy. It was obvious that this exhibition was going to be a success. There was a buzz about the place from the moment the doors were opened, and not just a social buzz but a serious 'looking-with-intent-to-buy' buzz. There is a world of difference.

At coffee time and on cue, a newer friend of the gallery came in. Recently relocated from the Midlands, Michael had become a regular visitor from his new house in the high Pennines. He was known as Designer Man by everyone on the staff because of his sartorial elegance and fondness for wearing trendy black. Tall and distinguished with a wicked sense of humour, he had inveigled himself into the gallery kitchen by

sheer charm and, more to the point, the box of cream cakes that he invariably brought as an entrée to back of house. Everyone was putting on weight! These days whenever he appeared someone would put the kettle on and he would follow them into the kitchen with his beautifully wrapped box of goodies. He made us all laugh with his dry wit and wicked observation of people. On this occasion he was a little more serious, and as he left he told us he would be returning to buy at the opening the following day. He didn't say what that might be and we didn't press him.

This proved to be an even hotter day. The night had been close and sticky. I rose early to attend to the multitude of last-minute jobs and by midday, with temperatures reaching the eighties, I was aware that a queue was forming on the doorstep – a jolly one by the sound of chatter and laughter.

An hour before the opening, Michael, outside in the queue, plaintively requested a glass of water. I smiled to myself. Was this a ploy to get preferential treatment, a bid for attention or genuine thirst due to the heat? Taking the glass of iced water out I was surprised to see the first place in the queue reserved with a stick. Noticing my raised eyebrows, Michael indicated its owner, the large lady, in the car opposite beside her still unsmiling husband. 'It's all right,' he said conspiratorially, 'we've had a conversation and she's after something totally different from me. She told me she doesn't like Marie Scott's work.'

Promptly at two o'clock, I opened the door, clipboard at the ready. Our lady of the stick rolled in looking rather like a large

lampshade (floral) and imperiously gave out two numbers – one a Charles MacQueen and the other a Marie Scott. Those behind gave a collective intake of breath and Michael's face hardened as the truth sank in.

'Are you sure?' he asked her with icy politeness, tapping her gently on the shoulder. 'Haven't you got the numbers wrong? That's a Scott painting – not the one you told us all you wanted.'

The lady turned on him with a cherubic smile. 'I don't think so,' she replied, and that is how the beautiful Marie Scott's semi-abstract painting *The Wave*, the pick of the show, gained a red spot, much to Michael's chagrin.

'She's changed her mind or she lied to us,' he spluttered through gritted teeth when the woman had followed my assistant through to check that the red spot was on the right painting. He could barely speak with rage.

Oblivious to the effect she had caused, the lady airily gave us her details and swept out to join her husband who was sleeping soundly in the car, driver's door open and long legs protruding on to the gravel like a giant stick insect. At her approach, he lazily roused himself, folded himself back into the car and started the engine, totally unaware of the chaos and disappointment his wife had left in her wake.

At the end of the exhibition a few weeks later, when Michael came to claim his second-choice painting, he spotted his first choice, encased in bubble wrap in the stack awaiting collection. 'Still there is it?' he inquired, wryly. 'She can't want it so badly then.'

He rang the gallery the next day. His new Scott was in a slightly different frame from the other two he already owned. He wondered if it would be possible to get it changed to match the others. I rarely changed frames and I must have forgotten he lived in a remote town up in the Pennines or maybe I was just curious to find out how and why this elegant, urbane man had chosen to live there. Whatever the reason, I agreed not only to change it but deliver as well. Some magic was obviously abroad.

So it was a few weeks later that I drove to Alston, home of aficionados of alternative bohemian lifestyles. Untouched by modern life, it sports a vertiginous cobbled main street full of incense-filled candle emporia, wind chimes and wholefood vegetarian delis. Time is not an issue in Alston, which is why it is so often chosen by directors of period films.

Following Michael's precise directions, I drove up to his pristine new house on the hill at the edge of the town. When I stepped inside I was totally disarmed by the unexpected minimalism that confronted me. The house was immaculate – crisp white throughout and surprisingly full of the most exquisite classic modern furniture, sculpture and paintings. It was a Grand Design. I would not have been surprised to see Kevin McCloud dramatically stomping about outside delivering some doom-laden observation to camera. The original Charles Eames and Mies van der Rohe chairs and Le Corbusier lounger were all perfectly placed.

Michael watched laconically as I removed his painting from the old frame and produced my tools. Embarrassingly, the new

frame was the wrong size, and after several desperate attempts to make the painting fit I had to give up. Much later I discovered that he is a superb craftsman and has a fine toolbox with every conceivable tool in pristine condition.

After my clumsy framing attempts the thought of which still make me squirm, we sat down to dinner at a library-matched rosewood Arnie Jacobson table which was laid with the finest white porcelain and modern cutlery presumably kept in the matching sideboard. Everything was studied perfection down to the Tizio lamps and Eileen Gray tables. I glanced into the kitchen, not surprised to see the iconic Smeg fridge, Alessi kettle and Dualit toaster.

So began a friendship which grew into very much more. He would say I fell in love with his furniture and I would say I fell for Designer Man – the man in black – but that is another story.

The two paintings reserved for the large lady remained in the gallery uncollected. They sat there reproachfully in the ever-diminishing heap, and when they were the last remaining forlorn parcel, I reminded her of her purchase by telephone. She immediately sent a cheque, which, disconcertingly, bounced. Another call was made and she again made lots of fatuous excuses and sent another cheque. This time it cleared but still the paintings remained uncollected, concealed in bubble wrap, Michael eyeing them hungrily on his ever more frequent visits.

Christmas approached and I rang her again. This time she

asked me to keep them for her until spring, as she was having an extension library built for her husband and the house was full of dust, she said. It was heartbreaking to see that magnificent Scott lying abandoned, and I was often tempted to remove its wrapping and release it into the wild where everyone could enjoy it.

About nine months after the exhibition had closed a long-standing client telephoned. 'I believe you have two of Twiggy's paintings,' he said.

'I'm sorry,' I said puzzled. 'What are we talking about?'

'Twigs,' said the man, '– you know.'

'Hold on a minute,' I said totally mystified. I couldn't believe I was discussing twigs with a distinguished surgeon. 'What twigs are these? I'm not following you.'

'Oh you know,' he continued, 'she's bought paintings from you – the ENT specialist from Newcastle.'

It took a while to make the link. Twiggy was the affectionate nickname her friends had given the large lady. I later learned that she had come to England from Australia as a young doctor half a century before. She had been stick thin and had made her entrance into the surgeons' common room at Guys in a tiny mini-skirt – hence the nickname, which had stuck long past its use-by date. The surgeon was proposing to visit the following day with a view to purchasing her paintings.

'I'm sorry,' I said, 'but she's the purchaser. She's paid for them. I can't re-sell them without her permission. Have you discussed this with her? Has she changed her mind?'

There was a long, uncomfortable silence.

'But she's dead,' he replied. 'Hasn't anyone let you know?'

I was stunned. Then all the questions as to how, why, when and – most importantly – who the executors of her estate were shot through my mind.

The call to her husband was tricky and mercifully brief. I found that she had died unexpectedly in her sleep some months before and he made it clear that he didn't want the paintings, never had done. They could be sold on his behalf to his late wife's old colleague.

The surgeon called the following day. The bubble wrap had been removed and the paintings hung for him to see. They were both lovely paintings but the Scott was magnificent. It made my heart sing but I managed to conceal my feelings. I held my breath.

'I'd love to buy that one,' he said, indicating the McQueen.

'And the other?' I asked, fingers crossed behind my back.

'Oh, I don't really like that one,' he said. 'Would you mind if I left it?'

As soon as he had gone, the McQueen under his arm, I picked up the phone to Michael. He responded with a quietly spoken certainty that he always knew he would end up with that painting, adding a humorous warning that the penalty for crossing him is severe.

The painting now hangs in the house that he and I share. It sits in perfect minimalist harmony with Charles Eames, Arnie Jacobson, Le Corbusier and Mies van der Rohe, and is always referred to as 'the dead woman's painting'.

CHAPTER EIGHT

Angel's Tears

From: Castlegate House Gallery

Sent: 20 October 2007

To: Ruth Wadsworth

Subject: thanks

Hi Ruth. Got home safely – straight run through. Thank you for a good lunch – it was lovely to see the children and share Maia's birthday.

Whoops – I did a very bad thing on the way back. – I didn't mention it but I'd booked a telephone bid for a Winifred Nicholson painting in Christie's Modern British auction yesterday afternoon. We viewed it last week when we were in London. It's not in very good condition at all – a lot of flaking paint and, in usual Winnie tradition, on a bit of rough board – she really didn't care what she painted on – she didn't need to because she just painted for herself. I liked the painting but Michael thought we should leave it alone. We argued about it for a bit and he won (or thought he had!).

I kept thinking about it — it was expected to fetch £50k or thereabouts. In the end I booked a telephone bid so I could hear what was going on and what it fetched. We would have been upset if it went for a lot less — or that's what I thought. We already have 3 Winifred's and they are worth a lot of money if we find the right buyer. Of course the higher the value, the fewer the buyers who can afford that sort of money — as M is never tired of pointing out. I know what you're thinking — you could buy three houses in Byker with the proceeds from those paintings — funny world eh? No doubt the social worker in you is very indignant at that but we're in the art business and that's life. Some people sort out human misery in Benwell and others sit on gold chairs in Christie's bidding hundreds of thousands for things which would appear useless to the residents of Benwell.

Anyway — as I was driving back on the A69 from yours, my mobile went and the lot had come up so I pulled into a layby to listen to the fun — you can hear really well from the bank of telephones down the side of the auction room. You can hear the auctioneer and the excitement is passed on. You can only be part of it if you've booked a bid. It felt quite funny to be in a layby in Northumberland listening in to a London auction. The bidding started at £25k and reached £35k really quickly — these things move very fast so you have to have your wits about you — and then there was a pause. 'Would you like to bid?' the Sloane with the posh voice asked me. It was still well under the estimated price so I didn't stand a chance of getting it (I thought). I felt a bit of a fraud asking for a telephone bid and then not bidding; it is a wrong thing to do. So in that split second I decided not to appear to be a time-waster so of course I said yes and this was taken up by the auctioneer and

there was a long silence. He tried a bit of encouragement but there were no more bids and before I could breathe again the hammer was down to me. 'Congratulations,' said the Sloane and I said, 'Sh*t'. I'd expected it to go for much more – so I had a bargain then? Would M agree – I don't think so.

Of course I had to ring M and he was furious – especially as a mutual friend and dealer had called into the gallery that afternoon and asked if we were bidding on it. Winifred's paintings come up so rarely that it was a talking point. M had said we weren't and they had both agreed it was a good decision as it was in such poor condition.

So I am eating humble pie and am likely to be eating it for a long time yet – smoked salmon is off – I don't think I'll be allowed a paddle* for a bit as am in disgrace.

Hope you have a good holiday – give my love to the Isle of Wight

Chrisma

* A paddle is the thing with a number on it for you to wave at the auctioneer when successful! Of course you can't do that on the phone so you have a metaphorical paddle if you get my meaning.

From: Ruth Wadsworth

Sent: 26 October 2007

To: Castlegate House Gallery

Subject: madness

Mother – do you realise you deal in amounts the like of which we folk with loads of kids and a big mortgage only dream about? No wonder

M is telling you off – serves you right. Will you ever manage to sell it? What is it of? Keep me up to speed on it won't you? Gotta go pack.

R

From: Castlegate House Gallery

Sent: 11 November 2007

To: Ruth Wadsworth

Subject: welcome back

Welcome back to the real world. How was the Island?

Re: painting saga. The painting is called Angels' Tears (hope it is not going to be mine – I'm no angel as I am constantly reminded. Still in the dog house!) – it's a pot of white flowers on a windowsill. Picked it up from Christie's last week and brought it back on the train. I love it. I'd like to keep it but no chance! Philip our insurance broker was on the same train and casually asked its value as I stuffed it in the space between the seats. He nearly passed out when I told him and spent an uneasy journey watching it surreptitiously. I've now taken it to Ron, our lugubrious weird restorer in Dumfries. He'll sort it – he is a brilliant craftsman with infinite patience but he's a humourless gent. M and I have a bet on as to which of us will be the first to make him laugh. Don't think either of us will win somehow.

Chrisma

From: Castlegate House Gallery

Sent: 15 February 2008

To: Ruth Wadsworth

Subject: Angels' Tears

Have picked up the dreaded Angel's Tears from the restorer and it is stunning. (Didn't make him laugh though – no chance.) He has stabilised and cleaned it and it looks a million dollars (so it should as it wasn't cheap!). I suppose it is a lonely occupation and very demanding working painstakingly over a painting finding the right solvents and putting back flaky bits with tweezers. There's not much room for error – misjudge the medium or varnish the artist has used and you're in dead trouble. You could end up removing the paint as well as the dirt. Anyway it looks much better now – much livelier. I'll put it up on the website and see what happens and I reckon M will eat his words. There won't be a lot of profit in it. It will be a pyrrhic victory – but a victory none the less.

Chrisma

From: Richard Pereira, Utopia Enterprises Ltd

Sent: 28 April 2008

To: Castlegate House Gallery

Subject: Winifred Nicholson

I see you have some paintings by Winifred Nicholson on your web site. Have you a price list?

From: Richard Pereira, Utopia Enterprises Ltd

Sent: 28 April 2008

To: Castlegate House Gallery

Subject: Re: Winifred Nicholson

Thank you for the price list. I want a Nicholson as a birthday present for my wife but I think those prices are too high? Is there a biography of the artist which I could get for her?

From: Castlegate House Gallery

Sent: 28 April 2008

To: Richard Pereira, Utopia Enterprises Ltd

Subject: Re: Winifred Nicholson

Sorry if the prices surprised you but they are in line with what Nicholsons are fetching at the moment. Angel's Tears is a very special painting. The artist Valerie Thornton saw it when she was a student. It was in an exhibition at the Lefevre Gallery and it made an indelible impression on this young woman who was to become a notable artist in her own right – a painter and printmaker par excellence. She described it as 'delicate and austere' in a letter to her mother, and to her great joy her mother gave it to her for her twenty-first birthday a few weeks later. Many years later she referred to it again saying, 'The magic has not diminished.' Valerie Thornton died in 1991 and this painting has come from her estate. This makes it even more special.

There is a sort of biography of Winifred – a charming collection of her writings and letters put together by her son Andrew. There are loads of

colour pages of her paintings as well as letters to and from Ben, her ex-husband, and other friends. It is a beautiful book and would make a lovely birthday present. The only problem is that it is out of print and changes hands on the internet at anything from £500 to £900. It is called Unknown Colour and is published by Faber and Faber. It explains her theories about colour which are most original. She used to carry a small prism around with her to make her own personal rainbows and towards the end of her life she put many of her neighbours on Rainbow Watch. They were instructed to ring her when they saw a good rainbow. And they did.

If you decide to buy the book on the web make sure the copy is in good condition. I have 2 copies – one is very well used and the other is in mint condition – I haven't even opened it as yet. I am saving it for posterity (and investment) where condition is everything. I think books should be looked at, though, so hope your wife enjoys doing just that:

Chris

From: Richard Pereira, Utopia Enterprises Ltd

Sent: 1 May 2008

To: Castlegate House Gallery

Subject: Re: Winifred Nicholson

Thank you for the information. I found a copy of Unknown Colour yesterday in very good condition on the internet and it will make a really good present.

Angels' Tears is a lovely painting but the price is well above my limits. I know that markets change but I see that this painting was sold not so long ago at auction for £38k and I would be prepared to pay 43k,

reflecting a 5k profit if my calculations are correct. Should this be acceptable, please get in touch.

Thanks again, Richard Pereira

From: Castlegate House Gallery

Sent: 1 May 2008

To: Richard Pereira, Utopia Enterprises Ltd

Subject: Re: Winifred Nicholson

I am so glad you got the Unknown Colour.

Yes, you are right – I was the bidder who bought Angels'Tears last year at £38k but with the buyer's premium of 21% and VAT the final invoice was well over £45k – many people don't realise that there are these extra costs. The painting was in ropey condition and also very dirty so my restorer had to clean and stabilise it as well – a highly skilled job. I don't know if you viewed it at the auction but it is now looking much better; lighter and brighter, with a good new frame (the one it was in was badly damaged). So in the end it cost me a lot more. When I resell I have VAT and tax to pay so £56k is the lowest I could accept. I guess you are in business and understand. We couldn't survive on less than that.

I am happy to hang on to it rather than sell for less because (apart from liking it a lot) her work is fetching big prices and appears on the market so rarely. The ones with pots of flowers or shells on windowsills fetch the highest prices. There has been nothing of hers for sale since that one in any of the auction houses nationally. We sold eight works in our November exhibition at similar prices. It took me five years and a considerable investment to get those many together to sell. There were

two others in the same sale and they fetched higher prices – mainly because they were in better condition.

There were four for sale at the London Art Fair in January and all were at much higher prices than this one and all had sold. Winifred's work can be a great investment while being enjoyable at the same time.

I posted a catalogue to you this morning.

Chris

From: Richard Pereira, Utopia Enterprises Ltd

Sent: 1 May 2008

To: Castlegate House Gallery

Subject: Re: Winifred Nicholson

Hi. Sorry about my misunderstanding about hammer prices and commissions etc. I have never bought in an auction and I guessed the buyer's premium was only 10%, I did try last year but was outbid! Just as well, since I obviously didn't understand what the total price would be!

Regards,

Richard

From: Richard Pereira, Utopia Enterprises Ltd

Sent: 1 May 2008

To: Castlegate House Gallery

Subject: Re: Winifred Nicholson

I've been thinking about Angels' Tears and looking at it on your website. I agree with you that it is a really good one. I've looked at others that are

on the market but this one is the best I've seen. You make £56k sound like a bargain so I'll take the offer! Any chance you could get it down to London for me? Can I send a cheque? To whom do I make it out?

Regards, Richard

From: Castlegate House Gallery

Sent: 2 May 2008

To: Richard Pereira, Utopia Enterprises Ltd

Subject: Re: Winifred Nicholson

Congratulations – that's great. I know you won't regret it. You can either pay by cheque made out to Castlegate Fine Art or pay it directly into the account by BACS (I will email details if that is easiest). The cheque will take 5 days to clear and I do need time to organise the carrier so BACS is better. When is your wife's birthday?

Chris

From: Richard Pereira, Utopia Enterprises Ltd

Sent: 2 May 2008

To: Castlegate House Gallery

Subject: Re: Winifred Nicholson

My wife's birthday is May 22, so May 20 or 21 is fine. I won't be around then but the office address for invoice and for delivery of painting is fine. I will send you a cheque tomorrow.

Thanks again,

Richard

From: Castlegate House Gallery

Sent: 2 May 2008

To: Richard Pereira, Enterprises Finance Ltd

Subject: Re: Winifred Nicholson

If you are not around 20/21st I will send it to your office by art carrier rather than make the trip to London unless I find another reason for coming down. But I will need time to clear the cheque. I would prefer to meet you and hand it over personally but if it is not possible maybe another time, another visit! I will also include a little hardback book called Winifred Nicholson in Scotland which I think your wife will find delightful. Gosh – she is in for a surprising birthday.

Invoice attached.

Chris

From: Richard Pereira, Utopia Enterprises Ltd

Sent: 3 May 2008

To: Castlegate House Gallery

Subject: Re: Winifred Nicholson

Thank you very much. I posted the cheque from here yesterday, so if you don't get it before the middle of next week please let me know!

Richard

From: Castlegate House Gallery

Sent: 4 May 2008

To: Richard Pereira, Utopia Enterprises Ltd

Subject: Re: Winifred Nicholson

When you say 'from here' – where are you?

Chris

From: Richard Pereira, Utopia Enterprises Ltd

Sent: 4 May 2008

To: Castlegate House Gallery

Subject: Re: Winifred Nicholson

I'm in Bogota at the moment but it shouldn't take too long – about a week at the most.

Richard

From: Castlegate House Gallery

Sent: 5 May 2008

To: Ruth Wadsworth

Subject: justified at last

Hey – remember my big mistake re the Winnie painting? I have a buyer. Michael has forgiven me at last but won't celebrate as yet – he quite rightly says it's not over until the fat lady sings (ie money cleared through account) and you know what the internet is like – full of sharks and time wasters – but I have a gut feeling that this guy is OK. (Though he is in Bogota!)

Chrisma

From: Castlegate House Gallery

Sent: 14 May 2008

To: Richard Pereira, Utopia Enterprises Ltd

Subject: Re: Winifred Nicholson

Richard – I am worried that your cheque hasn't yet arrived. You said it had been posted about two weeks ago so I thought you should know that. I need to sort out the carrier to get it to you for your wife's birthday in time and will need five days to clear the cheque. I hope it isn't lost. I will need your address for delivery as well.

Chris

From: Ruth Wadsworth

Sent: 14 May 2008

To: Castlegate House Gallery

Subject: Re: justified at last

Hi mum. Good to hear all the news. Are you coming over soon? The children are growing fast and you seem to be careering round the country buying paintings. What has happened re: your South American financier and the Angel's Tears (the two don't seem to go together do they?) You do realize Bogota is in Colombia, drugs capital of South America? Sounds dodgy to me.

Ruth

From: Castlegate House Gallery

Sent: 14 May 2008

To: Ruth Wadsworth

Subject: Re: justified at last

Will try to come soon.

Re the South American – I am still waiting for the cheque to arrive. Is this one of those internet scams, do you think? I am becoming deeply suspicious.

From: Ruth Wadsworth

Sent: 14 May 2008

To: Castlegate House Gallery

Subject: Re: justified at last

Don't get excited! It sounds like a scam to me – be careful. You'll end up winning the Spanish lottery, having a penis extension and ordering Viagra by the bucketload if you're not careful. You may end up having your bank account milked to support some minor revolution to line the coffers of a S. American dictator or drug baron.

Ruth

From: Richard Pereira, Utopia Enterprises Ltd

Sent: 14 May 2008

To: Castlegate House Gallery

Subject: Re: Winifred Nicholson

Sorry the cheque has not yet arrived – thank you for letting me know.

I am surprised. The post is usually reliable from here to Europe. I will make a wire transfer instead. Please give me your bank details and this way there will be no delay in clearing.

Sorry for the worry.

By the way, my wife Rebecca may get in touch with you about your other Nicholson paintings as she doesn't know that Angel's Tears is sold (to her!). Please don't let on that I bought it.

Richard

From: Castlegate House Gallery

Sent: 14 May 2008

To: Richard Pereira, Utopia Enterprises Ltd

Subject: Re: Winifred Nicholson

I think the best thing would be a wire transfer today so that I can get things organised for a delivery early next week. It will be Tuesday or Wednesday as I don't want the painting hanging around in a courier's store (or van!) over the weekend.

I will certainly be discreet if your wife contacts me. I never tell anyone the identity of the buyer of a painting. Is she in London?

Yours, Chris

From: Richard Pereira, Utopia Enterprises Ltd

Sent: 14 May 2008

To: Castlegate House Gallery

Subject: Re: Winifred Nicholson

Chris, I have changed my mind about delivery of the painting. I am flying into the U.K. on the morning of the 22nd May which is actually my wife Rebecca's birthday. We are going from Heathrow straight to a hotel south of Bristol for the night. Can you please have the painting delivered to the hotel so it can be kept for my arrival. My personal assistant, Susie Grant, will be in touch with you to coordinate details.

The wire transfer has to be made tomorrow so you should get it credited tomorrow or latest Friday. This should still give you enough time next week to have it sent, I hope.

Thanks again,

Richard

From: Castlegate House Gallery

Sent: 14 May 2008

To: Richard Pereira, Utopia Enterprises Ltd

Subject: Re: Winifred Nicholson

Richard,

We are getting very short of time as it needs a specialist art carrier. I can't arrange anything until the money is in our account.

Chris

From: Richard Pereira, Utopia Enterprises Ltd

Sent: 17 May 2008

To: Castlegate House Gallery

Subject: Re: Winifred Nicholson

We have met with a problem. The General Manager of the hotel is unhappy at the thought of taking responsibility for the painting, so I may have to have the London delivery after all. I told him what it was worth. Perhaps I shouldn't have done – it frightened him. Sorry.

Richard

From: Susie Grant

To: Castlegate House Gallery

Sent: 19 May 2008

Subject: Winnie delivery

Hi Chris. I am Richard Pereira's secretary. I wanted to let you know that you more than likely won't see the money until Wednesday, morning. I checked with our chap here and it takes a minimum of 24 hours to post – as it was posted on Friday, he would expect it to be with you on Wednesday.

I look forward to receiving confirmation from you when payment has been received. Also, when you do confirm you have payment, could you also advise me on the expected delivery date to our London office so that I can advise them there.

Best.

Susie

From: Castlegate House Gallery

Sent: 19 May 2008

To: Susie Grant

Subject: Re: Winnie delivery

OK. I'll make arrangements for London delivery when it is received. I can't arrange anything until then but even if the money arrives Wednesday, the painting will be delivered the following week as we have missed this week's opportunities with our art carrier and it does need special handling as you will appreciate. We can't send that value by Parcelforce. Chris.

From: Ruth Wadsworth

Sent: 19 May 2008

To: Castlegate House Gallery

Subject: South American Junta

You've gone quiet. How is it going with the South American junta? Bet you haven't got the money yet. It could be an evil internet scam. Be careful. Ruth

From: Castlegate House Gallery

Sent: 19 May 2008

To: Ruth Wadsworth

Subject: Re: South American Junta

I am running out of patience and also full of suspicious thoughts. Have checked with my bank and they tell me a wire transfer is effected

overnight but they have confirmed that when the money is in the bank account that it cannot be clawed back under any circumstances. Don't hold your breath.

This guy is changing his mind and his story every 5 minutes. Is he really in Bogota or is he in a bedsit in Bermondsey? That's the trouble with email – you don't know what is going on. His secretary could be in the scam as well – even if I send an email at midnight she replies straightaway which is a tad irregular. Of course she could be in Colombia as well which would explain it.

Chrisma

From: Susie Grant

To: Castlegate House Gallery

Sent: 19 May 2008

Subject: Re: Winnie delivery

Hi Chris.

Richard has had another idea re: delivery so that he could get the painting this week – he's asked me to look into how much it would cost for a driver to come up and get it.

Susie

From: Castlegate House Gallery

Sent: 19 May 2008

To: Susie Grant

Subject: Re: Winnie delivery

This is the safest and quickest plan. I think safety and security are paramount which rules out normal delivery companies, however good. If you send a car from London you will probably need two drivers because once the painting is on board, the vehicle must not be left unattended and presumably he'd need a toilet stop in more than 300 miles. Also I would need to see the driver's ID and a note from Mr P or you authorizing me to hand over the painting. Once he has signed for it it is Mr P's responsibility. The specialist company I use pick up once or twice a week rather than being able to do next day delivery. They will pick up this Friday on their way to Scotland and deliver to you Monday or Tuesday next week which I realise is too late for the birthday.

Chris

From: Susie Grant

To: Castlegate House Gallery

Sent: 19 May 2008

Subject: Re: Winnie delivery

Am getting quite anxious re: delivery. Mr P is insisting that his wife must have it for her birthday (Thursday) and will do anything for that to happen.

Susie

From: Castlegate House Gallery

To: Susie Grant

Sent: 20 May 2008

Subject: Re: Winnie delivery

What he needs to do is pay for it and then I will do everything to make it happen.

Chris

From: Castlegate House Gallery

Sent: 20 May 2008

To: Ruth Wadsworth

Subject: Re: South American Junta

This thing with the South American is getting hairy. I'm dealing with the secretary now and she knows how to put the pressure on. He's probably standing over her dictating. She says he'll do anything to get the picture for his wife's birthday which is Thursday. Well he only needs to do one thing – get the money into my account. I am doing nothing until it is there. He's willing to send a driver but it isn't leaving my hands until I have the dosh.

My imagination keeps running away with me and I worry that someone will turn up in the gallery with a dark glasses and a gun. Have taken the painting off the wall. It's in a safe place. Trying to be sensible.

Chrisma

From: Castlegate House Gallery

Sent: 21 May 2008

To: Susie Grant

Subject: Re: Winnie delivery

The payment has just landed in our account which means we can plan delivery at last. The driver idea is a good one but it is a long way as you are well aware. If all else fails I will deliver it personally to the hotel tomorrow – though I now have a meeting at 10am here in Cumbria so would set off after that. I always feel better if I have delivered it into the hands of the purchaser. We're not dealing in Athena prints here are we? I am sure we can resolve this. I too will do my best to get it to Mrs P for her birthday.

Chris

From: Susie Grant

To: Castlegate House Gallery

Sent: 21 May 2008

Subject: Re: Winnie delivery

Hi. OK, we have another plan.

Mr Pereira really doesn't want to put you to the trouble of driving yourself. He would pay for a taxi to drive the painting down from Cumbria to Somerset with the aim of arriving between 6.30 and 7.00 pm. This is when he will be at the hotel for the birthday dinner.

However, if you think you would be able to drive it down from Cumbria to arrive there for between 6.30 and 7.00 pm yourself, then Richard would

love for you to bring the other three Nicholson paintings for Mrs Pereira to see.

I look forward to hearing from you. Thanks so much for your continued efforts!

Susie

From: Castlegate House Gallery

Sent: 22 May 2008

To: Susie Grant

Subject: Re: Winnie delivery

That's a hard call! Can't find anyone (taxi etc) reliable enough in time scale so will drive it down myself for 6.30–7 tonight to Somerset after my meeting this morning.

Will also bring the others for Mrs. P to see.

Chris

From: Castlegate House Gallery

Sent: 22 May 2008

To: Ruth Wadsworth

Subject: Fat lady sings!

Hey – at last the money from the Junta arrived in my bank account magically last night. It has been all hell let loose since then trying to make delivery arrangements. So we are going to drive the paintings down tomorrow to arrive 6.30 pm. He has asked us to bring the other 3

paintings as well for her to see. I've been to the gallery and got them and then M has had terrible thoughts. He always sees the worst case scenario! We will have about a quarter of a million worth in the car boot which is a sobering thought. If our insurers knew they'd explode in fright.

What if it really is an internet scam and they have bought the one in order to hold us to ransom over the other 3. M is proposing to ride shotgun.

Have I been watching too many American gangster films?

Will let you know when we have arrived back safely. This could be my final message to you – save it!

Au revoir

Chrisma

From: Ruth Wadsworth

Sent: 22 May 2008

To: Castlegate House Gallery

Subject: Re: Fat lady sings!

Am deeply worried about your antics. Are you sure you should be getting mixed up in all this. It sounds very dubious to me. Are you getting involved with money laundering and stuff. Do you think you should be careering all over the country with a car full of valuable paintings? Think you should take a bodyguard! Better not stop for a wee – someone might nick the car for a joy ride.

Let me know as soon as you have mission accomplished.

Ruth

From: Castlegate House Gallery

Sent: 23 May 2008

To: Ruth Wadsworth

Subject: Re: South American Junta

Well we are back and all intact – just shattered. We didn't leave Cumbria until after midday. We drove very carefully in view of what we had in the boot. We had to stop and go to the loo separately (well, don't we always but you know what I mean) as we couldn't leave the car unattended at any time. Mr P's secretary rang at about 2 pm to see how we were getting on and then I got a call from Mr P himself. He appeared very concerned that we were driving down ourselves but glad I had a co-driver. He asked a few questions about him, which was a worry especially as both he and his secretary wanted to know exactly where we were. He has no idea of the difficulties involved in moving a picture as old and valuable as that. I told him we expected to be at the hotel about 6 pm and he said he would be there. His wife still had no idea about the picture – she had been given the book that morning and was thrilled. She thought that was her whole birthday present. Actually a £700 gift would be lavish in most people's minds anyway.

He said they were going to the school to pick up their daughter and would then return to the hotel. He would encourage his wife to go up to their room and change for dinner and then he would come through to see us in the hotel lounge. He told us to order a meal and put it on his tab. He asked if we had the other paintings and was pleased about that. (This increased M's suspicions re: kidnap as he was listening to the phone conversation.)

So . . . we arrived at about 6pm and unloaded the paintings into a locked

room provided by a rather nervous hotel manager in white gloves and then had a nice tea in this baronial hotel – couldn't do alcohol sadly as we would both be driving back. We were tired by now what with my meeting first and then Michael constantly on the on the lookout for an ambush. Ambush anticipation is quite stressful and wearing on the nerves. The hotel manager had been told the value of the painting and was obviously anxious not to handle it at all or take responsibility for it. When I told him the value of the other 3 he nearly freaked. He was convinced we were winding him up. Mind you, he must be used to dealing with the madly rich as a helicopter arrived while we were there and disgorged four people who had flown up from Jersey for dinner (do they not have restaurants in Jersey then?). They came and perused the menu while drinking Dom Perignon.

We spent the time rubbishing the mock mediaeval paintings hanging in the baronial hall. They were truly ghastly and had probably been knocked up last year and put in horrendous gold frames. Why do they do it eh? I think hotels of all star ratings have a central warehouse from hell where they order paintings by the yard. But I was impressed with the hanging. They were hung so high in this beamed room that they must have had to lasso the beams and climb up ropes to hang them, then abseil down again hoping they had got them level! I glanced into a television lounge and was amused to see the television was enveloped inside a tented arrangement with scalloped borders as used in a mediaeval joust – the flaps tied back with gold braid. It put my minimalist hackles up. Anyway we ate and drank everything. We scanned the room, read the papers and eyed up the other guests while the clock moved round.

At 8.00 we had had enough. We had a very long journey back. The manager confirmed that the Ps did have a table booked for 7pm for a birthday dinner. They were seriously late and would be in no mood to

look at paintings. He checked at the desk but there were no messages which puzzled us all. We were still uneasy at leaving it in case there was a fake robbery staged but the hotel is listed on the web and it would have been difficult to assemble such a large cast for the scam. Maybe we had been watching too many episodes of Hustle on television. We packed the three unsold pictures back into the car and left the one purchased in the manager's locked room. We piled back into the car to face another 300 miles. We were just driving away slowly over the speed bumps on the long narrow drive when we were met by an American landcruiser with those ominous darkened glass windows. If this was the road block I was ready. I was poised to accelerate over the grass and make for the gate. The driver's window was down and I caught his eye as we passed. He was young-ish, handsome, light-haired in a white polo-necked sweater and tweed jacket. He didn't look like a South American at all but an English gentleman. I was convinced it was Mr Pereira. I smiled and said 'Enjoy your evening' quite quietly and put my foot down giving him no chance to reply (or produce a gun!).

We arrived home well after midnight and can hardly concentrate today. What an anticlimax eh?

Chrisma

From: Ruth Wadsworth

Sent: 23 May 2008

To: Castlegate House Gallery

Subject: Re: South American Junta

Well at least you are home and in one piece. I was worried all day

wondering how you were getting on and whether we would ever see you again. Please do try to live a normal quiet life for a bit, will you?

Ruth

From: Castlegate House Gallery

Sent: 30 May 2008

To: Ruth Wadsworth

Subject: Re: South American Junta

Hey – you won't believe this but I just put a cheque made out to me for £56,000 through the shredder. It was a funny feeling! And it really hurt to do it.

It arrived by post this morning dated 2nd May and had been posted that day in Bogota – so all our suspicions were unfounded. I feel a real heel. I take it all back.

Chrisma

From: Castlegate House Gallery

Sent: 1 June 2008

To: Richard Pereira, Utopia Enterprises Ltd

Subject: Winnie

Hello Richard – hope you had a good trip. I just wanted you to know that the cheque dated 2nd May arrived at the gallery today. I have shredded it.

I do hope the birthday present was a success. We waited as long as we could at the hotel but we then had to start our long journey home. I think we may have passed you on the drive but figured that you were so

late you would want to get to your dinner etc. I am sure you would have been in no sort of mood to look at paintings so it was best we just disappeared. It was after midnight when we arrived home and I had a full day the next day. It was manageable though because there were two of us driving or I don't think I could have done it in the day.

Perhaps you'll come up to the Lake District to see the other Winifred paintings we have. I would be happy to take you both on a Winifred 'tour' and maybe visit Banks Head where she lived most of her life. You could see the painting of Ullswater (front of the catalogue I sent). There is a very good hotel there by the lake, Sharrow Bay, I think it would meet your high standards. I will send you a brochure.

I think you would enjoy the gallery. It is a beautiful Georgian house and we have lots of good things. If you give me warning of your visit I will do lunch at the gallery. I would like to meet your wife – a fellow Winifred fan.

All the best

Chris

From: Richard Pereira, Utopia Enterprises Ltd

Sent: 4 June 2008

To: Castlegate House Gallery

Subject: Winifred Nicholson

What a surprise to get your parcel. The little book about Winifred in Scotland and the brochure were delightfully received as was the painting and I am sincerely grateful to you for your efforts in making it all happen. Yes, I think we did pass on the hotel drive. I am so sorry

that we missed each other. We had been delayed at the school. I would have liked to ask you to dine with us but you quickly drove off before I had the chance. However, thinking about it afterwards it would have spoiled the surprise because Rebecca would have needed to know why I was asking you to join us. I had the painting hung on a wall in our suite while we had dinner and it took ages and plenty of hints after we returned to our suite before my wife noticed it. I had already given her the book in the morning and she really thought that was her present – and she loved it. I kept trying to draw her attention to the painting but not obviously. At last she noticed it and recognized it as a Nicholson and thought it might be a print. She went over to look more closely and, when she realized it wasn't a print, she was overawed and marvelled at the coincidence of having her favourite artist on the wall of a hotel room. I kept up the pretence for a while expressing surprise as well. Then I asked her if she thought it was a good example of Winifred's work and held my breath until she said it was the best she had ever seen. I then told her it was hers. It took some minutes for this to sink in but when it did she was all smiles and tears. Thank you again! I really enjoyed the surprise factor. I think this was the best birthday present ever and it was thanks to you and your tremendous efforts on my behalf.

I do hope we can make it to Cumbria this summer. Lunch at the gallery would be lovely! We both really want to see any other Nicholsons that you have.

Best regards,

Richard

From: Castlegate House Gallery

Sent: 23 June 2008

To: Ruth Wadsworth

Subject: Re: South American Junta

Well after all the fuss over that Nicholson painting life suddenly seemed very quiet . . . Until yesterday when a nice card arrived from Mrs Pereira with effusive and sincere thanks. She sounds lovely. She's hoping to come up in the summer. It will be very interesting to meet her at last. Will keep you posted.

I'll come over soon but I'll keep my mobile switched off on the A69. M can do telephone bids for a bit.

Chrisma

The Fish-and-Chip Shop at Cleator Moor

There is a little pencil drawing on the wall of my work-room, hanging above my desk. It is called *Girl Going Somewhere* and it shows a young woman dressed all in black with long black hair, chin raised, head slightly jutting forward, striding determinedly into the future. The signature at the bottom right reads 'L S Lowry RA 1965'.

After researching the life of Sheila Fell, I began to get more interested in her famous friend Lowry and his links with Cumberland. Slowly an idea began to form. Lowry also had links with Percy Kelly, whom Lowry and Sheila Fell used to visit at his home in Allonby. Kelly disliked Lowry. He admired Sheila – a native Cumbrian – but he thought Lowry was an interloper; he condemned him as pretentious, and was jealous of his fame.

If I could gather enough Lowrys together for a selling exhibition, it would be a first for Cumbria. I had just acquired a new collection of Kelly's work from his stepchildren. That would fill the other room and complement Lowry; it would also appeal to my sense of irony to put these two old enemies together. I located a Lowry drawing of Maryport and then another of Workington. This was encouraging. After a lot of research and networking I knew I could do it. The insurance was the biggest drawback – insurance companies are very jumpy about anything of great value, and they were understandably extremely nervous about insuring the work of such a high-profile artist. When I informed them that there would be more than a million pounds on the wall there was much stroking of chins and sucking of teeth. However, to counter that, the exhibition was impressive enough to attract sponsorship and I succeeded in persuading the Bank of Scotland to support it.

I spent months before the September exhibition hunting and gathering with increasing excitement. One Saturday morning a fellow dealer arrived with three Lowry drawings for me to sell for him on consignment. I unpacked them on the kitchen table. There was a beautiful early drawing of the head of a man and an interesting later drawing of some Manchester drunkards leering their way across the paper. The third was the girl going somewhere. As soon as I set eyes on that drawing I knew it had to be mine. This was no matchstick woman. She had life and vigour. In the simplest drawing Lowry had managed to convey pride, determination, ambition and self-confidence. This is a woman who knows herself and knows

where she wants to be. I like to think I'm going where she's going – somewhere.

Everybody has heard of Lowry. Such is his popularity that he is often looked down on in a snobbish way by the establishment in the art world. Maybe I unconsciously feel the same. My first real encounter with his work was eight years before my purchase of *Girl Going Somewhere*; on 23 March 1995, to be precise. You would have found me then sitting uncomfortably on one of the gilt chairs in Christies Auction house in St James's London. I was there to buy a fish-and-chip shop. I was well aware of the irony of even contemplating such a purchase in this the international temple of the art and antiques auction world. Mind you, this wasn't just any old fish-and-chip shop I wanted so badly, but Cowles Fish and Chip Shop at Cleator Moor.

Anyone who knows this area of West Cumberland will appreciate how bizarre the situation was. Cleator Moor is a run-down West Cumbrian town a few miles inland from the coast. Its economy was built on mining iron ore, but that has long since gone. Unemployment is now high, and the shop sits in a long row of back-to-back grey terraces punctuated by other takeaway food establishments, betting shops, off-licences, secondhand furniture shops and pubs, amongst a forest of satellite dishes. Not the most desirable property then?

So why would I want to buy a fish-and-chip shop? Nothing could be further from the smooth affluence of St James's and the opulence of the auction rooms. What I was there for was

Lot 100 – a small pastel drawing of the fish-and-chip shop by L.S. Lowry. This was exactly the sort of subject which Lowry loved. He must have drawn it on a Saturday lunchtime because the shop looks packed. Crowds of men, women and children are queuing up and spilling out of the door on to the pavement. There are all the Lowry favourites: dogs, cats, children, prams, babies. The decrepit and dilapidated were always favourites with him. The more tawdry and unsavoury anything or anybody was, the more he was attracted to them. He was deliberately politically incorrect, taking great pleasure in shocking people by drawing freaks, people with disabilities, drunkards and prostitutes.

While waiting for the lot to come up, I recalled he was once arrested in Newcastle outside Bainbridges department store. The window-dressers were busy putting fur coats on mannequins (this was before the days when fur was frowned upon). He stayed there so long, his nose pressed against the glass, and he looked so scruffy in his floor-length dirty old mac, that the girls in the window became unnerved. Unable to pretend to ignore him any longer, they sent for the manager, who assumed he was a pervert and immediately summoned the police, who escorted Lowry away from the shop with a warning not to come back. They asked him where he was heading.

'My gallery,' he stated, gruffly offended.

'Which gallery is that then, sir?' they asked, cynically.

'The Stone Gallery,' came the reply.

'We'll take you there,' they said, firmly taking his arm.

When the party arrived at the gallery, its owners, his friends the Marshalls, didn't bat an eyelid. They were used to Lowry's strange fetishes and had dug him out of embarrassing situations many times before. They smoothed him down and explained to the police that he was a famous painter. The police were unimpressed and warned him again to stay away from shop windows.

On another occasion he was out for dinner with the Marshalls at a well-known upmarket Newcastle restaurant, the Café Royal. A blind pianist was playing the grand piano in the splendid large dining room. Lowry objected to 'the awful noise', claiming it put him off his food. He complained so loudly and at such length that in the end the Marshalls had a word with the manager and embarrassingly paid the pianist to go away to avert an even more difficult situation.

I brought my thoughts back to the present. This was an important sale. It would begin at two o'clock precisely. I had arrived early to be sure of getting a good seat. Others had done the same and there was a hum of expectation as the chairs filled up. The battery of telephones down the left-hand side, soon to be manned by a host of smart, plum-voiced staff, seemed to have doubled since the last time I was there.

The Lowry wasn't for me. Recently widowed, I couldn't afford such a thing then. I was bidding on behalf of clients. Nevertheless I was feeling quite nervous. The sale had attracted a lot of attention, and the Lowry works were its highlight. There were fourteen drawings and paintings from the collection of the Reverend Geoffrey Bennett, Lowry's

friend of more than fifty years. He and Lowry first met when Bennett was a clerk in the National Westminster Bank in Manchester, where Lowry's cousin Grace also worked. Lowry would call in to take her out to lunch once a week and a friendship had sprung up between him and Bennett, who was a keen amateur painter. After Bennett's marriage in 1933, his new wife Alice loved Lowry's paintings and they decided to buy one for their new home. She fancied one they had recently seen in an exhibition. It was called *The Removal*, which must have struck a chord with their present circumstances, but it was too expensive for them, so Lowry offered to paint them a picture for five pounds. He asked them what they wanted in it. After some thought, Bennett said he would like a street with a barrel organ, a lot of people, a mill and a dog. The result was Lot 113 in this sale – *The Organ Grinder*.

After the war Geoffrey Bennett was promoted to bank manager of the National Westminster Bank in Cleator Moor and the family moved there from Manchester, which must have been a culture shock for them but not for their good friend Lowry, who soon became a frequent visitor and began to paint local scenes. West Cumberland offered him all the elements that inspired his art. The decaying industry and ordinary working people and their families interested him, and he would often use the Bennetts' young son's crayons for his pictures

Bennett had a dramatic career change in 1962: he was ordained as an Anglican clergyman and moved to Carlisle. When Lowry died in 1976 his friend conducted the funeral

service, only to discover afterwards that Lowry had bequeathed him many of his paintings and his Tompion grandfather clock. When Bennett himself died in 1991 he left his paintings to a trust to benefit retired clergy and Carlisle Cathedral, and that was why his collection had finally come down to London to be auctioned at Christie's. The cathedral needed a new roof.

The sale began promptly. The growing, shuffling audience had to be patient. It took well over an hour to wade through the Sickerts, Seagos and Pissarros that formed the first part of the sale. I glanced behind me. The large room was now packed to the door and the crowd filled the palatial anteroom as well. I wouldn't have got anywhere near the front if I hadn't arrived so early. The heady smell of lilies filled the air in the stuffy atmosphere. It was an affluent London crowd – mainly men in smart suits, as well as a few well-dressed women clutching glossy catalogues in gloved hands. No doubt there were many more overflowing down the elegant broad stairs that led up from the vestibule. What a crush.

Lot 100, my lot, was the first of the Lowrys to come under the hammer, and I sat nervously poised, upright and alert, clutching my paddle with my pre-allocated number. If successful, I would hold this up so the auctioneer could mark it down to me. The picture had an estimated price of £5,000 to £8,000 printed in small letters under the description in the catalogue, and after much discussion my clients had opted for a £10,000 limit because they wanted it so badly. I had strongly advised them to give me permission to go a little beyond that,

because people often have a limit of a rounded number like ten and an extra little push might secure it. So I had been given carte blanche to go to £11,000 if necessary, which to me at that time was a small fortune – in fact I could probably have bought the actual fish-and-chip shop and the house next door for much less than that.

The bidding began at £3,000 and quickly moved up in rapid and frightening stages to £10,000. I hadn't even had the chance to make a bid yet because it was moving so fast. I was just about to chip in at the next pause but £11,000 was reached and surpassed and the bidding was moving at a cracking pace to more than £20,000 and then before anyone could even sneeze we were at £30,000. Surely it couldn't go further – but it did. The hammer finally went down at £40,000. Of course the buyer's premium and VAT would bring the final bill payable closer to £50,000 – unbelievable for a small pastel on paper in a child's crayons.

Now, regretfully out of the bidding and somewhat disappointed, I sat back to relax and enjoy the rest of this theatrical production while my pulse rate returned to normal. A good auctioneer is like the conductor of an orchestra, vigilant and alert, never missing a cue. He must work the audience like a showman, cajole and entertain while never losing concentration. This one was particularly talented.

The next lot, *Open Air Meeting*, again in crayon with an estimate of £6,000 to £8,000, finished on a hammer price of £22,000 and the first oil, *Going to the Match*, went for £46,000. It was a telephone bid that secured it and I wondered whether

it had gone to a Manchester United football player. Because Lowry paintings always seem to increase in value, sometimes at an extraordinary rate, financial advisers to wealthy football players and lottery winners sometimes recommend investing in a few, especially if their subject is relevant to the purchaser. Mind you, I felt that the prices achieved at this sale were surely top of the market; they would never go above these values. How wrong could I be?

Next up was a tiny oil on card, *Mother and Child*, painted on a postcard, which fetched an amazing £16,000. This was no Virgin Mary and Jesus but a mini-skirted woman in very high heels and long hair, probably a prostitute, patting (or smacking) a small boy on the head. This would appeal to Lowry's strangely perverse sense of humour.

At this point we reached the terrifying *Portrait of a Young Man* which Christie's had used on the front cover of the catalogue. The young man in question had extraordinarily thick red lips, as though he was an early guinea pig for collagen treatment which had gone horribly wrong, and the scariest staring round eyes imaginable. They were like glass marbles rotating in a bloodshot socket – very frightening. Combined with his bright blue suit, the overall effect was nauseous. It was the stuff that nightmares are made of, and I couldn't imagine that anyone would want to hang it in their house. Maybe one of the public galleries would buy it. At a diminutive twelve by eight inches, it carried a surprising estimate of £10,000 to £15,000. It would be lucky to reach the lower limit, I thought to myself. A slow start seemed to confirm my prediction, but

by £10,000 the game was being played by a telephone bidder (who I found out afterwards was possibly David Bowie) and a voluble man on the front row who sported a very snazzy striped shirt and a long pigtail, the only man in the room without a jacket and tie. Where most bidders are discreet, almost secretive, this guy was playing to the crowd and enjoying every minute. The bidding crept up to£40,000.

At £45,000 in favour of the telephone bidder, the man on the front row stood up and turned round to face us all. He threw out his arms dramatically and exclaimed, 'This is ridiculous!' He turned to the sardonically smiling auctioneer and announced, 'I'm out.' And he sat down heavily in a defiant manner.

My heart leaped. I recognised the man. It was Jonathan Silver, of the legendary Salts Mill in Saltaire, Bradford, which he had set up from scratch after making millions in the clothes trade. He was something of an entrepreneurial hero of mine. Now out of the bidding, Silver was moodily silent and still on the front row, conspicuously sitting on his hands. Immediately another bidder entered the arena in his place and the bidding continued to an incredible £55,000. There was a long silence as the auctioneer scanned the room.

'The telephone has it, ladies and gentlemen,' he announced. 'Fifty-five thousand pounds. Are you all done?' Another pause. 'At fifty-five thousand then. Going once, going twice.' The hammer was poised to fall.

'Oh, go on then, fifty-six,' shouted Silver, standing up again dramatically.

There was another pause to give anyone else a last chance.

Finally, as the silence became oppressive, the hammer came down. Showman that he was, Jonathan Silver stood up again, turned round and bowed flamboyantly. We all clapped. I looked at him in amazement and admiration. How could he want to buy this awful painting so much, and how could he afford to spend such a ludicrous amount of money on it? What would he do with it now that he had this hard-won prize?

The auction continued in the same vein, with virtually everything fetching way above the Christie's estimates. The five-pound painting Lowry had made for the Bennetts after they married, with the organ grinder, lots of people, a mill and a dog, went for more than double its estimate at a substantial £67,000, and the final lot, *The Seaside*, made a hefty £81,000. These were just the hammer prices – a buyer's premium of 15 per cent would be added to the winning bid on the final bill. The retired clergy and Carlisle Cathedral would do very well, I thought, and why not?

Two years later in 1997 I was shocked to hear that Jonathan Silver had died of cancer aged just forty-seven. He had achieved more in this short lifetime than most of us would in an eternity.

He did not excel academically at school in Bradford but by the age of ten he was buying pens and pencils and selling them back to his mates at a profit. He went to the local auction rooms in the school lunch break, opened an account and began to buy and sell. He ran a free-range egg round, making sure

the eggs still had feathers on them and undercutting the competition. He wrote to David Hockney, also a son of Bradford, and asked him to design a cover for the school magazine. Hockney did it. People always found it hard to say no to Silver. At twenty-one he had a chain of men's clothing stores called Silvers which were the talk of Manchester. This man was a monumental risk-taker. And his biggest, most grandiose risk of all was Salts Mill.

In 1987 nobody wanted Salts Mill. It was the brainchild of another great entrepreneur and Victorian benefactor, Isaac Salt. He built the huge mill buildings and the whole village of Saltaire around it for his workers with an infrastructure of sports and leisure facilities. Now these massive buildings on seventeen acres were empty and derelict. Nobody knew what to do with them. Jonathan Silver, showman, art lover and adventurer, had the vision of a massive palace of culture, bought it, and created Gallery 1853 in the Spinning Mill. He had built on that first connection with David Hockney all those years before, and now he filled it with the largest single collection of works by Hockney in the world, and scattered huge vases of white lilies throughout. This was ambition on a grand scale. Admission to the gallery was and still is free. Silver made the money to keep it going through selling books, posters and merchandise, and let out the other floors and buildings to other businesses. It is the perfect combination of art and commerce.

I visited Salts Mill not long after his death, wondering if there would be any difference in this marvellous place and still

curious about what had happened to the awful Lowry portrait he had bought. I was told by staff that he had hung it in the gallery and loved it. He had an idea for a Lowry gallery which he thought would be perfect in this industrial setting. One of his staff told me wryly that if he didn't have a new challenge to face he was a 'pain in the arse'. He had the space, so why not?

I was delighted to see that an excellent history of Saltaire had just been published by Bradford Libraries: *Salt and Silver*, by journalist Jim Greenhalf. In it I learned a bit more about his connection with Lowry, which explained his eagerness to buy the painting in the auction.

Silver met Lowry as a teenager. He had bought an unsigned painting for fifty pence in a junk shop and he thought it might be a Lowry, so he went on the bus to Manchester, located the painter's house and spent the whole day with the great man, talking about clocks and tax, Lowry's favourite subjects. He hated the tax people and felt they demanded too much of him (don't we all?) and he loved his large collection of clocks which were all set at different times, presumably to stagger the chimes.

I found the book compulsive reading and my heart jumped when, near the end, Greenhalf refers to the purchase of the *Portrait of a Young Man*. *I was there!* I thought. He describes the painting vividly: 'a cross between a pierrot and a corpse stares fixedly out of the picture. After a while you get an eerie feeling that what you are looking at is a reflection. It is like a mirror in an M.R. James horror story.'

Apparently, Silver began to believe that the painting

brought a curse with it. Shortly after he acquired and hung it, the wife of his manager and friend Jack Hook had a heart attack and then Silver himself began to suffer ill health. He had appendicitis followed by jaundice and then pancreatic cancer was diagnosed. Although he was hot on the trail of a large collection of previously unseen Lowry works, he dropped the idea of a Lowry gallery. This was a lucky decision, because Salford secured a huge lottery award to build the Lowry Centre and gallery soon after.

Since that auction at Christies when I thought his prices had peaked, Lowry prices have risen steeply and steadily with the first million-pound sale achieved in 2000. It is very similar to buying a house with a big mortgage, when one is stretched to the limit to begin with yet within a few years that same amount seems quite small by comparison with current prices. The prices achieved in that 1995 auction now seem ridiculously low in the present context. Lowry has now hit the two-million mark and his work is always in huge demand.

I am relieved to say that Salts Mill is still thriving and developing and building on the amazing empire that was Silver's vision. His legacy lives on and his philosophy of attempting the impossible still survives.

On a totally different scale of risk-taking, the Lowry exhibition at Castlegate House in 2003 with twenty-four works for sale was a an overwhelming success.

I rang the local police after we had finished hanging to tell them what was going on up at the gallery and to make sure

that if our alarm went off they would respond immediately. I was nervous and so were they. On a Sunday afternoon, in the middle of the opening, the local sergeant telephoned requesting a visit. He arrived as it was ending and pointed out that there was a crack in our Georgian wooden shutters. The shutters were open at the time so I asked him how he could know this, to which he replied that he had had officers over the high wall that surrounds the gallery the night before and they had noticed it. I was impressed. He promised me a response time of up to two minutes from the alarms being activated. A week later we had occasion to test it out.

I arrived first and there was a queue waiting on the doorstep even though I was over half an hour early. I told them we would open in half an hour. I unlocked the door and walked in with the alarm on countdown, preparing to knock it off, when I realised that a man at the front of the crowd had followed me in. I stopped, turned round and asked him to leave but, because of the delay the alarm was activated. Within thirty seconds a patrol car screeched to a halt outside and three officers leaped out and charged in. It was Cockermouth police's big moment – the event for which they had trained for years. The intruding man had immediately fled and was probably quite innocent or deaf, having not heard me say we wouldn't be opening for a while, such was his eagerness to see the paintings.

More than twenty thousand people came through that door in the six-week duration of the show. We had no admission charge – we relied on selling the paintings to cover the costs. They wore the carpet out and I began to dread arriving in the

morning to face the queue on the steps, and then having to throw people out at night when we closed. The oil above the mantelpiece of a typical industrial scene sold for £350,000. If only I'd had the money to buy in that auction in 1995. But would I have had the courage and conviction to go on bidding so far beyond the estimates like Jonathan Silver? I don't think so. Hindsight is a marvellous thing.

Lowry holds a special place in the hearts of the English people. They naturally identify with the ordinary people in the paintings, scurrying to work or to a football match, and they love the sense of community in paintings that tell stories of everyday occurrences like *The Ambulance* or *The Removal*. There is a sense of nostalgia too – of days past when there was an organ grinder and Punch and Judy show. Fame was never Lowry's intention and he would probably be very scathing about hitting *Top of the Pops* with his *Matchstalk Men and Matchstalk Cats and Dogs*. He would be amazed at the prices his work fetched but would grumble loudly about the amount of money the government, the dealers and the auction houses picked up on the way. He enjoyed his image as a poor, exploited artist, however far from the truth.

I sometimes wonder what he would make of his native Manchester today, with the Lowry Centre at the heart of a transformed Salford full of high-rise apartments and lofts. I suspect he would have been very derisory about the region's redevelopment. The trendy bars and shops that line the canal would have disappointed him, and what would he think about the five-star hotel that bears his name? Would he be amused? I think not.

CHAPTER TEN

The Striped Cat

There were hundreds of paintings on the walls of the Royal West of England Academy in Bristol that evening. It was the private view of their popular annual exhibition, and the pictures were hung three deep, so closely packed that it was hard to focus on anything. But one painting stood out for me. I saw it as soon as I entered the room and then I couldn't take my eyes away from it. This was surprising because it was a very small, tiny even, watercolour of white crocuses and a moth. I rushed up to it but it had a red spot on it signifying it had already been sold. Devastated, I retreated to the company of my next door neighbour and friend, Deborah Carter.

This was long before I moved to Cumbria, long before the gallery. I lived in a mid-terrace house in Clifton, Bristol. Deborah was in her eighties, recently widowed and we used to go to exhibitions together. We got on very well despite the forty-year age difference. She had led an interesting life and her house, a

mirror-image of ours, was full of unbelievably good paintings. I remember my first visit for 'meet-the-neighbours' drinks when we were moving in. I was struck dumb by what I saw in her sitting room. Was that a Henry Moore? Was it real? There was a huge John Piper, the painting illustrated on the front of the biography on my own bookshelf. There was a large Mary Fedden of a graveyard in Brittany, sitting comfortably beside an overview of the harbour in Bristol by her husband Julian Trevelyan. There were Mirós, a Sydney Nolan, a William Scott. They rendered me speechless. I didn't really meet the neighbours at all that day. They must have considered me not just very poor company but rather rude as well, silently staring round the walls, glass in hand.

A few days later Deborah lent my daughter an art book for her homework, out of which fell a drawing and handwritten note in French. There was something familiar about the style, and to our utter astonishment we realised that its author was none other than Pablo Picasso himself. Deborah had used it to make a page, and forgotten it was there. Yes, she knew Picasso – her family had had a little cottage in the south of France, and he had been a neighbour and friend.

This led to the first of many conversations about the artists Deborah had personally known, and there was no shortage of them. She also had lived in Hampstead, in Keats Grove, near Henry Moore, Bertrand Russell and many other mid-century movers and shakers. A great campaigner, she went on the first CND march in 1958 with Dora Russell. I still see them both sometimes when they run the early footage on a newsreel. There is Deborah, indomitable, at the front, striding along with a CND

placard. We became close friends, particularly after her husband Bobby died, and I would listen for sounds of activity in the mornings through the party wall to be sure she was up and all right. She introduced me to Berthold Lubetkin, the Russian architect, who lived round the corner from our terrace in Princess Victoria Street. She told me that during the war Bobby had worked for the UN. One day a friend asked him if he would pay £5 to have his portrait painted by a penniless Austrian refugee who had fled the Nazis. Bobby didn't have the time to sit for him but gave the painter £5 anyway and sent him off with good wishes and suggestions of other patrons who might have the time to sit. The man was Oskar Kokoschka. It was Deborah's lasting regret that she could have had a Kokoschka portrait of Bobby hanging on her wall.

I was standing frustratedly in front of *Crocus and Moth* when Deborah caught up with me. 'I can see you like that one,' she smiled. 'Isn't it lovely?'

'Yes, it's gone,' I replied dolefully.

'Feddens always sell straight away. It happens every time. But don't worry,' she said, seeing my face. 'Would you like one? I know her very well. We've been friends for years. Why don't you go and see her? I'm sure she'll let you have something from her studio.'

And that is how I came to enter Mary's enchanted garden for the first time.

Mary was born in Bristol in 1915, the daughter of a sugar importer. They were a well-to-do family. Her father owned the

first car to be seen on the Bristol streets, and she was sent to Badminton, a posh girls' school close to the Clifton Downs. She hated it. She was not academic but she excelled in art and with the encouragement of an inspired art teacher, Miss Young, she won a scholarship to study for four years at the Slade School of Art.

When she was thirty-four she met the artist Julian Trevelyan; they married in 1951 and lived, loved, worked and travelled together for forty years. They made a tremendously strong partnership, helping, criticising and influencing each other. On my early visits Julian too was there, busily working in an adjoining room. A tall, bearded, ascetic man, he lives on in Mary's paintings, fishing, sailing or striding by the sea in his blue fisherman's jersey or yellow oilskins. Julian died in 1988 and Mary has carried on painting almost every day since in the studios that they shared together. In fact it is since Julian died that she has truly come into her own. She was, to some extent, in the shadow of her beloved husband and did a lot of the more menial tasks, pulling editions of prints for him.

Mary Fedden's reputation, and prices, have grown and grown in the last twenty years. She became an RA in 1992 and an OBE in 1997, and her work is in nearly every important modern British collection in the country. I was recently invited to a small exhibition of her recent works in the Royal Academy Friends' Room. The pictures were to go on sale at six o'clock on a Sunday evening, and, knowing her work would be in great demand I arrived about midday, expecting to find a queue already forming. But there was no queue. I rushed into the Friends' Room thinking the Academy may

have reneged on their promise not to sell before 6.00. But no, there were no red spots. Puzzled, I went to the desk to find out what was happening, only to be told that the queue had started to form at five that morning and at nine o'clock they had decided to hand out numbered tickets. I immediately asked how many tickets had been issued so far.

'Thirty-four,' came the answer. Since there were only twenty-four paintings on sale! clearly had no hope of buying anything.

I was disappointed, but that wasn't the only point of the day. At a few minutes to six Mary appeared in the company of Christopher Andreae, her biographer, looking very beautiful indeed at ninety-two in an unusual black-and-white linen dress. She signed more than a hundred books that evening and of course all the paintings sold immediately.

What is the magnetic quality that Mary's paintings hold for so many people? I think it is mainly their simplicity and accessibility, combined with a clever use of clear colour and a masterly feel for composition. Her work is never formulaic; there is always something in it that surprises the viewer. She always prides herself that she has never followed fashion: she paints exactly what she wants to paint. Her work is about the pleasures of life rather than its horrors – wine and food, travel and sunshine. But they are not predictable. She uses everyday household objects in her still lives but there is an element of the surreal. An unexpected volcano or stray zebra may pop up in strange circumstances in her landscapes. It is that elusive, mysterious quality that makes her work so satisfying.

I have paid many visits to her wonderful secret world since

that first visit but, nevertheless, every time I go I still feel the same frisson of excitement and anticipation as I ring the bell set into the high wall by the blue gate. A visit to Mary is a wonderful experience and a great privilege because her little patch of real estate by the Thames is an unexpected paradise. It is a secret place, well guarded by high surrounding walls and answerphone entry, strictly by invitation only. Once inside her magical domain one is admitted to the private unpretentious world of Mary Fedden. Situated among chi-chi houses and flats worth millions, she lives simply in a wooden boat house which is much older than she is, using the adjoining single-storey boat house as her studio.

It was late spring 2007 when Michael and I made one of our habitual visits. The gallery was to celebrate its twentieth birthday in July with an exhibition showing twenty outstanding artists. We had Frink and Chadwick, Fell and Nicholson, Frost and Barns Graham, Kelly, Blow and Scott and a host of other big names in the art world, and Mary had painted four works especially for us and the birthday show. We were there to select and collect them, and we were excited.

Mary came to greet us down the dappled path between the two ancient boathouses. The end window of the house with a sill of Julian's etching plates drops down vertiginously to the Thames. Inside it is a treasure trove of their works and their life together, as well as work by other artists and a lifetime's collection of objects and books, many of which feature in her still lifes.

We took coffee and home-made chocolate and walnut cake

(yes, she had made it herself earlier that morning, knowing that Michael has a sweet tooth) in the small but wondrous garden to the sound of small craft making their way up and down the river. The days when she would climb the steps over the clematis-clad wall and down the metal ladder into their boat are long since gone, but the inspiration for her extraordinary pictures is all around in her planting: Tall cow parsley and giant hogweed heads dried in sculptural shapes, large gunnera leaves contrasting with poppies and catmint, all popular subjects in her paintings. Her tabby cat, called simply Pussy, another star in the cast of characters in her paintings, crept out from the undergrowth to rub round our legs and jump up onto Michael's lap. Cats always seem to know he is soft about the feline species and make straight for him.

Pussy didn't know it but she was going to be the star of our birthday show. We already had a superb oil on canvas entitled *Striped Cat* starring Pussy posing on a window sill against a landscape, across a lake towards mountains, overseeing a dish containing three speckled eggs. We had acquired it a long time before and, having enjoyed its presence on our walls, had now earmarked it for this special show. Having a succession of amazing original artworks on show at home is one of the perks of being in the business, but the downside comes when we have to sell something we have grown to love. We constantly remind each other that we are dealers and must sell in order to buy something else, but it is still hard. Knowing the *Striped Cat* would be a popular piece we had used it on our invitations, posters and advertising for this important show, and we were

not wrong. We could have sold that painting many times before the opening of the birthday show.

I had sent Mary a copy of the book about PK's painted letters some months earlier. She was fascinated and, seeing the telephone number of the reference page, had immediately rung it. At ninety-two, her memory was failing.

'Hello,' she said. 'Do you know, someone has sent me this marvellous book and I don't know who. I haven't paid for it.'

'Hello Mary,' I replied. 'It's me, Chris, Deborah's friend in Cumbria. I sent you the book. I thought you would like it. It's a gift for you.'

'Oh thank you. It's wonderful. What a great artist he was. When are you coming down? I want to talk to you about him.'

So now we sat in her secret garden discussing Percy. I had taken a few of my own personal collection of PK letters and invited her to take one to keep. She chose one featuring boats in Brittany and was thrilled. She started to make her own painted letters; she had sent one to a friend's daughter in hospital which had been much appreciated, and she showed us a few more which were ready to send. It was almost worth being ill to get one of those beautiful things. She also made us a painting inspired by Percy's work and Robert Frost's poem *Winter*:

> The woods are lovely, dark and deep.
> But I have promises to keep,
> And miles to go before I sleep,
> And miles to go before I sleep.

We reproduced it as a Christmas card that year and it sold the best of them all, raising a lot of money for the charity Water Aid.

Coffee and chat over, we made our way down the primrose path to the studio, a huge space full of wonderful things. My eyes and brain go into overdrive every time I am in there as I try to absorb it all. There are battered tables covered in paint, an old sofa strewn with fabrics of familiar patterns used in many paintings, vases full of flowers dead and alive and piles of shells, feathers, stones, postcards and paintings all round the walls – delicious, tasty oils, serendipitous watercolours and collages, some made from cutting up some of Julian's prints. The press is in another room next door.

Mary is not precious about anything and certainly not about herself or her own incredibly popular, highly collected and valued work. Her still-life paintings are simple and satisfying, with a clarity of colour and a masterful and instinctive feel for composition. Objects sit together with a symbiosis of shape and texture, often on a flattened table top reminiscent of a William Scott painting. There is a low easel and chair with work in progress tantalisingly balanced on it and glass-doored cupboards containing books, paintings and canvasses. At the end of the room are two small heaps of paintings, one of them water-colours, the other oils, from which we could choose four. What a dilemma. We chose two peopled landscapes and two still lifes and after a glass or two of wine to celebrate our visit we reluctantly took our leave back to the real world, clutching our prizes. As we murmured our thanks, she remembered something.

'I say,' she said diffidently. 'I've got an invitation to the Modigliani opening tonight at the Royal Academy. I can't go. I'm still in my painting things. Would you two like to go on my ticket? I'm sure it will be all right.'

I looked at the invitation. The crisp white card invites Miss Mary Fedden RA OBE PPRWA and guest to the 'Champagne reception at the Royal Academy'. We looked at each other with raised eyebrows. We were not dressed for a gala opening and I certainly bore no resemblance to such a famous artist. (And I don't think I look ninety two, though sometimes I feel it.) There was no time to go back to the hotel and spruce up. But yes, we did go. We couldn't resist it. We nodded obeisance to Sir Joshua on his plinth in the courtyard. We flashed the invitation confidently at the guardian of the revolving doors, knowing that there was no way we looked remotely like Mary – either of us. We took the elliptical glass lift up to the Clore Gallery and mingled with some famous names and faces while enjoying the exhibition in comparative peace.

Hanging day for the birthday show arrived, and *Striped Cat* was hung in a prominent position in the Adam Room, above the Corbusier chair by the fireplace. As I went to the back kitchen to bring more paintings through I noticed with some irritation a real live tabby cat sitting on the kitchen window sill and mewing to come in. It had been hanging about for a while, even though I had asked the staff not to feed it or let it in. We had put notices in shop windows and in the local paper and

hoped its owner would come forward, but they hadn't, and by now it was very thin and in distress. It had obviously chosen us to be its saviours. We had enough to do with the exhibition and big twentieth-birthday party to organise. But the cat was shrewd – she had made a good choice.

'Oh, just look at her,' said Michael. 'She has nowhere to go. We can't leave her like that – she'll die. She's very thin.'

With this he opened the door and in she came. She slowly strutted along the hall, rubbed round his legs in thanks, purring loudly and went straight into the Adam room, and jumped up on to the back of the Corbusier chair, adopting precisely the pose of the cat in the painting above her. It was an uncanny moment.

The hanging was put on hold, of course. Michael rushed off and bought cat food for her and we rang the local papers and gave them the story. Photographers arrived and Fedden, as we named her, posed and pouted on the Corbusier chair like a professional model. She had a voracious appetite and she soon put the weight back on and became sleek and contented. She was the most affectionate cat we had ever known, and her behaviour could not have been more perfect. She was clearly trying to prove to us that she had earned her place.

But now we had a problem. A big problem. We already had a cat, a Blue Persian designer creature who isn't really a cat at all but a superior being. There was no way Queen Natasha would share us with a tabby stray, however beautifully marked. We continued to search for Fedden's owners and hoped against hope that they would reappear. Meanwhile

Michael got her checked over by the vet, who informed him (for the sum of forty pounds, which included injections) that she was about eight months old and in good health.

Striped Cat was the first painting to sell at our birthday opening, by telephone to someone we had never met. He had been trying to buy a good Fedden oil painting unsuccessfully for a few years and experiencing the same frustration that I had known in Bristol all those decades before. He bought it from the photograph on the card because he knew he would love it, and he did. We were tempted to tell him that he would get a real cat with it – a BOGOF – buy one get one free! – but he lived partly in a London flat and partly abroad so that old supermarket con wouldn't work.

Fedden was popular with visitors to the gallery. Quite apart from anything else, she was beautiful, with intricate patterns on her coat that now shone thanks to Michael's brushing. She trotted out to greet our clients when they entered the gallery and lapped up the admiration heaped on her. I secretly suspected that she lived in hope of being given extra food. After the near-starvation she had endured she was constantly hungry, and in return for our care she brought us desirable tit-bits like bits of mice or birds. By now we had become very fond of her and we were travelling back and forth even on our days off to see and feed her. It had got to stop.

We offered her to our clients via the gallery network and email and got several applicants, most of them quite a distance away and some with small children. But we found ourselves

developing a tough interview technique with would-be owners, as if we were looking for reasons to find them unsuitable. We were strangely reluctant to hand her over.

We had a big party for the gallery's birthday and invited all the people who had contributed to the gallery's success over the past twenty years. We put up a dome in the garden, bought on eBay from an aging hippy in Wales. We had entertainers and bonfires, puppets and jugglers. Fedden looked on quietly, unfazed by the crowds.

It was almost midnight when Philip, my IT engineer, arrived with his wife Hilary. They apologised for their lateness and explained that they had almost decided not to come. Their beloved old tabby cat called Chiswick had died that morning and they were heartbroken. Hilary became tearful as she told me. I gave them a drink and led them into the Adam Room which was quiet – all the action was in the garden. There was Fedden, a younger version of Chiswick, sitting in her now habitual place. I didn't even hesitate.

'Would you, could you possibly take Fedden off our hands?' I asked.

They couldn't believe it, and it was tears and hugs all round. We miss the painting and the cat a lot. They were a concerted asset to the gallery. Fedden is only half a mile away and I call in to see her from time to time. She's put on weight with all the pampering she gets. The local press had covered the story when we were trying to find her owner (under the predictable but cringe-making headline 'Picture Purrfect') so I sent a copy to Mary telling her the full saga and its happy ending.

She sent us a beautifully written letter in response (sadly not an illustrated one), writing, 'I've never had a cat named after me before. I'm absolutely delighted.'

The last time we went to see Mary her memory had totally gone. She still paints every day and the work is good, which at ninety-three is a great achievement. We looked around for 'Pussy' but she wasn't anywhere to be seen, and a friend of Mary's told us that Pussy had disappeared a few weeks before. This sad loss makes 'our' Fedden even more precious.

The Purple House

The house came as a shock the first time I saw it in 1987. It was blatantly purple and stood on tiptoe, very big and tall in this idyllic green and quiet valley. It looked as though it had been hastily dropped by mistake on the roadside and forgotten. I had been dawdling along the beautiful Lorton Valley on my bike. There was nothing to disturb the eye. The Lake District Special Planning Board is zealous in preserving the National Park in amber. Anyone putting a foot – or window – wrong must appear before the Inquisition and be subjected to mental torture. This punishment often becomes physical with the forced amputation of the offending part unless an appeal to the Lord High Executioner in London proves successful.

I was at peace with nature and the world as I skirted the edge of Crummock Water in the sunshine, swerving to avoid the indigenous Herdwick sheep with their cartoon-like smiley faces and thick fleeces dyed deep red/brown and 'hefted' (to use the

local term) to their own particular territory (as are indeed many of the indigenous human inhabitants). This was the first of many occasions that I made the long and steep climb up to Newlands Hause from the small grey hamlet of Buttermere with its tiny church and grey stone farms, cottages and hostelries. At the top, stopping to dip my bright red face in the ice-cold waterfall that comes off Robinson, I looked down the long hill into the Newlands valley and checked my brakes. It is the sort of descent that cyclists love – long and straight with good visibility for several miles, so you can really let go with a gigantic swoop. I launched myself down the hill, feeling like the King of the Mountains as the adrenaline flowed through my veins, as the wind brushed and stung my face. I felt weightless, flying.

Reality kicked in again near the end of the swoop with a steep, sudden double bend followed swiftly by the lethal, narrow stone-edged bridge of Keskadale – a timely wake-up call to find the brakes again. A mile further on, sitting on an awkward junction by Devil's Elbow Bridge, there it was, big and purple and confrontational. Who on earth had got permission to build a clapboard house in this area of outstanding beauty? Who had had the temerity and mad, bad taste to paint it bright purple? It wasn't even a uniform purple. It was as if a band of goblins had each been given a pot of some vaguely violet shade and a brush, then let loose to scamper all over it at will. On closer inspection it was also much neglected. There were broken windows and an overgrown thicket for a garden. A grand decaying stone fountain, some relic of a stately home, was crammed into the small clearing at the back.

Curious, I made enquiries, and it soon turned out that there was no shortage of people eager to talk about it. The house was called Rigg Beck, and occupied by an eccentric old lady who took lodgers and was once a sculptor. Her favourite colour is purple (now there's a surprise!) and legend has it that when she moved into the house in the fifties she painted not only the exterior that particularly repellent shade of puce but the interior as well. I was told that she inherited a green stair carpet when she bought the house and painted that too with purple emulsion paint. This may or may not be the truth. Legends abound and proliferate around the mystery of the Purple House in the valley, in Keswick and way beyond.

Rigg Beck was probably the first clapboard house in the whole of the Lake District. It was built by a Canadian in 1881, but did not turn purple until it was bought by the Purple Lady and her husband in the fifties. After that first mad painting it enjoyed very little maintenance, so that over the years the colour faded and aged into a dusky washed-out lilac until it began to blend with the slate-grey fells surrounding it, merging into the August heather as if camouflaged. A huge tree came down in the gales of 1998, falling through the roof and into one of the top-floor windows. It was allowed to stay in this position for several years, which did nothing for the structural stability of this four-storey, timber-built house.

The Purple Lady and her husband had nine children. I was almost tempted to say they brought up nine children in that house, but in fact the children brought themselves and each

other up. For a long time there was no electricity and no heating apart from an old wood stove in the kitchen. The family never owned a car so they were very isolated. The parents were middle-class bohemians and, although they let their children run wild, they did believe in the power of education, and tried to make sure they attended school first in the schoolroom attached to the lovely little Newlands church and then at secondary school in Keswick. The children rarely had the right things and never had school uniform, which made them stand out in the crowd, a painful experience at an age when children like to conform. A large black car would collect them along with other children from farms in the valley to take them to school. Their father had a habit of disappearing from time to time and their mother was not a cook so food was a haphazard affair. The boys made friends with farm children and spent time in their warm kitchens. The girls weren't so lucky and often went hungry. It was an unusual childhood.

In the gallery's first year, when I was very keen to find artists to exhibit, a visitor whose opinion I respected mentioned a painter in Millom whose work he felt I should see. Since the artist wasn't on the telephone (strange but true) I had no alternative but to make the journey there. Millom is a town on the west coast of Cumbria, It is quite close to Cockermouth as the crow flies but the Lake District is arranged like a cartwheel, with the mountains and lakes radiating like the spokes of the wheel from a central point. As a result the journey is a tortuous sixty-mile drive. Dropping down from Muncaster into the

Esk valley, one feels as if one is entering bandit country. In times past there were highwaymen here and a particularly nasty character, Tom Fool, who was the steward at Muncaster Castle and used to direct any travellers he disliked into the deadly quicksands of Eskholme Marsh below. (Hence, according to legend, the term 'tomfoolery', which wasn't funny at all then.) These travellers were never seen again, and I began to wonder if I would meet a similar fate.

When I finally reached the artist's small terrace house I was disappointed. His work, although perfectly competent, didn't give me a buzz. It was flat and unexciting, and the room was empty and bleak with a small smelly terrier in the corner. I wanted to escape but found it difficult to leave without being rude. We made awkward conversation, and I inquired politely if he ever came to Cockermouth.

'I don't drive,' he said, adding after a pause, 'But I come to Keswick once a year.'

This surprised me. 'How do you get there?' I asked.

'We walk. Me and the dog.'

'All that way?' I was intrigued. 'How?'

'We go over the mountains,' He explained, matter-of-factly. 'We set off over Black Combe.' This is the big dark lump of a mountain that presides over Millom – a dominating presence.

'Then I drop down into Eskdale and up over Scafell.' This is the highest mountain in England at 3,209 feet. It is not an easy option.

'Then we go across Great Gable, top of Honister Pass, up to Hindscarth and then we drop down into Newlands Valley.'

'Where do you stay in Keswick?' I knew he couldn't do the return journey in a day. This was a marathon hike.

'I stay at Rigg Beck. Do you know it? They take in lodgers. I like it there. There's always somebody interesting – actors and people.'

'So you have a bit of a holiday then?' I said. I was interested now.

'I come for the AGM.'

Right. This could be the AGM of Eccentrics Anonymous. The Arts' Fringe. The Comedians' Convention. I waited for it.

'The AGM of the Keswick Chess Club,' he explained, seeing my raised eyebrow.

These were days before the world wide web was invented. He didn't have a telephone. How did he manage to play chess in Keswick? I didn't ask. The reply might take too long.

He did turn up at the gallery that summer. His dog's legs seemed even shorter – maybe worn down with all the walking. He'd walked from Rigg Beck that day. I didn't ask the route this time. I guessed he'd applied his usual method of simply drawing a line from the Purple House to the gallery and walking it – about twelve miles over high rough terrain. By a more conventional and easier route it would be about twenty miles, but not half as interesting of course.

In 1996 I paid one of my regular visits to Percy Kelly's first wife, Audrey. Percy had died three years earlier, and Audrey was just treating me to another long diatribe about his shortcomings

when she suddenly mentioned that he had had an affair with 'the woman at Rigg Beck'.

'When would that be?' I quickly asked.

'In the 1960s,' she replied. 'It was when he went to that art college and began behaving like a teenager again despite being in his forties. That college put funny ideas into his head, you know. I confronted him with it and he pretended he didn't know what I was talking about. I followed him one day on my day off. I knew he had gone to the Newlands Valley and sure enough his car was parked outside that woman's house.'

'The Purple House?' I prompted, wanting to be sure.

'Oh yes,' she replied instantly. 'I parked in the quarry by the bridge and waited a long time for him to come out, several hours. When he did, he looked right and caught sight of my car. He immediately leaped into his old MG and set off up the valley at speed. That's the long way round back home to Allonby – over the top of the pass and along Buttermere to Cockermouth and home. I went the other way down the single track road and then put my foot down ready for the confrontation when he arrived home. Guess what though? He got home before me. I don't know how he did it but he did. When I arrived home, he was sitting in the armchair by the fire and he denied everything. He said he'd been painting higher up the valley. He was lying. I knew he was and I found her clogs in his car.'

I was fascinated. By now I had discovered that the Purple House had impressive literary and romantic connections. As a lodging house, it had been a magnet over the years for all

manner of eccentrics, theatricals and writers. Ted Hughes had stayed there with his second wife. Shelagh Delaney, writer of *A Taste of Honey*, spent many weeks there writing a new play, and a young Victoria Wood and Bob Hoskins were residents for a short time when appearing at the theatre in Keswick. Ken Russell the film director had a cottage in the next valley and came to visit, putting forward some ideas for film sets on the site. The list of celebrity lodgers and the rumours of some of their antics were the source of much Keswick gossip, so it was not surprising that Percy had been attracted to the easy-going bohemian and artistic lifestyle of the place. He would have fitted in very well.

When I heard about the possible connection with Percy Kelly from Audrey, I wrote to the Purple Lady asking if I could come and talk to her about him but, unsurprisingly, received no reply. A few months later I was approached by a Channel 4 researcher who wanted to make a film about Percy Kelly. We had just mounted the second solo exhibition of his work and it was drawing attention nationally. The Government had bought several of his paintings for the National Art Collection and his reputation was growing. Channel 4 had also heard of his transvestism and felt that it would make a good film.

The producer seemed to have more interest in his sexual proclivities than his art, and I was determined not to be drawn on that one. I wanted Kelly to be known for the quality of his work – not his frocks and wigs. But they were desperate for something sensational. The producer arrived and pestered me

for photographs of him in drag which I refused. I agreed to be interviewed about his work and nothing else. Joan David, his last friend and correspondent, firmly refused to have anything to do with it, as did Chris, his second wife.

People in Wales and Norfolk agreed to be interviewed and filmed, as well as Audrey and his son Brian who enjoyed the spotlight. The producer wined and dined me and asked me for more people to interview locally. In an unguarded moment I mentioned the Purple House and he was onto it in a flash. I felt it could do no harm and gave them directions to Rigg Beck, extorting a promise that they must report their findings back to me.

As they later recalled, the producer and researcher found Rigg Beck easily (who could miss it?) and knocked politely on the wrecked door. They got no reply but the repeated knocking pushed the unlocked door open (or so they told me) and they stepped inside. They shouted a bit and finally an untidy-looking woman appeared from upstairs in her nightclothes and a purple dressing gown. She looked as though she had just got out of bed, which she probably had. She offered them a cup of tea which never materialised (possibly for the best, given the state of the kitchen). After the polite preliminaries, they gently broached the subject of her relationship with Percy Kelly. She looked puzzled at first and then laughed.

'Oh that wasn't me,' she explained. 'It was my daughter. They were very friendly for a while.'

'So where's your daughter now?' they asked in surprise, because she was nearer Percy's age group.

'I have several daughters,' she replied. 'I have had nine children, you know.'

They didn't. 'So which daughter was it?' the researcher persisted.

'Oh I can't remember,' came the reply. 'It was a long time ago.'

'Can you give us their contact details, then we can ask them?'

''Fraid not,' she answered, dolefully and convincingly. 'I have mislaid all my children.' Despite further questioning, they left empty-handed and reported back to me the disappointing news.

This information immediately fired me up and I tried my best to find the daughter, but my lines of enquiry led nowhere. Apart from the Purple Lady herself the family seemed to have disappeared, covering their tracks behind them. I got on with running the gallery.

When I began to read Joan David's letters from Percy Kelly some years later, I came upon a reference to Rigg Beck and the Purple Lady, whose first name was Varya.

Percy wrote to Joan,

I can understand Varya painting her house purple because she could be rather odd. One day a treacle pudding was left in a pan of boiling water on a stove in the second floor kitchen. I was talking to Varya on the ground floor when there was a terrible bang. I dashed upstairs to find that the tin had exploded. The ceiling and walls of the kitchen were covered in

treacle pudding. Varya, who had followed me upstairs, was upset and I consoled her by saying that it would easily wipe off and I would help her. I said, 'If you have a ladder I'll soon scrape the ceiling clean!' Well, a ladder was produced. Alas, I was soon to discover that the pud was like toffee and stuck to the walls and ceiling as if glued. More laughter and I wasn't the only one. As far as I know the pudding remained on the ceiling for years.

The auction was held in Keswick Golf Club on 18 April 2007. It was a sad occasion. Rigg Beck was in such total decay and disrepair that it was beyond redemption and was being sold with a demolition order on it and planning permission for redevelopment. This provided a rare opportunity in the National Park for someone to build a house of their choice on the site – and what a site, with Causey Pike protecting it to the west and the Cat Bells ridge rising across the valley to the east. A variation of Frank Lloyd Wright's iconic house, Falling Water, built in concrete and glass, would sit beautifully on the site. The Lake District needs some twenty-first-century architecture.

The Purple Lady had long since lost her licence to run a bed and breakfast, she'd been unable to conform to fire and other modern health and safety standards, and so had been camping out in it alone for some years. Now, no longer able to live by herself, she had gone into a nursing home. I would have loved to buy it but, on inspection of the estate agent's details, I realised that there were too many problems. It was estimated

that the demolition would cost at least £50,000 because all the timber had to be transported off site to landfill – a big bonfire was not an option in that situation. There were at least ten pages in the blurb about the only residents left on site: the bats. The house was full of them and because they were a protected species the rules for demolition were stringent, seasonal and expensive. What's more, the tall mature trees close to the house that spoiled the view had a protection order on them.

Apart from all that, I knew I just couldn't afford it. It was just a dream but I went to the auction all the same. That house had a hypnotic fascination for me – and obviously for many others as well. The clubroom was packed beyond saturation point. Most of the builders and speculators of Keswick were at the bar, alongside a good sprinkling of farmers and some very well-heeled couples, not to mention a huge crowd of curious spectators. I wish I could report a thrilling evening of bids and counter-bids, shouts and tears, but the auction was a very lifeless, unemotional affair for such a colourful property, and the two television crews present must have been left very disappointed.

Four grey men in suits took the table at the front of the pressing crowd and the auctioneer, who had a flat depressing voice and an uneventful face, took charge of the proceedings. The most interesting thing he did all evening was knock over the water jug not once but twice, drenching the front row of bidders/voyeurs with an early bath. The winning bidder had to be there in person to sign the contract and pay the 10 per cent deposit, so a telephone bid and anonymity was not an

option. It was very different from the art auctions I was accustomed to, with the banks of busy telephones down one side of the room.

The first lot to come under the hammer was a parcel of agricultural land at Troutbeck. This was where the farmers came in. Their manner of bidding was discreet, not to say surreptitious. I had a panoramic view of the whole room from my pole position at the bar (I had made sure of that) and still couldn't detect where the bids were coming from. I saw the odd movement of a finger, the flickering of an eyelid, a 'who wants to be a millionaire' cough or slight incline of a head and it was all over. The hammer came down at £100,000 for 106 acres and I hadn't seen a single bid.

After a short, barely animated discussion amongst the men in suits, Rigg Beck was up for auction. The auctioneer was doubly emphatic that this was Rigg Beck and not the previous parcel of land. Uncharacteristically for an estate agent, he even talked the property down, pointing out its disadvantages quite clearly. His cautious off-putting preamble seemed to succeed. What a slow auction it was – it was like pulling teeth getting any bids from this crowd. Surely the site was worth £200,000 at least. At last it got going and moved spasmodically along, with much quiet cajoling by the auctioneer. The hammer nearly came down at £280,000 but bidding rekindled, like a smouldering bonfire in the wind, and juddered on. A consortium of developers were still in. A young solicitor and his wife dropped out at £320,000. An earnest middle-aged couple at the back bravely went to £400,000 and then, after a heart-wrenching long silence, were

outbid by a family at the bar next to me. The five main con-
tenders had now sorted themselves out and the bid stood at
£460,000. At this point, as the hammer was poised to come
down, a tall man standing opposite, casually leaning against the
wall, entered the arena for the first time.

'Five,' he said shortly and distinctly.

The auctioneer's face lit up for the first time that evening –
possibly for the first time in his life.

'Five hundred thousand. Thank you sir,' he said.

'*Sixty* five,' the man emphasised. 'Four hundred and sixty
five thousand.'

'We don't move in fives,' the auctioneer retorted. 'Are you
bidding four hundred and seventy thousand?'

'No. I'm not. Four hundred and sixty five,' he repeated
firmly.

'I'm sorry – I can't take that bid, sir. Is it staying with the
last bidder at four sixty or are you bidding four hundred and
seventy thousand?'

There was an eyeball-to-eyeball stand-off until the laconic
man reluctantly gave in with an incline of the head and the
hammer came down on £470,000.

And this is how a management consultant from Surrey
came to be the new owner of the purple wreck. It was going
to cost him at least £50,000 to demolish and clear the site, not
to mention patience and a detailed knowledge of the mating
seasons and habits of bats. Who knows how much money and
how long it would take to build the house of his dreams? He
could not fail to have seen the irony of the 106 acres selling for

£100,000 and his one-acre site with a multitude of problems costing nearly five times as much. However, as some cynic close to me was quick to point out, he had probably sold his garden shed in the south of England to finance it.

Soon after the auction of Rigg Beck an interesting woman visited the gallery several times. She was quiet and shy with a sharp intelligence, and I began to get to know her. It turned out that she lived and worked in London and came up to visit her elderly mother nearby. One day we had some Percy Kelly paintings hung in the exhibition and she was more than a little interested.

'Tell me more about Kelly,' she demanded. 'I have a friend who knew him well. She was at college in Carlisle with him.'

I told her a bit of background and then of course I wanted to know more about her friend. I was on the PK trail again. You never know where Percy will pop up.

'She has lots of letters from him,' she said.

This was intriguing. 'Have you seen them?' I asked eagerly. 'Are they illustrated?'

'I've seen a few,' she said. 'My friend lived at the purple house. I see it's just been sold at auction.'

At last I was within reach of my goal: I had found the Rigg Beck daughter. What information could be gleaned from those letters about PK's college days? The woman left quietly and swiftly, without leaving me any details of how to get in touch with her again. I just had to hope she would come in again – and soon. I was impatient.

Now Rigg Beck was empty, squatters had taken over, flying

the flag of St George (patron saint of football) from the roof. The house was perilously unsafe and must have creaked, groaned and sighed through the night. Rumours abounded in Keswick that it was haunted.

After the auction, I went back to Rigg Beck for a last look. There was now a board nailed to the protective fence that surrounded the building, announcing the details of a local demolition company. Rather sadly I wandered down the hill to the little church at Newlands. It is a simple building with a small schoolroom attached, where the Rigg Beck children were taught and cared for. The setting is peaceful and serene, protected by the encircling fells. I went into the grassy graveyard at the side. After some quiet exploration of the headstones, I found what I wanted – the family grave. The headstone told me that three of the nine children rested there – all boys. Their mother had outlived them. How sad can that be? One of them, Daniel, had been just seventeen when he died. I was even more intrigued. I was getting sucked deeper into this. On my office wall, I have a huge charcoal drawing by Percy Kelly of the Newlands valley, with the little white church nestling at its centre. Sitting on the hillside above Rigg Beck, I realised that my drawing had been done inside the house itself, from one of the upper rooms. This knowledge about something that had become so familiar to me made my scalp prickle.

The quiet woman came back a few weeks later and said she had mentioned me to her friend. I sent her a copy of my book, *The Painted Letters*, and asked if she could get in touch, but her

friend said she was abroad and busy and unable to cope with it at the moment. I had to be patient – not an outstanding quality of mine.

In March 2008 I mounted an exhibition of some newly discovered paintings by Percy Kelly at the gallery. The preview was on a Sunday afternoon and the week before I received the exciting news that the daughter of the Purple House would be coming to the opening. I was beside myself with excitement, but also quite nervous. The nine children of Rigg Beck had grown up with minimum parenting and no boundaries, and I imagined a wild, bohemian woman coming through the door. Maybe she would be confrontational, secretive, damaged by life. I was scrutinising everyone at the preview while putting up the red spots as paintings sold.

At last my new friend came in with a tall, elegant fair-haired woman and introduced us. I couldn't believe it. She had a low melodious voice and a gentle manner, and I liked her immediately. When all the frenzy of the show was over we sat in the kitchen quietly and chatted over tea as she told me about the term she spent at Carlisle College of Art, Percy's first term as well. That marked the beginning of a their spasmodic friendship.

A few weeks later she came back, bringing me her letters from Percy, all piled up in a shoebox. Written over seven years, beginning when they met at Carlisle College of Art in September 1962 and ending 1968, when she was living in London with two small children, these letters are very revealing about his state of mind and throw light on his thoughts and

feelings about the college course, his friends and lecturers, his printmaking skill, his artistic genius and his failing first marriage. In an early letter he recalls their first meeting:

On Wednesdays I wanted to be so much friendlier but I kept thinking I might be intruding even though the years between us never seemed to matter and when you asked me to join you for coffee again I thought you were just being kind. The figs, the tomatoes, little things but I remember them all. I shan't ever forget. I loved the all too short day at your home. Although I wanted the children [her siblings] to have the train set – it was an excuse to see you again.

Of all the students I thought you would be the one who would go places. Your first litho was really excellent and I was impressed with your figure drawing when you used a heavy black line. I must show you the book of Permeke's drawing when you come to Allonby, and then you will see what I mean. I would love the life drawing if I could have absolute freedom and not be directed.

In April 1965 he wrote to her about his final exams.

Dear R

Thank you for your letter received this morning.

The exams are now over so it remains to be seen what the marks turn out to be.

My litho was quite a good one – a poster interpretation of Allonby 20 x 15. Several of the staff wanted a copy of the

print but I only part with my work reluctantly so I was rather mean.

The past few weeks have been a period of mixed emotions. Firstly during the exams there existed a nice sense of camaraderie. Each lunch break we resorted to the local and during fine weather we would pile into cars and make for the river at Warwick Bridge – a lovely place. There were talks of parties but the enthusiasm has waned and little is left except a feeling of sadness. Although I have had pleasant days there, there is a feeling now of urgency to get away from it all. The period I shall dislike will be winter – being shut in by gales and rain and the resulting feeling of loneliness.

Last week I took a day off and went into the fields around Ennerdale. The sun was warm, the wind barmy so I wandered about without clothes enjoying the complete freedom of it all.

We talked about PK's personality disorder, which was obviously flourishing and accelerating at speed. His procrastination and retentiveness were also most apparent. She was generous and trusting enough to leave the letters with me, grateful that I was promoting PK's work. We parted good friends, with a promise to get together again when I had sorted and read the letters. Unlike other, later letters to other people which had been carefully placed unfolded in A4 envelopes, these had been folded several times and posted in small envelopes. She had apparently stuffed them back into the envelopes after reading and there they had remained for over forty years. I felt a frisson of anticipation as I began to sort

them into chronological order. Michael walked through the kitchen one day and, finding me at the ironing board, stopped and asked, 'What are you ironing?'

'Percy Kelly's letters,' I replied 'But the iron's not on steam!'

We both burst out laughing. It's not the first time I've ironed a Kelly and I am sure it won't be the last.

I had an operation on my right foot on 2 June 2008. It was more debilitating than I could ever have imagined. I was in plaster and on crutches for six weeks; I couldn't drive and had to go to our local cottage hospital in Keswick for changes of dressing. On a Monday morning early in July, Michael had driven me in to the hospital early in the morning and we were just on our way back home when my mobile went. It was ITV's northern arm – Border Television, based in Carlisle.

'Is that Chris Wadsworth?' the reporter asked.

'Yes,' I answered cautiously.

'My name's Victoria. I'm told you are writing a book on the Purple House.'

I was on the defensive now. *Was I?* I asked myself. *Maybe I was.* 'Who told you that?' I quickly asked.

'I can't tell you. Are you?'

'No, yes, possibly,' I floundered.

'Do you know the owner of the house?' she went on.

'No, it sold to a man from Surrey. Your crew was at the auction. You will have it on record – it was last April I think,' I said impatiently.

'No, I want to know where the previous lady owner is. What's her name?'

'She's in a nursing home.'

'Where?'

'I don't know. Why do you want her. She has dementia.'

'Well, it's just that Rigg Beck is on fire,' she stated quite plainly and calmly, as though she was telling me it was raining or there was an offer on chocolate biscuits at Booths. 'I'm just going there now. Can you come and do an interview for us?'

'What?' I said. I couldn't believe what she was saying. 'The house. On fire. Now?'

'Yes, quite a blaze. It's burned to the ground I'm told. We're just about to set off from Carlisle. Can I meet you there?'

I was shocked, but I had to think quickly. I didn't want to do an interview. I had nothing to say.

'I'm so sorry,' I replied politely, 'but I've just had an operation on my foot. I can't drive or walk. You will have to try someone else.' And I immediately rang off.

Michael had already stopped the car. 'So am I turning round then my lady?' he asked, laughing.

'Of course you are Parker. Let's go.'

We arrived before the television crew. As the reporter had said, Rigg Beck had been razed to the ground. The firemen told me the fire had started in the early hours, and because it was all timber it had gone up very quickly. There was barely anything left, just smoking wood ash. As I pulled myself around the ruins on my crutches the television crew arrived

and I made a surreptitious retreat, holding my breath in case they spotted me and my duplicitous behaviour.

I emailed the Rigg Beck daughter as soon as I got home. 'Rigg Beck just burnt to the ground. Watch the news!'

She came up to stay with us the following weekend and we met her from the train and went straight to the site. We picked our way carefully over the piles of rubble and ashes, now cold. There were a few odd things lying unburnt – a piece of purple wood, a few pages from a book, a piece of lead from the roof. We filled a box with the ashes. We all agreed that it was a far more dramatic and dignified end for this historic house than a demolition gang. It was a fitting end. More of a bang than a whimper.

Epilogue

It is a cold, dark, February night. I am shivering, despite being wrapped in at least two pairs of everything, standing on a grassy, muddy knoll within sight of the lights of the A1. It is 1998 and I have just returned from a currently peaceful Zimbabwe where I have been gathering together a wonderful collection of stone sculpture for the gallery. It will at this moment be in a container on a train to Durban in South Africa, where it will be loaded on a ship and sail to Tilbury; there my carrier will pick it up and bring it up to the garden at Castlegate House. Africa suddenly seems a million miles away from here.

The contrast with the heat of Africa is almost too much to bear, but I and a small crowd are anxiously awaiting a different piece of sculpture. From above, this little hill, the site of a former colliery, must look like an ant heap with all the frantic activity around it. We are silhouetted against the skyline, dwarfed by tall cranes poised for action. There is a far-off stirring and the flash of yellow lights, and the excitement mounts. It ripples along the adjacent dual carriageway.

Finally a convoy of low loaders slowly emerges into view. The road has been closed to give it a clear passage. It is massive and we can see as it draws nearer that it is like the pied piper. Hoards of children and some adults are skipping and jostling along beside it. It is moving at walking pace. More people are joining all the time. They are converging in a huge triumphal procession. From the houses, from the side streets they come.

A man is lying on the low loader. He is fastened down like Gulliver in the hands of the Lilliputians. He is immobile, tamed and tethered. He is the Angel of the North.

As he draws to a halt beside his final position, where he will enjoy spectacular views over the Tyne Valley and beyond, the children take their last opportunity to climb on him and touch his head. After this it will only ever be touched by the birds. His wings, the size of those of a jumbo jet, are separate; each has its own low loader. They will be welded onto him in situ once the body is bolted to the awaiting plinth, making him complete, omnipotent. He is a symbol of regeneration and resilience. The sculptor, Antony Gormley, is calmly hovering; watching over his progeny. It is a scaled-up version of himself.

As dawn breaks more people arrive. The traffic on the A1 slows to a crawl while drivers gawp dangerously at the activity above them. Police stand guard, a helicopter whirrs overhead relaying pictures across the world. As the local skilled workmen are raised on a crane platform to weld the wings to the torso, there is a carnival atmosphere. It is like a

scene out of a Brueghel painting. It is a triumph for Gateshead and a triumph for the North.

I was there as a member of Northern Arts Board. In my six years on the board I saw many brave innovations. I saw the purchase of the Baltic Flour Mill on the Tyne and watched its transformation into the arts centre it is today. When it had been gutted and reduced to a shell of just four walls, I took my grandchild in his pushchair to see the temporary installation inside of a vast red trumpet called *Tarantarantara* by its designer, Anish Kapoor. I saw the 'Blinking' Bridge as it was slowly tugged up the Tyne and manoeuvred into place with perfect precision. I was at Shipley art gallery the night Norman Foster revealed his plans for the Sage Music Centre. He brought up images of three boring cubes on a screen and explained the function of each. Just as we were becoming worried, he clicked the mouse and a huge silver canopy magically arched its way over the whole complex. In 1996 I was present at the opening of a rare major Lucian Freud exhibition at Abbot Hall, Kendal, a real coup for Cumbria. The reclusive artist didn't travel up himself. 'Thank you very much,' he said in response to the invitation, 'but I've seen the paintings already.'

I have enjoyed more than twenty years at Castlegate House, and it has brought me not only the fulfilment of countless ambitions but more friends and a richer social life than I can realistically cope with. The support that came from nowhere was astounding. An unbroken panorama of interesting people

has passed before me like a film strip. The big oak table in the kitchen, which seats twelve comfortably, and more rather less comfortably, has seen some fascinating after-preview tea parties as well as more formal dinners and less formal impromptu gatherings. Art, cooking, love and friendship have all come together in that kitchen and given me infinite happiness. There has been plenty of laughter, buckets of tears and masses of deep discussion. Relationships have begun – and ended – in that kitchen, and in our famous queues before previews. And of course the best stories can never be told. Private and confidential, they are written only in my memory.

Visitors, of course only see the surface. 'You have a wonderful life,' they tell me. 'You live in a beautiful house among fabulous works of art. I wish I had a job like that.'

They don't realise that, apart from anything else, it is hard physical work. The laughter, successes, rewards and triumphs don't come without a price measured in stress and frustration. I'm dealing with artists who live on the edge much of the time. I'm always planning the next year while coping with the present one. While hanging the current show, I'm sending out invitations to the next, always planning months ahead and always stepping up the publicity. Without this constant effort the gallery would flounder.

I started the gallery with no knowledge of the business but a passion for art. Passion can be a powerful and dangerous thing, though, and I needed my trusty business plan to keep me straight. I never fail to be amazed, when I occasionally take stock and get the original out, how all these plans and ambitions

have been fulfilled. In many divers ways it has transcended them all, and taken me along paths that I never dreamed possible all those years ago.

The last two decades have seen dramatic developments. If Michael the First walked in now it would be to a world that is unrecognisable. He died in 1994, leaving a basic wind-up Amstrad computer. I'd never used a computer so had to commandeer my eldest son Andrew, the IT expert, to give me a crash course. Together with my other son Peter, who worked in a brewery, and my daughter Ruth, a social worker, my children provided an ideal support package. Along with the strong support from clients who had become friends and artists who had become loyal, I was in a good position to move forward. The advances into broadband, email, mobile technology and the world wide web, none of which I could have envisaged in 1986, have all made life so much easier; in fact the website almost makes the gallery building redundant.

The coming of Michael the Second into my life added a different vision, a different perspective. He has given me tremendous support and managed to modify some of my madder ideas and schemes. He raises the 'what ifs' that Michael the First used to raise when I was getting carried away. I still ignore them sometimes.

All this has come about through a passion for art and an interest in people. Without passion and without people of passion, and most of all without art in its widest sense, life would be very empty indeed.

Acknowledgements

My main thanks go to the novelist and biographer James Long for spotting my writing and story-telling ability. Sitting on a bench in a sunny courtyard in Umbria, with three of my stories in his hand, I heard him shout.

'Hey, I want a word with you. Come over here.'

'These are publishable,' he said when I joined him on the bench. 'Did these things really happen? Have you written any more?'

I was absolutely amazed and disbelieving. We ran them past a few other people at dinner that evening. They liked them too. They wanted more.

'Can you write twenty by Christmas?' James asked.

I could and I did.

Thanks also to Kay Dunbar and Stephen Bristow of Ways with Words who organise excellent literary festivals and courses. They are always supportive and spurred me on when I was rejected and dejected.

My grateful thanks to my 'angel' Angie Summers, herself a formidable painter, who sees to the day-to-day running of the

gallery and frees up my writing time.

To my wonderful IT man, Phil Tattershall, who not only sorts out computer glitches but, with his wife Hilary, took Fedden off my hands.

To the late Brian Kelly and his mother Audrey, who entrusted the Kelly estate to me and let me manage it unconditionally. To Audrey particularly for filling in gaps in my knowledge and providing me with so much interesting material.

To my agent Vivien Green at Sheil Land for taking me on and giving me excellent advice and support, and to the team at Aurum, particularly my editor Sam Harrison.

To all the artists who have exhibited with me, especially those in the early days who trusted me with their work; particularly June and Michael Bennett, Patricia Sadler, Karen Wallbank, Charles Oakley, Mary Fedden and Marie Scott, who have become friends.

And to other friends, too numerous to mention individually (you know who you are), including Terry Northam and Ailsa Lawrence. You all make me feel valued.

Most of all to Michael the Second who always offers practical support and love and can be relied upon to do the 'What ifs!'

Bibliography

The Painted Letters from Percy Kelly to Joan David 1983–1993, Castlegate House, 2004

Sheila Fell, Castlegate House, 2005

A Cumbrian Odyssey: Winifred Nicholson Paintings Castlegate House, 2005

Whitewash and Brown Paint: The Sketchbooks of Percy Kelly, Castlegate House, 2006

Letters to My Stepdaughter: Letters from Percy Kelly to Kim Griffith, Castlegate House, 2009

Andreae, Christopher, *Mary Fedden: Enigmas and Variations*, Lund Humphreys, 2007

Greenhalf, Jim, *Salt and Silver: A Story of Hope*, Bradford Libraries, 1998

Marshall, Tilly, *Life with Lowry*, Hutchinson, 1981

Peascod, Bill, *Journey After Dawn*, Cicerone Press, 1985

Rohde, Shelley, *L.S. Lowry: A Biography*, Lowry Press 1979

BB 9/10
cs 2/14.